The Art of

Truth-telling

about

Authoritarian

Rule

GARAVI GUJARAT NEWS WEEKLY
2020, BEA VER RUIN ROAD,
NORCROSS, GA 30071.

D1425926

The Art of

Truth-telling

EDITED BY
KSENIJA BILBIJA
JO ELLEN FAIR
CYNTHIA E. MILTON
LEIGH A. PAYNE

about

Authoritarian

THE
UNIVERSITY OF
WISCONSIN PRESS

Rule

Publication of this book was made possible by grants from Université de Montréal and from the following programs at the University of Wisconsin–Madison: African Studies Program; Center for Russia, East Europe, and Central Asia; Center for Southeast Asian Studies; Global Studies Program; Latin American, Caribbean, and Iberian Studies Program; the Anonymous Fund for the Humanities; and the University of Wisconsin Foundation.

The University of Wisconsin Press
1930 Monroe Street
Madison, Wisconsin 53711

www.wisc.edu/wisconsinpress/

3 Henrietta Street
London WC2E 8LU, England

Library of Congress Cataloging-in-Publication Data

The art of truth-telling about authoritarian rule / edited by Ksenija
Bilbija . . . [et al.].
 p. cm.
 Includes bibliographic references and index.
 ISBN 0-299-20900-8 (hardcover : alk. paper) —
 ISBN 0-299-20904-0 (pbk. : alk. paper)
 1. Reconciliation—Political aspects—Cross-cultural studies.
 2. Authoritarianism—Cross-cultural studies. 3. Truthfulness and
 falsehood—Cross-cultural studies. 4. Democratization—Cross-
 cultural studies. 5. Truth commissions—Case studies. I. Bilbija,
 Ksenija.
 JC571.A72 2005
 323.4'9—dc22
 2005001338

To a future generation of truth tellers, especially Una, Zack, Mela, Nina, and Abbe.

All profits from this book will be directed to the Scott Kloeck-Jenson memorial scholarship fund to support social justice research and internships by University of Wisconsin–Madison students from Africa, Latin America, Southeast Asia, and the former Yugoslavia.

Contents

LUISA VALENZUELA TRANSLATED BY CATHERINE JAGOE

"Haunting," writes sociologist Avery F. Gordon, is "a story about what happens when we admit the ghost – that special instance of the merging of the visible and the invisible, the dead and the living, the past and the present – into the making of worldly relations and into the making of our accounts of the world." Elsewhere in her seminal work, *Ghostly Matters*, she adds that "haunting describes how that which appears to be not there is often a seething presence."[1]

It would be hard to come up with any more appropriate quotes to define the essence of this book, which explores ways of breaking the siege of silence, of unveiling the omnipresent latency of a truth that with each return to normality and democracy is cancelled out in appearance only. Because there is an abiding responsibility to confront the teeming multitude of events in the past that contaminate the present. Periods of horror in the world leave aftermaths, gaping scars in the social fabric; the wounds begin to heal but only deceptively, superficially, and often it becomes necessary to open them up again – by referring to them – so that they can heal properly, from the bottom up, avoiding outbreaks of infection. The truth of what happened, of what cannot be spoken, will eventually surface by the most unexpected and convoluted of routes, and gradually the necessary pieces will start to fit together so that a thread of light can penetrate the deep darkness of the jigsaw puzzle of horror.

A great deal of water has flowed under the bridge since Theodor W. Adorno made his famous remark in a radio broadcast that writing poetry after Auschwitz is barbaric, that it is impossible nowadays to write poetry – an idea he was to repeat in his later work. The experience of various universal artists and intellectuals has managed to undermine this devastating critique. Because the true artist manages to carry out the Taoist project of making the invisible visible, and finds ways of portraying the full dimensions of suffering without profaning it. Paul Celan, Primo Levi and many others have demonstrated that this is possible.

In *Literature or Life*, Jorge Semprún writes about his experiences in Buchenwald concentration camp, after fifty years of painful silence on the subject. He says: "I start to doubt the possibility of telling the story. Not that what we lived through is indescribable. It was unbearable, which is something else entirely (that won't be hard to understand), something that doesn't concern the form of a possible account, but its substance. Not its articulation, but its density. The only ones who will manage to reach this substance, this transparent density, will be those able to shape their evidence into an artistic object, a space of creation. Or of re-creation. Only the artifice of a masterly narrative will prove capable of conveying some of the truth of such testimony."[2]

Actually, the truths of testimony seem to emerge rather like a giant jigsaw puzzle, thanks to multiple varieties of narrative interweaving and complementing one another: humor, songs, dramatizations, literature, memorials.

This is not a work of denunciation but rather of reflection, less risky but no less problematic because at every step one encounters not only that which resists being spoken but also those who resist hearing. In my own experience in Argentina I have often heard local phrases cast like a silencing stone at the heads of those of us who are trying to prevent the traces of genocide from being erased: "Nothing happened here," they used to say a while back. "We need to make a fresh start," they claimed, later on. "It's time to turn over a new leaf." "We're sick and tired of all that." Others, at different levels of power, beg or propose or command. General Perón once eradicated malaria in the northern part of the country with a decree. These new advocates of mass oblivion seem to want to wipe out our memory by decree. Fortunately, the resistance to that, both here and in other countries which have been at some point affected by authoritarianism, is becoming more and more vociferous, as this anthology demonstrates.

Devising and deciphering metaphors is perhaps the only means available to the thinking person who seeks to make sense of what is beyond reason, and to combat what Avery Gordon calls "ghostly matters." On that note, I am reminded of a short story, so brief it is almost a parable, that the great Argentinian writer and activist Rodolfo Walsh once told me many years ago.

Walsh was planning to write this story and he seemed to be trying it out on me. The years after our meeting were full of conflict and struggle, and I never found out if my friend had written his story or not. I only know that it does not appear in his complete works, but it has lived on in my memory. I know that its creator carried his story to its ultimate consequences in real life, and that if he ever managed to write it, it may be among the manuscripts that were confiscated by the army after they murdered him and ransacked his home. Many people have said that those manuscripts were seen in one of the Junta's secret

detention centers, at the Naval Mechanics School. A couple of years ago I went with a group of intellectuals to claim them; I hope they will some day appear and that the parable will be among those papers.

I can see now how the metaphor implicit in that short narrative has become richer and more nuanced over the years in the context of subsequent political developments in Argentina. I also understand how a whole range of options for the speleology of truth-telling can begin to unfold based on this bare-bones symbolic situation.

Here, in my own words, is the story that Rodolfo Walsh imagined and told: A man is walking across a meadow carpeted with flowers. Drawn by the unusual beauty of the place, he has ignored a sign saying *Keep Out*, and has crossed a wire fence that appears to be there for nobody. It's a glorious day, the terrain is rolling, and the man ambles dreamily towards a small grove of trees, feeling as if he were walking into paradise. The tall grass springs back up behind him, as soft as a carpet. With each of these trackless steps he feels happier and happier. He is almost levitating as he walks. In the heart of this paradise that he has discovered beyond the wire fence, he spies a stream of pure water that will quench all his thirst. He can hear the stream babbling now, and the birds singing in the grove. But when, at last, he reaches the heart of this place of ecstasy, he comes upon a notice that teaches him what may be his last lesson. *Danger*, says the sign: *Minefield*.

The storyline ends there. Walsh told it to me shortly before the outbreak of terror engineered by López Rega and his sinister Argentine Anticommunist Alliance that preceded the military coup in 1976. The premonition in that parable began to emerge gradually until almost all the inhabitants of my beautiful country came to feel like that rapturous walker, trapped in the midst of a false paradise that had suddenly revealed its sinister nature lurking just below the surface.

At that point we started to realize that we were living surrounded by what one might call mines, and that it was no longer possible to turn back, because our footsteps — in other words, our illusions — had vanished beneath the tall grass of pretence and fear.

That's what life was like in Argentina during that dreadful period of state-sponsored terrorism. In the throes of the military dictatorship, a few years after Walsh told me his story, that

unwritten, open-ended piece of his seemed to be pointing towards a sinister dénouement: in order to survive, the man would walk on trying to *avoid* the mines. Showing enormous courage, he has irrevocably sworn to emerge from the trap to try to save all those who in one way or another were trapped in the middle of the fenced-off area. To save us from the mines that were systematically exploding, to save us by destroying himself if necessary, as Rodolfo Walsh himself did with his *Open Letter to the Military Junta*, dated March 24, 1977; he was assassinated the next day. Those were the last pages, the last lucid revelation of a writer who, as the eminent critic Angel Rama has said, managed to pass from the investigation of individual crime (when he was completing his first book of detective stories, *Variaciones en rojo* [*Variations in Red*]) to the investigation of social crime and a search for justice that would eventually embrace society as a whole.

Nowadays the multiple possible readings of that short story seem to be opening up to include a new scenario: The Everyman figure, incarnation of the many, is in the middle of what he believed was a paradise when he realizes that the beautiful field of his dreams is mined (no big surprise — he should have suspected it right from the beginning, from the moment he decided to trespass beyond a barrier that was designed to keep him out, accepting a bucolic perfection that reeked of deception). Then, assuming his value as a symbol, at the risk of losing his privileges and having to face the painful truth, he proceeds slowly and meticulously, with infinite patience, to discover, unearth and disarm one by one all the mines that are poisoning his land, his own true paradise. For even though it is holed and battered and partially blown apart by explosions, it is his own.

The so-called "legacies of authoritarianism" can be compared to mines hidden deep below the apparently smooth surface of the social fabric. Bringing them to light, deactivating them, remembering them, is part of the truth-telling project that is analyzed here.

"The ghosts feed on the story of themselves. The past is laid to rest when it is told," writes Fred D'Aguiar in his recent novel *Feeding the Ghosts*.[3] Regardless of the form the telling takes, the present volume demonstrates the validity of that statement. ∎

1919
1954
1955
196
196
19
19
19
1

MANA
NACI
GOLPE MILITAR
DEMOCRACIA
GOLPE MILITAR
MATAN AL CHE
LA IMAGINACION AL PODER
DEMOCRACIA
GOLPE Y T
DESAPAR
INTENTA
77 EXILIO
78 SECUEST
979 MI HEI
980 GUERR
1982 DEMOCRACIA
1983 REGRESO AL PAÍS
1984 JUICIO A LAS JUNTA
1985 PUNTO FINAL
1986 ALZAMIENTO CARAPINTADA
1987 OBEDIENCIA
CARAPINTADA

TERMO DE ESTADO
R AMIGO
RME

The Art of Truth-telling about Authoritarian Rule

Introduction

KSENIJA BILBIJA, JO ELLEN FAIR,
CYNTHIA E. MILTON, AND LEIGH A. PAYNE

We gathered at the site in Guguletu where seven children were gunned down during South Africa's apartheid regime. Or so we thought. A monument commemorated the event at that spot. And our guides from the community had brought us there to understand the violence of the apartheid regime and community efforts to reconcile with the past.

An encounter at the site challenged our understanding of the truth about the memorial and the event it commemorated. Two women emerged from a nearby house and began to speak angrily to our guide in Xhosa. While the guide attempted to calm them, the two Xhosa speakers in our group interpreted the confrontation for us. The women wanted to know why our guides had brought us to that spot. According to them, the shooting had not occurred there, but down the road. Had we not seen the graffiti on the wall indicating the location of the killings? We should be in that spot, not in this public square chosen by the city to commemorate it. The women thought the city had robbed them and future generations of an accurate record of an event that had profoundly affected the community. Without any participation from the community, the city had hired the artist, provided the funding, and built a monument where it saw fit. In pursuit of a broader collective memory project, the city had disregarded how the community wished to tell its story about the ambush and murder of seven children by apartheid's security apparatus. The official monument had meaning in the community, but not the meaning the city had intended.

Our encounter with the women in Guguletu taught us an important lesson about truth-telling. A site intended to tell truths about the horrors of apartheid became a symbol of deception. The city had presumed to tell the community's story, denying official status to the community's own version of the truth. Yet another government, this one a government of the people, was insisting on its own account of history.

Guguletu was a revealing stop on a journey that began in 1998 in Madison, Wisconsin, and continued through South Africa, the Philippines, and Argentina. With international partners, the Instituto de Desarrollo Económico y Social (Institute for Economic and Social Development – IDES) in Buenos Aires, Gaston Z. Ortigas Peace Institute in Manila, Robben Island Museum in Cape Town, and the Legacies of Authoritarianism Research Circle in Madison, we sought to understand authoritarian legacies in democracies emerging in South Africa, Southeast Asia, Latin America, and the former Yugoslavia. Each year one of the institutional partners sponsored a workshop that brought together participants from their region. These meetings benefited from a range of intellectual and creative approaches: university professors and graduate students from several disciplines, artists, human rights activists, former political prisoners, and truth commissioners. We worked together for five years (1998–2003) with support from the Ford Foundation's Crossing Borders Initiative, the MacArthur Foundation's International Peace and Security Program, the University of Michigan's International Institute, and the University of Wisconsin–Madison's International Institute, Global Studies Program, and National Resource Centers for Africa, Russia, Eastern Europe, Latin America, and Southeast Asia.

Our trip to South Africa probed "alternative truth-telling," that is, truths about authoritarian pasts that emerge in the absence of truth commissions, as in parts of Southeast Asia and the former Yugoslavia; or where truth commissions have ended, as in Latin America; or where telling truths is taboo and/or left out of truth commission processes, as in Africa and other parts of the world. We wanted to find out how individuals and communities express truths outside formal transitional justice arrangements and what form these truths take.

South Africa's Truth and Reconciliation Commission (TRC) had been heralded as the model for all others. We understood its groundbreaking qualities and respected its role in opening South Africa to frank, wrenching confrontations with its past. Yet we knew that few TRC insiders or outsiders were entirely content with the TRC process of exposing human rights abuses that occurred under apartheid. Those in our group who had hoped to replicate the South African TRC in their own countries were especially interested to hear their South African counterparts detail the limitations of the process and its outcomes. Partners from Latin America and the former Yugoslavia, who were inclined to be especially admiring of the South African TRC and to attribute its success to the African National Congress's electoral defeat of the old apartheid forces, began to doubt whether liberation movements could produce better outcomes than the highly compromised political transitions they had experienced.

Belgrade Center for Cultural Decontamination

Disillusionment with the TRC model grew among our group during the visit. We developed a great interest in finding other models for restorative processes of truth-telling in countries emerging from authoritarian rule.

Visiting memory sites such as Guguletu, listening to victims' stories, poems, and songs, watching films and plays, and speaking with each other about our own experiences, we slowly came to understand that post-authoritarian truth-telling is more an art than a process, more about the creativity of individuals and communities than about official hearings, testimonies, and reports generated by state institutions. The idea of an art of truth-telling about authoritarian rule became the foundation of this book.

Truth-telling

The women we met in Guguletu engaged us in truth-telling. They contested a form of official memorializing that excluded them. They challenged the notion that a government body could or

would establish the truth as they understood it. As respectable and legitimate as the South African TRC was (and, like most South Africans, the women almost certainly valued the process), they knew that it was only a beginning, not the end, of teasing out truths about the past. Confronting visitors to the official monument, these women engaged in "everyday forms of resistance"[1] against political amnesia. Their encounters were calls on those around them to remember the past, and to remember it in ways meaningful to themselves and their past and present political struggles.

Multiple representations of the authoritarian past have been described by South African historian Deborah Posel as "a rainbow of truths." She constructs a conceptual grid, which she calls "wobbly," to capture the multilayered truths that emerged from apartheid: factual/forensic truth; personal/narrative truth; social/dialogue truth; and healing/restorative truth.[2] We tend to associate factual/forensic truth with official processes of trying to get the story straight, documenting and recording what happened. Despite the funds and national energy dedicated to these efforts, the findings of official processes are often challenged because their accounts, chronologies, geographies, statistics, and lists of victims and perpetrators often do not match local understandings. The mangling of details in Guguletu is but a small example.

Official processes — truth commissions, judicial proceedings, museums, monuments, and the like — rarely limit themselves to factual or forensic truth. They do not simply recount, they explain. Their ultimate aim is to forge a national consensus, a shared understanding of the past designed to advance a particular vision of the nation's political future. And so it is that debates emerge. How can the state claim possession of undeniable facts and correct interpretations of the past? Do others not know contradictory truths? Are official processes silencing competing accounts because they are politically inconvenient, or come from the powerless, or threaten the transitional moment?

It is our claim that official processes rarely, if ever, dominate popular understandings of the past. Facts and interpretations are multiple and malleable. Contradictory truths are inevitable. Those who have lived through authoritarian rule often deeply want their unofficial versions of events to come out: truths that may still be

uncomfortable to parties on different sides of still salient divides, truths that risk being silenced and censored. These truths are often personal and complicate or challenge official versions. Even when they have been expressed in official truth-telling processes, their meanings may have been sacrificed for broader political goals.

Unofficial truth-telling in all of its forms — the story told by one neighbor to another, the graffiti message scrawled on a compound wall, the song sung on the street and eventually recorded and distributed — often seeks in the first instance validation and acknowledgment of the experiences of the protagonist. But unofficial truths about the authoritarian period are socially transformative when they enter (and sometimes even create) a new public discourse about events of the violent past. Without fanfare, invisible to those unattuned to them, unofficial discourses of truth shift people's perceptions as effectively as any official process or account will do. They become social truths, shared understandings about the past derived from public discussions of it. They are informed, no doubt, by official truths, but they are independent of them. Personal truths are made social as they circulate from person to person and through the media. Anecdotes, stories, jokes, songs, and rumors provoke discussions in living rooms, bars, cafes, and schools. Movies, works of art, performances, written memoirs and novels, recorded music, and memorials are parallel fora for discussion about the authoritarian past and its meaning in everyday life.

Tensions develop between official and unofficial accounts. Official truths appeal to the need to move forward quickly, to put the nation's difficult past behind it. They rely on the alluring fiction that carefully managed processes can yield an objective consensus. Yet, unofficial accounts, reflecting the messy subjectivity of lived experience, have staying power. A traumatized society, comprising so many stories, does not put the past quickly behind it. In Guguletu, the women's response to the monument we visited taught us the limitations of any managed plan to arrive at a consensus about the past.

The accounts and commentaries we have assembled demonstrate that memories, private and public, derive from experience, observation, thought, and imagination, creatively combined in unique ways in different times and places. This is the art of truth-telling about authoritarian legacies.

Legacies of Authoritarianism

Each of the countries explored in this book has undergone significant political change, transitioning from authoritarian rule to some form of democratic governance. One, Argentina, has been engaged in this process for two decades. Others have emerged from authoritarian rule during the past 10 years or so: Chile, Guatemala, Nigeria, South Africa, and the Philippines. Still others, Cambodia, Indonesia, Thailand, and Yugoslavia, have just begun the process.

Drawing from all of these countries and others, this volume explores its theme across a range of national experiences, each with its own unique set of historical, institutional, and cultural conditions. Despite their differences, all the countries looked at here share two characteristics. First, all experienced widespread state violence that suppressed individual and group freedoms. Second, in each country persons and communities have emerged from this violence wanting to speak about it. Their desire is sometimes expressed as a quest for personal healing. But public exposure is neither strictly personal nor necessarily healing. It requires courage. It can be re-traumatizing. All forms of attesting to past violence are, in fact, social acts designed in part to wall up repression and contain it in the past. The words "nunca más," never again, used throughout Latin America and elsewhere express a simple ambition: to use truth and memory about the violent and authoritarian past to prevent its return.

Despite transitions from authoritarian rule and a variety of institutional mechanisms to resolve past violence, truths about the past often remain unexpressed. In some countries, such as Cambodia and Indonesia, official processes have not (yet) provided a forum for public truth-telling. Others, such as Argentina, Chile, Guatemala, Nigeria, South Africa, and Yugoslavia, have adopted trials and truth commissions for this purpose. Even with these public processes, individuals and groups feel excluded and certain truths remain taboo. Blanket amnesties, and political accommodation to avoid polarization and breakdown, have produced "forgive and forget" strategies that close off official avenues for public truth-telling and accountability for past violence, as we have seen in Brazil and Thailand.

Official processes, in other words, have fallen short of their promise to deliver truth about the past to avoid repeating atrocities in the future. This book acknowledges that political

transition – from authoritarian rule and dictatorship to formal democratic governance – does not necessarily bring dramatic change in individuals' lives. Continued human rights violations and political, economic, and social exclusion may prevail even after formal political transitions. Private security forces, made up of vigilante groups, paramilitaries, or moonlighting police and military, replace state security forces in some countries and carry out the same types of terrorism against political opposition groups. "Cultures of fear" that stymied collective social action in the past may prevail even after the formal adoption of democratic governance, inhibiting political expression. Impunity, amnesty laws, and legal systems that protect the legal and economic privileges of the powerful pose obstacles to investigation, prosecution, and imprisonment for corruption and violence. The similarities between the new democratic order and its old authoritarian predecessor heighten disillusionment with social and political change and weaken the motivation to work toward it.

Olympus Garage.

The human spirit remains resilient in the pursuit of truth. Official truth-seeking processes are limited. Unofficial and alternative truths about authoritarian rule rise to fill the breach: they repudiate past violence, they demand remembrance, and they insist that violence not be repeated. The tellers of unofficial truths form, in effect, informal networks of watchdogs against new encroachments. They speak their truths to power, to themselves, to their compatriots, to anyone who might be listening.

The Art of Truth-telling

This volume examines the creative expression of personal and social truths outside official processes. As such, the book involves more than stockpiling the atrocities committed by authoritarian regimes. As valuable as the exercise of truth-in-numbers might be, it often engenders skepticism over the accuracy of the process or its findings. In addition, for the victims of state violence, the numbers are not necessarily relevant. That atrocity occurred at all, and that those who committed it have immunity from prosecution and public accountability, is more at issue. To condemn the past and deter repetition of its horrors, victims and human rights activists simultaneously document atrocity and give that atrocity meaning through stories.[3]

This book shows how victims and human rights activists tell their truths. Because of the central role of story-telling, the book both begins and ends with a discussion of story as truth. But visual art, rumor, music, film, humor, performance, and memory sites take their place with story as modes of truth-telling. We organize the book around these eight different modes. Following each framing chapter, three examples of truth-telling from different parts of the world demonstrate the power of these eight modes.

"Now for a Story," by Harold Scheub, argues that the most powerful messages about the past come not from lessons told in a didactic style or even from historically specific accounts of past events. Rather, says Scheub, stories are the most powerful conveyers of moral lessons about the past mostly because they allow the audience to connect the present with the past through emotions. The same may be said for other arts.

This chapter is followed by illustrations from Indonesia, South Africa, and Argentina. Fadjar Thufail in "Writing Pasts" presents the context in which new writers in Indonesia have begun to express the past they lived during the Suharto dictatorship (1965–1998). Though these voices could be heard among a few journalists and political activists during the struggle against Suharto, many writers, such as Seno Gumira Ajidarma, became internationally recognized only after the end of the dictatorship.

In "Youth Struggle," Monica Eileen Patterson explores how a mural tells the story of apartheid violence and its mark on a generation born into it. It looks at children involved in the liberation struggle as both protagonists and victims, and what their experiences mean for their identities after apartheid's end.

"Banging Out the Truth" recounts through narrative and photographs a popular protest in Argentina in 2001. Ksenija Bilbija and Nicole Breazeale, through text, and Enrique García Medina, through photographs, show how Argentines shed their fear of authoritarian repression to create a cacophony of banging pots and pans to protest economic exclusion and impunity for the corrupt and repressive forces in the country.

The second chapter, "Artworlds" by Jo Ellen Fair, shows how the visual arts in countries emerging from authoritarian rule state truths about past violence, aid the creation of social memory, and advance justice by addressing past crimes. Paradoxically, argues Fair, post-authoritarian freedoms also open the way for non-political art, broadening the range of the national imagination, but temporarily disorienting those accustomed to political themes.

Examples of truth-telling through art from Yugoslavia, South Africa, and Argentina follow. Three of Zoran Mojsilov's sculptures, as described by Ksenija Bilbija, capture "Fragments of the Past," the bits and pieces of Yugoslavia torn apart and put back together by ethnic, religious, and nationalist struggles in the region.

Senzeni Marasela's tablecloth tableau captures the way that apartheid disrupted South Africans' everyday lives. She uses table linen to represent the murder of anti-apartheid activists, the Craddock Four. In "Reckoning with State Violence" Nyameka Goniwe, one of the surviving widows of four men murdered, provides an autobiographical account to illustrate the breakdown of family and normal life under apartheid.

In "A Park for Memories" Nancy J. Gates Madsen examines a project in Buenos Aires constructed along the shores of the river in which bodies were thrown from planes during the military dictatorship. While still under construction, the park will include sculptures and other art forms intended to remember the estimated 9,000 to 30,000 dead and disappeared in the Argentine dictatorship (1976–1983). In the absence of official remembrance, the park provides the space for both private and public reflection on the past.

The next chapter examines how rumor can ironically express truth about the past. Cynthia E. Milton's "Through the Grapevine" shows the many ways that censorship and the suppression of truth give rise to a creative process of spinning interpretations about violence, conflict, and murky conditions that extend beyond even the control of authoritarian regimes. Depending on their source and the context in which they evolve, rumors can possess more power — and even truth — than the official record since it is often purged of inconvenient facts. Milton suggests that a rumor functions as "a credible alternative to incredible reality," helping individuals make sense of their pasts and their futures.

Examples of rumor as a form of truth-telling follow, drawing on events in Argentina, Thailand, and Bosnia. The Argentine military refused to acknowledge the systematic use of torture and murder in its clandestine detention centers. Rumors, however, circulated about where the bodies of the disappeared could be found. The Argentine forensics team described by Courtney Monahan in "Recollecting the Dead" often had to pursue rumors to find and excavate human bones, linking them to the disappeared.

Thongchai Winichakul further explains the workings of rumor in "Alive, Until Truth Arrived," the story of a father's search for his son. While Winichakul and his comrades long suspected that the man's son had died in student revolts, and even believed they had seen his dead body in a photograph, they allowed their friend's father to believe the rumor that he might be alive. It was the planning of a public commemoration for those killed in the 1976 Thai student revolts that compelled them to disclose the death of their friend to his father.

At Nangrong Shrine, a temple in Buriram in northeast Thailand, survivors of the 1976 Massacre place urns containing the remains of their killed comrades. *Source: Thongchai Winichakul*

"Rumors of War," by Marina Antić, shows the sense of hope that rumors provide, albeit in a different historical and political context. Bosnians began to spin rumors to try to find certainty in the chaotic situation of war in which they lived. They used the rumors as a sense of security – violence could be avoided if one took the right precautions. And when events challenged their beliefs in old rumors, they sought new ones that offered a promise of protection. Roger Richards's vivid photos of the siege of Sarajevo trace its impact on those who live there.

How music becomes a form of political expression from the past, and is later remade to match different historical contexts is the basis of "The Power of Song" chapter by Michael Cullinane and Teresita Gimenez Maceda. Music endures, but it changes its meaning to match new political moments. The songs, chants, dances, and marches used to protest authoritarian rule and animate a liberation movement form part of memory politics in the aftermath of authoritarian rule. The style and themes of those protest songs become internationalized and reproduced with their own meanings. New songs and new music also emerge to record the past in ways that resonate with new generations of people, not always devoid of controversy.

Song forms part of traditional rituals, as expressed in the photo essay "Exhuming Popular Memory" by Victoria Sanford. The clandestine mass burials during the Guatemalan dictatorship prevented communities from carrying out their customary funeral rituals. After the bodies were found and identified, communities could begin the process of mourning, delayed by censorship and cover-ups.

Janet Cherry's "Traces" describes the impact of a song like Peter Gabriel's "Biko" in making a place – the cell where the South African police beat anti-apartheid activist Steve Biko to death – a spot for international memory tourism. Despite interest in including Biko's cell on sojourns to South Africa, local activists have not had widespread support in transforming it into a memory site.

"Politics in the Raw" by Jelena Subotić looks at the gritty underside of popular culture in the example of young, alienated Serbian rap artists who have used this music genre to express their rejection of the political past and the problems it has brought for the new nation.

Truth about the past is also captured on film and video.

Ksenija Bilbija and Tomislav Longinović's chapter "Moving Images" suggests that while authoritarian regimes used both documentaries and fictionalized films to advance their own agendas, audiences and filmmakers challenged these politicized images by providing myriad critical perspectives on the past and its lasting emotional impacts.

The essays that follow explore the use of film as a truth-telling device in Yugoslavia, Chile, and the Philippines. In "Coming Back" Cecilia Herrera studies the Chilean documentary film *Fernando Is Back,* the story of the piecing together of a skeleton belonging to a disappeared activist and his family's reaction to learning the truth about his murder and disappearance. "Alternate Visions," by Tomislav Longinović, focuses on the use of film by the political media group B-92 in raising awareness about the past.

The film *Batas Militar* summarizes the martial law era in the Philippines as a tool "to remember and not repeat." Lidy B. Nacpil, a student who grew up under martial law, writes in her essay *"Batas Militar"* about how the film educated her to a reality that she lived, without fully understanding it.

"Humor That Makes Trouble," by Leigh A. Payne, analyzes the role that humor can play as a form of truth-telling in the aftermath of authoritarian rule. Humorous devices learned during authoritarian rule become recycled in its aftermath. Solidarity humor, for example, provides a social bond that unites those who share a particular way of remembering the past. Subversive humor turns the innocuous form of "poking fun" into a political act. Vigilante humor provides the means to bring popular retribution for past acts, or for the absence of justice in the present for criminal acts committed in the past.

Humorists from South Africa, Yugoslavia, and Argentina represent these strategies of using humor to voice silenced truths. Jonathan Shapiro, better-known as Zapiro was an anti-apartheid cartoonist in South Africa. In "Teasing Out the Truth," he discusses his new role as a humorous critic of the South African Truth and Reconciliation Commission.

Corax, a well-known satirist from Yugoslavia is the subject of Jelena Subotić's "Laughing at Power." She provides examples of Corax's work as well as the contribution he made to a nation recovering from Slobodan Milošević's rule.

Erica Nathan's "Seriously Funny" explores the boundaries of

telling the truth about the past. By looking at Argentine graphic humorists, specifically Rep, Quino, and Fontanarrosa, she raises the question of whether certain subjects, or truths, remain off limits even for satirists.

The chapter "Performing Truth" by Laurie Beth Clark considers formally organized and spontaneous popular theatrical expressions of the memory of authoritarian rule. She evokes the emotional content of these performances, ranging from defiance, to shame, to nostalgia.

Drawing on Clark's broad understanding of political performance, Tyrone Siren's "Unearthed Truths," describes and illustrates with photos the odd and unsettling experience of tourism in the killing fields of Cambodia. The tourist on the scene of past atrocities becomes a player in the unfolding drama of the host nation's reconciliation of the present with the past, but sometimes brings a different script than the one learned or tutored at the site.

Sarah A. Thomas writes about Argentine *escraches* in her "Outing Perpetrators" essay. These popular forms of protests provide a carnivalesque atmosphere in which marching, chanting, and dancing youths take over the streets surrounding past perpetrators' houses and call on the community, and particularly their neighbors, to acknowledge their responsibility for the nation's atrocities.

Ksenija Bilbija and Tomislav Longinović's essay "After the Fall" accompanies the photographs by Mileta Prodanović. The photographs and text record how popular groups and individuals transformed the meaning of old symbols and images into criticism of the nationalist project of former Yugoslav ruler Slobodan Milošević.

"Memoryscapes" by Louis Bickford provides the final chapter of truth-telling modes. Bickford creates six categories of memoryscapes: reconfiguring conventional forms of memorials; building museums of conscience to reconstruct a past experience in the present; guided tours to places where momentous events occurred; folk memorials that spring up spontaneously to remember the past; transforming existing places into a site of memory; and commemorative activities that often take place on key dates from the past. The essay explores the enduring controversies that emerge around remembrance through memorials.

Reclaiming history is the subject of Sanja Iveković's "GEN-XX"

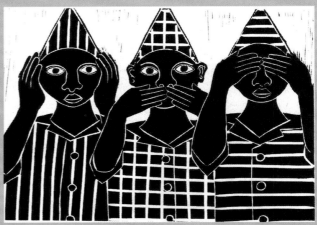

Hear No Evil, Speak No Evil, See No Evil (1994) by Billy Mandindi

project. She transforms fashion photography into a means for young Croatian women to learn about and remember the country's political heroines of the anti-fascist struggle in Croatia.

"Naming," as demonstrated in Cynthia E. Milton's essay, becomes a common form of remembering the past. Those who the old authoritarian regime attempted to erase, eliminate, or disappear, become visible again with their names engraved in national memory sites.

Nancy J. Gates Madsen, in "Ruins of the Past," examines the recovery of memory sites. By excavating a clandestine detention center in Buenos Aires, survivors of the center reclaimed that space as a site for remembering and not to repeat the past.

The book closes with Ksenija Bilbija's essay "Story Is History Is Story . . ." Stories are not just the kind told to children or read in books, but also include the other forms of truth-telling we have examined in this book. These stories told in writing and speaking, moving and still images, passed from individuals through speech, laughter, song, and movement, or made to endure in stone, metal, concrete, or wood are the truths that become history, that part of history often lost in the official versions of the past.

Using Truth Politically

Truths about the authoritarian past that come out during transitions are politically useful. Democratic governments use them to draw thick lines separating past from present, promote new visions of a country tarnished by a violent and authoritarian image, mend debilitating schisms, punish wrongdoers, and create a new future while closing the book on the past. Perpetrators of

violence and their supporters do not always try to silence truths about the past. Sometimes they seek to redeem their role in a violent history by resurrecting the authoritarian regime's justifications and their own heroism in a cause to defend the country from subversion. In rare moments, perpetrators may take the opportunity to tell the truth about their past, to apologize to victims, and contribute to national rebuilding. Like perpetrators, victims do not always share common political goals. Some remain too traumatized to engage in public memory and truth-telling exercises. Some seek the truth to bring justice for past atrocities. For others, acknowledgement of their suffering is enough to restore their dignity. Still others use truth to remind their own society and others about the human capacity for violence to avert repetition of the suffering they endured.

This book deliberately avoids a foray some might expect of it: a wandering through the thicket of truths to find TRUTH. It would be fruitless territory. The approach adopted here is the only one that made sense to us. We acknowledge that the past looks different from different angles. We know that delusion and even deception figure in some statements of "truth." Though arbitration of conflicting truths is often important, we, working on a global scale, would be very imperfect arbiters. Thus, we and most of our contributors accept and report without judgment or comment statements of truth offered in apparent good faith. This approach, we believe, approximates the standards of the imperfect world it ventures to portray. Are some purported truths demonstrably false? Certainly. Are some truths more defensible, more noble than others? Certainly. The distinctions are for the implicated, and, when necessary, for each of us to judge.

The book has its own uses. It recounts atrocities committed around the world, often in the name of something that seemed righteous to some. It documents struggles to expose egregious violations of human rights across many cultures and polities. To those actively engaged in condemning these violations, and to all of us who might wish to be, the book is offered, above all, as a manual of creative operations. Truth-telling is a people's creative art, an occasion for some of our most pointed satire and deprecation, some of our most cleverly conceived political commentary. Authoritarianism inspires artful opposition. This book, by showing how this is so, means to foster creative political action for basic human rights wherever they are threatened. ■

HAROLD SCHEUB

Source: Douglas Rosenberg

Story is the way we remember, the way we make judgments – and perhaps, because they touch the heart – stories point the way to forgiveness and understanding. By means of story, we can experience the terrible and noble dimensions of what happened, we can put names to faces, meaning to places and events, gain a sense of the humanity of the victims and the victimizers, relive the events of history in their fearsome detail.

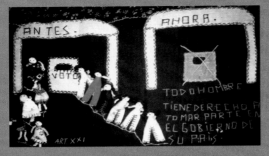

A combination of appliqué and embroidery, a patchwork tapestry, the *arpilleras* depict a story that is impossible to put into words. The tradition is old, and as a decoration it probably has its roots in Europe. But in Chile and many other countries of Latin America that have experienced military dictatorship, the *arpilleras* has acquired a different meaning: it denounces and brings human rights violations to light. The tradition began spontaneously in 1974 when 13 women who were searching for their husbands, sons, and daughters started recognizing each other in the most gruesome places: hospitals, morgues, military centers. There was a chilling, common thread in their story: all of them had someone they loved who had vanished without the trace. As they searched for their missing family members they became political and started organizing workshops in which they not only shared the truncated stories of disappearance but also inscribed in the cloth the pain of their absence. The images, often made of pieces from old clothing, vary. Some *arpilleras* feature Chilean landscapes in which some kind of violence has occurred, while others show explicit depiction of torture and gatherings of family members of the disappeared. The *arpilleras* shown here were displayed in 1999 at the Parroquia de San Cayetano in La Legua neighborhood in Santiago, Chile.

"And now for a story . . .": the opening formula is pronounced, and an enchanting fusion of past and present is about to transpire, time is about to be arrested, and we are in the presence of history. . . . It is a time of masks. Reality, the present, is here, with emotional images giving it a context. The storyteller's art is to mask the past, making it mysterious, seemingly inaccessible. But it is inaccessible only to our present intellect: it is always available to our hearts, our emotions.

> Fourteen years ago, no, sixteen years ago, my father died. He died quickly, in the twinkling of an eye, as my mother used to say, though I was sure he had died slowly, over years, that he had become infected with death the instant when, forty years before, he found himself behind a barbed wire fence in a German camp for tortured officers. Mother, of course, denied it. "One dies only once," she said. "No one walks around like a living corpse." My friends were on her side. "You look at history," they said to me, "like some romantic, at fate as at a pastoral scene in which, stealthily, evil spirits lurks." No," I said. "There are threads that bind a person to crucial moments, when the soul yields, and life after that is only an unwinding of the spool, until the threat reaches its end, becomes taut, and tears out – there are no other words for it – the soul from its worn out place of resistance." The friends dismissed me with a wave of the hand; Mother poured a little more brandy into the glasses and the women brought hot crescent rolls filled with cheese from the kitchen.[1]

Many of us, when we hear stories, look for lessons, obvious and simple morals. But stories are not obviously didactic. They are moral, but they are not morals. It is only nervous observers who give the stories such foolish contexts. What they are is music, song, dance . . . and the moral, or message, or meaning of a story is not what is so obviously basking on its surface. Meanings are deeply entwined in human emotions, which is where meaning can be found, and catharsis.

> "Vasca," she called out.
> "Yes . . ."
> "They gave me some slippers with only one flower."
> "At last."
> "Did you understand me? Just one flower, two slippers and just one flower."

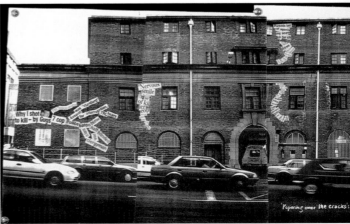

South African artist Sue Williamson created her own memory site out of the Calendon Square police station in Cape Town where the police tortured anti-apartheid activists. Her photograph of the station includes "graffiti" made from statements by victims about torture they experienced there.

Vasca stretched her neck and lifted up her face to peek under the blindfold. The flower, a huge plastic daisy, looked up at them from the floor. The other slipper, without flower, was more like them. But the one-flowered slipper amid the dirt and fear, the screams and the torture, that flower so plastic, so unbelievable, so ridiculous, was like a stage prop, almost obscene, absurd, a joke."[2]

We often cannot get out of the terrible shadow of our historical journey because we have never come to terms with it, have never faced its stories. Story, the beginning of a necessary return to things past, can help us to understand, showing the way to wholeness. Guilt, judgment, forgiveness: Story chronicles our way, logs the trajectory as we make life's corrections and move through our personal and national rites of passage, it seeks to make sense of those journeys. This was a purpose of South Africa's Truth and Reconciliation Commission. By means of story, we can learn the terrible and noble dimensions of what happened, we can put names to faces, dimension to places and events, gain a sense of the humanity of the victims and the victimizers, relive the events of history in their fearsome detail: story provides that.

> *Dawie Ackerman: May I ask the applicants to turn around and to face me? This is the first opportunity that we've had to look at each other in the eye. I want to ask Mr. Makoma who actually entered the church. My wife was sitting right at the door where you came in. She was wearing a long blue coat. Can you remember if you shot her?*
>
> *Khaya Makoma: I do remember that I fired some shots. But I couldn't identify [anyone]. I don't know whom did I shoot or not, but my gun pointed at the people . . .*
>
> *Dawie Ackerman: It is important for me to know if it is possible. As much as it is important for your people who suffered to know who killed. I don't know why it is so important for me, it . . . it just is . . .*
>
> *. . . I would like to hear from each one of you, as you look me in the face, that you are sorry for what you've done. That you regret it and that you want to be personally reconciled.*
>
> *Amnesty Applicant: We are sorry for what we have done. Although people died during that struggle, we didn't do that out of our own will. It's the situation that we were living under. We are asking from you, please do forgive us.*

Dele Giwa, founding editor-in-chief of the Nigerian news weekly *Newswatch,* died October 19, 1986, from injuries sustained in a parcel bomb explosion at his home. Giwa's final words, "they have got me," have long provoked debate among Nigerians about government implication in the murder. After nearly 17 years of finding no killer, the country's Human Rights Investigation (Oputa) Panel ordered the case re-opened "for further investigations in the public's interest."

DELE GIWA
by Olufisayo Gali

*We stand here today
Because we notice
Acknowledge a void
In time and space
In thought and reason
We feel it
Emptiness in our lives
He is gone
And even now so long after
The tears flow too readily
They do not stop
They do not pause
They see no reason to
There is no reason to
The pain remains, ever as strong
We stand here today
Because we acknowledge
The loss of your presence
And we acknowledge
There is nothing we can do
But pay homage and rejoice in
Our only true joy
We knew you
You graced our world
You taught us*

OSVALDO BALBI "RAFA"
Kidnapped - Disappeared - August 1978
From whom we learned to put fantasy into practice

Your daughters Caro and Fer, your little grandson Juan Manuel and all of us who love you

(appeared in *Página/12* on August 18, 2002)

FRANCA JARACH
Kidnapped and disappeared on June 25, 1976, when she was 18 years old

The murderers who wanted to "erase" you failed.
Your radiant, wonderful, passionate soul lives on.
Your engaging personality and creativity still excite.
You live on in the heart of all those who loved and admired you, your mother and all your family, and your many friends and comrades, as well as in the memory of your teachers and professors. You were so full of life that even those who never met you find themselves drawn to you. In your name, and for your sake, we demand truth and justice, truth and memory. For you and for all the "disappeared." You made sure that you would be remembered and we strive to protect that memory.

(appeared in *Página/12* on June 25, 2004)

OLGA MAMANI DE TORRES
LUIS EDUARDO TORRES
Disappeared on June 30, 1976

28 years after the atrocity
28 years of thinking of you each day
28 years without hearing your bright laughter
We don't forget – We don't pardon –
We don't reconcile!

Your loved ones

(appeared in *Página/12* on June 30, 2004)

Dawie Ackerman: I want you to know that I forgive you uncon-ditionally.[3]

Story provides a space for real-life experiences, giving them a sense of theater. But that by itself does not provide release, catharsis. The narratives of past events never occur in isolation. South African story-tellers, asked why their stories did not contain explicit references to the daily horrors of apartheid, responded, "How do you think we have survived for 350 years? These stories were around long before the advent of apartheid, they will be around long after apartheid is gone." The stories we tell occur within that wider context; that is the promise and the hope of storytelling. There is always the sense of the familiar, and that recognition, that echo, that resonance that we experience when we hear stories is the poem in the story, the ancient past forming, shaping, commenting upon our real-life experiences.

> *I miss my former cell – why is that? – because it had a hole in the ground into which to urinate and defecate. In my present one I must call the guard to take me to the bathroom. It's a complicated procedure, and they're not always in the mood. It requires that they open a door, the entrance to the ward where my cell is located, close it from the inside, announce that they're about to open the door of my cell in order for me to turn my back to it, blindfold my eyes, guide me toward the bathroom, and bring me back, reversing the whole procedure. It amuses them sometimes to tell me that I'm alongside the latrine when I am not. Or to guide me – by one hand, or shoving me from behind – so that I stick one foot into the latrine. Eventually they tire of this game and don't respond to my call. I do it on myself. Which is why I miss the cell with the hole in it.*[4]

The story's curvature seduces an audience, as its members become an active part of a metaphor. What stories must do above all is make us a part of them. Because of the music, or meaning, of the story, it touches us emotionally; in that music we can comprehend what story means in post-authoritarian societies . . . any society. When the story-teller touches the heart of the story – which means touching his heart and those of the audience – the story comes to life and does its work. Story begins where ambiguity, irony, metaphor – in that order – join forces. This is where history, autobiography, reality merge with fantasy, fiction, fabrication.

> *I put away those memories. What purpose is there in dwelling on the past? The past should not become a burden if it is not also willing to be a help.*[5]

We never escape the ancient myths, our myths: what we do reverberates to those mythic stories. The stories that we tell today, whether we call them fictional or truth, occur within the context of the myths. Do we literally believe in the myths? Put it this way, as a storyteller once told me: stories, myths, are not true, they are a way of getting at truth. ∎

Página/12 (Ads for the disappeared)

Nearly every day family, friends, and colleagues remember the disappeared through these tributes sent to the progressive newspaper *Página/12*.

The Legacy of Page Zero

Paula Di Dio Translated by Catherine Jagoe

June 1977. Luisa Valenzuela publishes her novel *Como en la guerra,* minus the so-called "Page Zero." The author herself removed the page from the body of the text for the sake of prudence, a necessary virtue at the time, since the Argentinian government was in the hands of the armed forces.

December 2001. After an acute institutional crisis, Argentina is ruled by four presidents and their respective ministerial entourages in the space of fewer than 20 days. The 1977 Page Zero takes on a new meaning.

This page, cut in the first edition but never eliminated from the table of contents, recounts the testimony of a man who is being tortured and raped with the barrel of a gun, an everyday occurrence during the Dirty War. Everyone would say that things have changed nowadays. And that's true, but only partially. A lot of water has flowed under the bridge since then, but it has left a kind of sludge that will not let reality flow or move. Something is still stagnating in Argentina and it's beginning to smell really bad. Fortunately, the stench is becoming noticeable and society is being opened up thanks to the street protests and because people have hung on and resisted, verbs that every self-respecting Argentine can conjugate perfectly. But the thread on which all that resistance hung finally snapped. People took to the streets not just to lift lids and let themselves be overtaken by the nauseating odor emanating from beneath all those cans of worms but also to bang those lids on their pots and pans and demand that all forms of corruption be abolished.

However, many of the peaceful demonstrations in which most of the population participated were distorted by the presence of small groups of activists under orders from whatever government was in power at that moment, who took it upon themselves to ransack supermarkets, destroy public monuments, burn down part of the Congress building, and smash up whatever lay in their path.

The banging of the pots and pans has merged into the same demand that issues from the tortured man on Page Zero. Valenzuela's character says, "I'm yelling to prove that I exist because I've been forgotten." Similarly, people are taking to the streets now to demand they not be forgotten because of the corruption of the ruling class.

In 1977, the damage to the individual appeared mainly from within; the scars became internal ones, faced with the indifference of those who couldn't or wouldn't see what was going on. Nowadays, the damage to the individual is also seen on the social level, thanks to an economic and political structure that demands subjectivity be silenced. Thus, the term "the disappeared," which is used to designate the 30,000 dead during the military dictatorship, is as fictitious and euphemistic as the atmosphere of "productive revolution" we experienced during the two successive re-elections engineered by the government of Carlos Menem, who used and abused the powers of fiction.

Today, the torturers do not wield weapons directly. They opt for white collars during the day and black suits at night so as to pass unnoticed among honest citizens. At least they don't wear army fatigues any more and they have stopped calling what they're doing a "Process of National Reorganization." But the army uniforms left their legacy and, needless to say, some of their methods of torture, albeit in a somewhat more covert and sophisticated guise. Some of the old methods doled out on Page Zero reappear in today's Argentina. They ignore basic social rights, such as the right to earn a decent living rather than a pittance, the right to equal access to cultural products and the right to have a vision for the future, among others. The public sphere has become a battlefield and the private sphere a tortured body from which the corruption and disguised authoritarianism of the political class extort more than it can give.

The legacy of the situation narrated on Page Zero is significant. The judicial immunity of those in power is seen both in the figure of the torturer of 1977 and in the subtler but no less perverse politician of the '90s and the start of the new millenium. Both of them, protected by a structure of fictions constructed to suit themselves, have devoted themselves to exerting such pressure on the social body that the voice of the tortured can no longer be silenced. One sees the same pain and the same impotence in the two time periods, both of which articulate the absence of freedom and the need to express that absence.

Paula Di Dio is a Ph.D. student in Spanish at the University of Wisconsin–Madison. Her research interests include cruelty and punishment in the context of Southern Cone Literature. She works as assistant to the editor of the scholarly journal *Letras Femeninas*. Her publications include "Como en la guerra: una vocación por lo inefable" in Casa de las Americas 226 (Havana 2002).

Writing Pasts
The Work of Seno Gumira Ajidarma

FADJAR THUFAIL · ARTWORK BY AGUNG KURNIAWAN

Seno Gumira Ajidarma is one of a few Indonesian writers who has written fiction about state violence in Indonesia. Since the 1980s, the theme of violence has been Ajidarma's obsession. When the military stepped up its violent operations in Aceh and East Timor in the early 1990s, Ajidarma responded by writing several pieces that explored the psychological and physical suffering of East Timorese and Acehnese under military rule. One of his collections of fiction, *Saksi Mata* (Eyewitnesses), won several international awards.

In 1997, when Indonesian students protested against President Suharto's inability to cope with economic and political crisis and when ethnic and racial riots rocked Indonesian cities, Ajidarma's stories showed how the state resorted to violent practices, such as kidnapping and extra-judicial killing, in response to opposition movements. Ajidarma's anger toward the state's violence seems to have reached its peak when he wrote a powerful piece titled "Jakarta: February 14, 2039." February 14 refers to the date when massive rioting destroyed many Indonesian cities in 1998. The riots preceded President Suharto's forced resignation after 32 years of authoritarian control. During these riots, stories about gang rapes of Indonesian Chinese women and the military's involvement in them circulated. In the piece, set in the year 2039, Ajidarma describes how the riots haunt both child victims and perpetrators 41 years later.

Ajidarma has been one of the few Indonesian writers, painters, and artists to confront the state and military violence head-on. His prose from the early 1980s until now is full of allegories, illustrating the violence practiced by the military and militias to spread fear among ordinary citizens throughout Indonesia, particularly in East Timor and Aceh.

The Incident
Seno Gumira Ajidarma

(Excerpt from the novel, *Jazz, Perfume, and the Incident*. Jakarta: Yayasan Bentang Budaya, 1996, taken from http://muse.jhu.edu/journals/manoa/v012/12.1ajidarma.html. Translation by Greg Harris.)

The telephone rings, but I don't answer it. I feel as if I'm somewhere else entirely. My mouth is dry, so I take a plastic cup and walk over to the water cooler. I push both knobs, hot and cold. One swallow and the water is gone. I then walk back to my desk. I can hear a song playing. It's "Strangers in the Night" — not a jazz tune, but then any song can be turned into jazz, right? Is it all that important whether a song is jazz or not?

On my desk, the folders I'm reading are still scattered about. Outside, the dawn is approaching. I'm so drowsy I can't do much more than glance at bits and pieces. The next report, written in English, is titled "Disappearances and Extra-Judicial Executions."

The identity of at least 100 civilians, and possibly as many as 250, killed by ██████ forces in the ████████████ massacre and its immediate aftermath remains unresolved. The ████████ military has also failed to resolve the fate of the more than 250 people who reportedly "disappeared" after the massacre. The official government figure of 64 disappearances falls far short of the more than 200 people who remain unaccounted for. . . . ████████ has received reports of dozens of new disappearances in ██████ since the massacre . . . ████████████ has also received reports of at least 45 extra-judicial executions. These reports, though difficult to confirm, suggest that unlawful killing by ██████ forces persist. . . . At least two extra-judicial killings are reported to have been carried out by ████████ during a period of heightened counter-insurgency activity in the area in mid-1992. A man called Humberto is said to have been shot by ████████████ while working in his field in August. According to reports, the ██████ cut off his head and arms and hung them in a tree beside the road to frighten passersby. . . .

I put down the report. I am so very tired, physically and spiritually. Must I keep reading? It's my job, I know, but how many more reports must I read? I feel exhausted just thinking about it.

I look at my watch. Maybe it's time for me to go home. I can continue my reading tomorrow or the next day. I can read until doomsday. I look at the city outside the window. It should be morning, but why does the world look so dark?

Images from *Saksi Mata* (Eyewitnesses) by Seno Gumira Ajidarma (Jakarta: Yayasan Bentang Budaya, 2002).

Third Day. Solitary Cell

Excerpt from Prison Stories *by Helon Habila (Epik Books: 2000, Nigeria)*

When I heard metal touch the lock on the door I sat down from my blind pacing. I composed my countenance. The door opened, bringing in unaccustomed rays of light. I blinked. "Oh, sweet light. May your face meeting mine bring me good fortune." When my eyes adjusted to the light, the superintendent was standing on the threshold – the cell entrance was a tight, lighted frame around his looming form. He advanced into the cell and stood in the center, before my disadvantaged position on the bunk. His legs were planted apart, like an A. He looked like a cartoon figure: his jodhpurs-like uniform trousers emphasized the skinniness of his calves, where they disappeared into the glass-glossy boots. His stomach bulged and hung like a belted sack.

He cleared his voice. When I looked at his face I saw his blubber lips twitching with the efforts of an attempted smile, but he couldn't quite carry it off. He started to speak, then stopped abruptly and began to pace the tiny space before the bunk; when he returned to his original position he stopped. Now I noticed the sheaf of papers in his hands. He gestured in my face with it. "These. Are the. Your papers." His English was more disfigured than usual: soaking wet with the effort of saying whatever it was he wanted to say. "I read. All. I read your file again. Also. You are journalist. This is your second year. Here. Awaiting trial. For organizing violence. Demonstration against. Anti-government demonstration against the military legal government." He did not thunder as usual. "It is not true. Eh?" The surprise on his face was comical. "You deny?" "I did not organize a demonstration. I went there as a reporter." "Well . . ." He shrugged. "That is not my business. The truth. Will come out at your. Trial." "But when will that be? I have been forgotten. I am not allowed a lawyer or visitors. I have been awaiting trial for two years now . . ." "Do you complain? Look. Twenty years I've worked in prisons all over this country. Nigeria. North. South. East. West. Twenty years. Don't be stupid. Sometimes it is better this way. How. Can you win a case against government? Wait. Hope." Now he lowered his voice, like a conspirator, "Maybe there'll be another coup, eh? Maybe the leader will collapse and die; he is mortal after all. Maybe a civilian government will come. Then. There will be amnesty for all political prisoners. Amnesty. Don't worry. Enjoy yourself." I looked at him, planted before me like a tree, his hands clasped behind him, the papier-mache smile on his lips. Enjoy yourself. "Your papers," he said, thrusting them at me once more. I was not sure if he was offering them to me. "I read them. All. Poems. Letters. Poems, no problem. The letters, illegal. I burned them. Prisoners sometimes smuggle out letters to the press to make us look foolish. Embarrass the government. But the poems are harmless. Love poems and diaries. You wrote the poems for your girl, isn't it?" He bent forward; he clapped a hand on my shoulder. I realized with wonder that the man, in his awkward, flatfooted way, was making overtures of friendship to me. My eyes fell on the boot that had stepped on my neck just five days ago. What did he want?

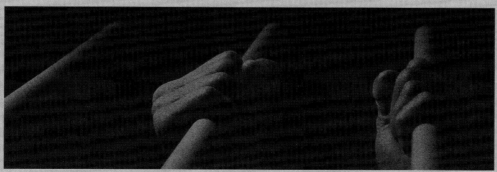

Source: Jenny Young

Youth Struggle

MONICA EILEEN PATTERSON

And suddenly on the lips of every child you met was Hector Peterson, Hector Peterson, Hector Peterson! That young boy on that day, yes, he died. He was killed by the police. But overnight he became a hero and you had to ask: Who is Hector Peterson?[1]

Ellen Kuzwayo remembers Soweto, and the brutal killing of Hector Peterson by the apartheid-era police. The Soweto Uprising was the defining moment of youth involvement in the anti-apartheid struggle. On June 16, 1976, more than 20,000 students gathered to protest a proposed education policy change that would have made Afrikaans the only medium of instruction in black South African schools. The police used tear gas and opened fire on the crowd. The massacre and the days of violence that followed left more than 500 dead, 104 of them children, many of them shot in the back. The international coverage and ensuing public outcry emphasized the young age and innocence of the victims and the unjustifiable actions of the police.

Sipho Ndlovu's mural, which hangs in the South African Constitutional Court, depicts Soweto as part of the story of the fight for freedom and the birth of a new nation. Young people are prominent in the mural as they were in South Africa's anti-apartheid struggle: at the formation of the African National Congress Youth League in 1943, in the African Students Movement of 1968, in the South African Students' Organization in 1969, and in the Congress of South African Students in 1979. Youths helped mobilize and enforce worker stay-aways and consumer boycotts.

Many South Africans today remember the Soweto Uprising as the event that galvanized a generation of young people to fight by any means possible. As former Soweto activist Peter Mugubane says: "I will never, never forget 1976. I had never seen such brutality. Yes, I have seen the Sharpeville massacre. It happened one day. The next day everybody went to work as if nothing has happened. But June 16, you kill one, you kill all!"[2]

The story of youth struggle, therefore, is not only one of victimization and trauma, but also one of violence. After Soweto, many young people left South Africa to train as freedom fighters in the armies of exiled political movements such as the armed wing of the African National Congress, Umkhonto weSizwe (MK), and the armed wing of the Pan African Congress, the Azanian People's Liberation Army (APLA).

When former MK Commissar Aboobaker Ismail applied to South Africa's Truth and Reconciliation Commission for amnesty

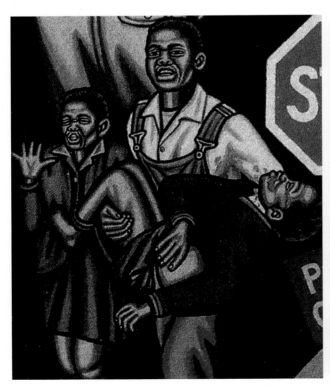

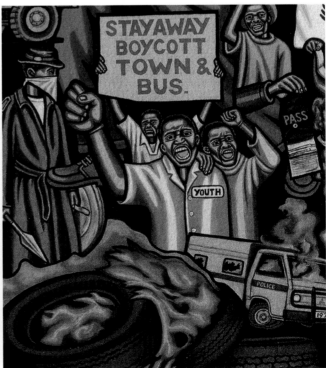

he explained his mixed feelings about his own acts of violence, bombings that killed 30 people and injured 350 others:

I regret the deaths of innocent civilians killed in the cause of the fight for justice and freedom. In the course of a war, life is lost. The injury to and the loss of life of innocent civilians sometimes become inevitable.[3]

Yet, at the same time, young people's armed struggle against the apartheid system was a source of pride:

I am proud of the bravery, discipline and selfless sacrifices of the cadres of the Special Operations Units who operated under my command. Many of them laid down their lives in the pursuit of freedom for all in South Africa.

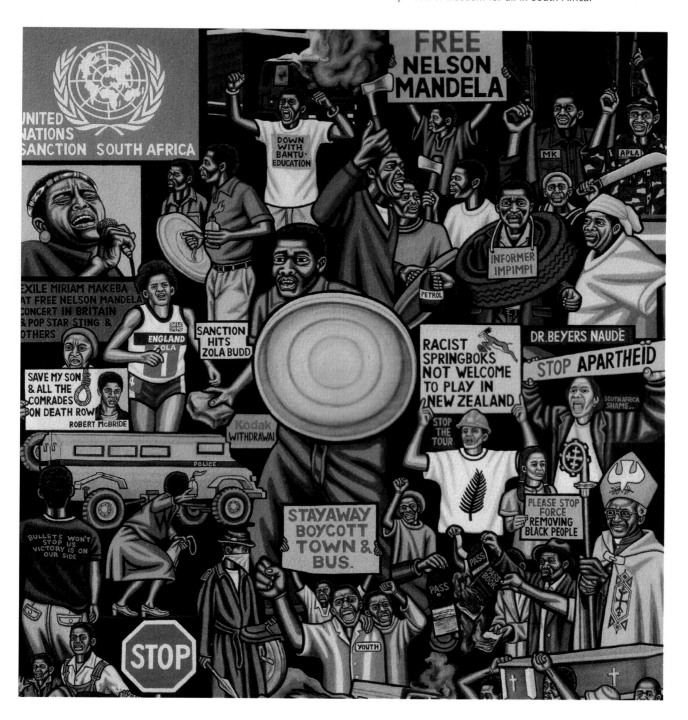

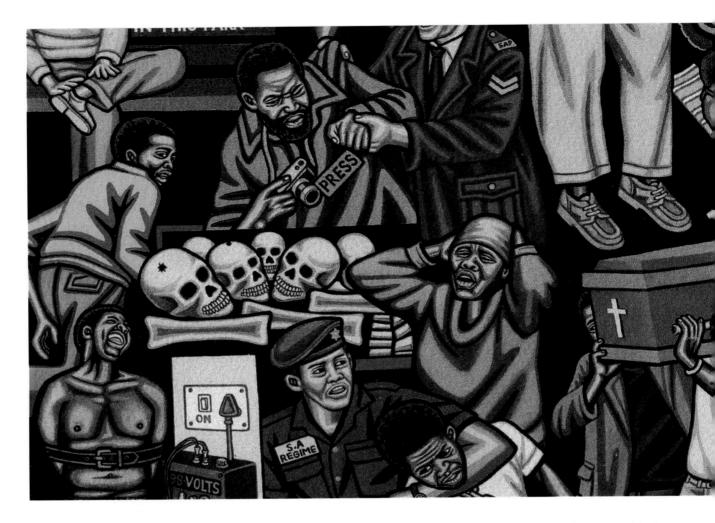

Contradictory images of youths as both freedom fighters and terrorists continue to complicate the story of the youth struggle. Extolled by Nelson Mandela as "young lions," many young South Africans took to the streets in violent protests. Armed with placards, songs, stones, fire, guns, and other weapons, they became perpetrators of a different kind of violence: violence to destroy the apartheid state and reveal its real and suspected agents. Young people picked up by police units often were tortured and pressured to collaborate with the apartheid regime as informers or agents. Distrust and suspicion ran rampant in the townships as rumors circulated and people disappeared. Within some communities, vigilante justice was used to identify, punish, and kill political sell-outs, known as *impimpis*. Youths participated in retaliatory "necklacings," murder committed by placing a rubber tire doused in gasoline around the victim's neck and setting it on fire. Killing accused *impimpis* in public spaces was meant to deter others from collaborating with the state.

Reverend Frank Chikane described the environment in which young black South Africans grew up. Such a world was:

made up of tear gas, bullets, whippings, detention, and death on the streets. It is an experience of military operations and night raids, of roadblocks, and body searches. It is a world where parents and friends get carried away in the night to be interrogated. It is a world where people simply disappear, where parents are assassinated and homes are petrol bombed.[4]

Nkosinathi Biko, reflecting on the murder of his father, Steve Biko, writes of his loss:

Should I begin with "Dear Tata"? Was that what I called you 19 years ago? It strikes me now that I am a man, I don't have a name for you. I cannot imagine what I might have called you.

But Nkosinathi does not only dwell on the past and his own losses. He also mourns the loss of a great political leader by the apartheid state.

I am not sure if our focus should be on helping perpetrators of crime to be at peace with themselves. Rather we should be sending a very unambiguous message to victims in KwaZulu-Natal that many years from now their killers will remain accountable for their deeds. One has to ask oneself what kind of settlement lets a self-confessed killer of 35 people continue to

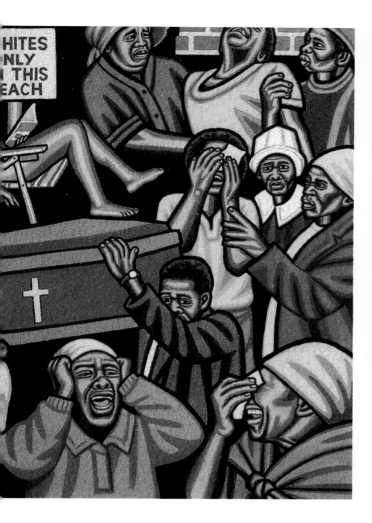

roam the streets freely, hold public office and draw income from the very pool to which victims of his actions are contributors. If you were able to speak with me now and if you asked for my most cogent thoughts, this is what I would tell you. I have often been asked if you were violent or not. It occurs to me that you were thoughtful in your approach to violence, advocating exhaustion of the other options first. . . . There came a time at which all options were indeed exhausted. Thousands of young people, most of them freshly baptized with the waters of BC [Black Consciousness], took to neighboring countries to pursue the struggle for liberation. The rest is, as they say, history.[5]

Through their participation in resistance activities, self-defense units, and local gangs, some youth in South Africa rose to leadership positions, establishing social and political power that challenged traditional social hierarchies based on age and gender. The term "intergenerational conflict" has been used to describe the tensions that at times result in violence within and across communities. In South Africa, some vigilante groups of male elders resorted to violence and intimidation to maintain their social and political control. Vigilantism forced many young people to flee their home areas, particularly in KwaZulu-Natal during the 1990s. Typical places of safety and refuge for young people such as schools, churches, and most importantly, the home, could not ensure protection from police and competing political parties. Such displacement from family homes and communities strained and eroded kin and social networks.

Now grown, many of these adults confront the legacies of their childhood experiences alone, facing the daunting challenges associated with poverty, illiteracy, unemployment, emotional and physical illness, and a lack of education, opportunity, and resources. Labeled by many contemporary analysts as the "lost generation," they have been simply written off by society as hopeless. They are blamed for a range of contemporary social problems, including high crime rates, drug trafficking, violence, and often are described as dangerous and unproductive leeches of society. Despite the many sacrifices they made during the struggle, most have not benefited from South Africa's transition to democracy. As former Soweto activist Sophie Thema laments, "What I can tell you is that nothing much to affect our human lives has changed since 1976. Very little has changed. Our education is still the same."[6]

Perhaps remembering the youth struggle will put pressure on the new government for material changes for all South Africans. Today, the role of young people in the struggle is commemorated in the Hector Peterson Museum in Soweto and in murals such as those made by Sipho Ndlovu. June 16 is now known as Youth Day. It is a national holiday that celebrates young people's contribution to South Africa's liberation. Many of the former youth activists, once regarded by the apartheid state as lawless and irresponsible, have become leaders in the new South Africa. But the lasting repercussions of young people's involvement often elude representation. For many, participation came at great cost, as many still bear the scars — physical and emotional — of the apartheid system.

Banging Out the Truth
The Story of Empty Pots and Pans

KSENIJA BILBIJA AND NICOLE BREAZEALE PHOTOGRAPHS BY ENRIQUE GARCÍA MEDINA

"Impotence was the main feeling we had in those days."

One might assume that these words from Nora Sánchez, a teacher from Córdoba, Argentina, recall her emotions during the military dictatorship of the late 1970s. Instead, they reflect a sentiment that was widespread in the country in late 2001, nearly two decades after the end of authoritarian rule. Says Sánchez about people's disgust with government in 2001, "History weighed heavily on us, but suddenly the injustice that we had experienced for decades, screamed out, demonstrated, and escaped in the form of a unique protest: the *cacerolazos*."[1]

On December 19 and 20, 2001, some 200,000 Argentines took to the streets and staged massive demonstrations, banging pots and pans — *cacerolazos* (from the Spanish word for cookery, *cacerolas*) — and looting supermarkets and other stores. The cacerolazos symbolized Argentines' frustration with the empty pots and pans and cupboards in their own homes.

"Day after day we shouted and beat our pots and pans against the enemy: the banks and the state. We knew that the politicians feared this new form of protest. We intimidated them with our solidarity," adds Sánchez.

Demonstrators hang a "For Sale/For Rent" sign on the Casa Rosada, the government palace in Buenos Aires.

The events of 2001 can be traced to neoliberal economic policies instituted by the military government (1976–1983) 20 years before, but the democratic government's insistence on continuing and extending these policies was the infuriating, proximate cause. The democratic government, the government of the people, pegged the peso to the dollar, privatized state enterprises, and opened Argentine markets to the global free trade economy. Unemployment rose, living standards declined, public debt doubled, a debt repayment crisis ensued, capital fled Argentina, and the country spiraled into a severe recession. By late 2001 middle class citizens tried to withdraw their savings before the banking system collapsed. The government responded by freezing and then confiscating private assets in the system, some $50 billion, limiting an individual's bank withdrawals to $250 per week.

The government's theft of citizens' cash was the last straw. No longer able to stomach their government's actions, Argentines screamed "Enough!" and took to the streets with their pots and pans. A man who calls himself Carlos, from the Caballito neighborhood of Buenos Aires, says of the movement: "The Argentine people spontaneously protested the political leadership that for many years governed only for a few, putting millions of Argentines into unemployment and misery. And this protest was peaceful, without any violence, using things from the kitchen, cooking pots and other items, and achieved extraordinary results."[2] Participant José Piterman described the objective as establishing "a legitimate institutional structure . . . with functionaries who function . . . and a society that also functions, sanctioned by a judiciary that also functions."[3]

Argentine sociologist Gloria Bonder believes that the cacerolazos told a new story about politics, a story of resistance and political action, overcoming the culture of fear and the political inertia of the military era.

"What happened in Argentina was an exercise in citizenship. It was a spontaneous massive participation in a society that has been paralyzed for years by authoritarianism and fear. . . . We Argentines are starting to overcome the legacies of our many dictatorships and paternalistic democratic governments. We are starting to believe in ourselves as active social actors who take responsibility for our future and the future of our country. I know difficult times are still ahead of us, both economic and political, but we have made one fundamental step forward. I am proud of how we citizens of Argentina have reacted against an alliance made between a totally incompetent government and greedy global financiers."[4]

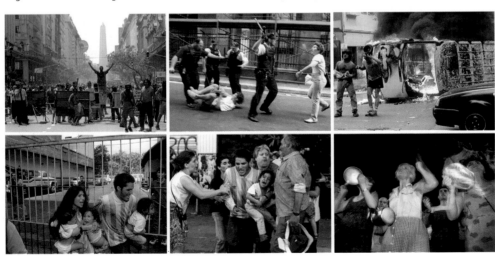

Protesters did not stop even when police reacted with tear gas and bullets. Thirty-two people were killed across the country and hundreds were arrested, but the spontaneous December insurrection, the furious banging of pots and pans, continued. When President de la Rúa pronounced a state of emergency to quell the riots, even more Argentines took over the streets in an outcry against the erosion of democratic rights: "I was watching television, seeing the lootings and the uprisings in the country's

interior. Suddenly the president appeared on the screen. He talked about differentiating between the criminals and the needy. He spoke quietly, almost elegantly, trying to sound in charge. He said he had announced a state of siege that day. I knew that it was unconstitutional in Argentina for the president to declare a state of siege. Only Congress can do that. I was disgusted and I turned off the TV. Then I started hearing sounds, very quiet but getting louder. I went to the balcony of my apartment, looked out, and saw people on every balcony banging pots and pans. The sound got louder and louder. It became a roar. And it wasn't going to stop. I saw some people on the corner of the street where I live, no more than 10. I put on a shirt and went down. It was strange and exciting. On every corner I could see people were gathering. . . . [E]veryone's been fucked by what's going on. And it's been going on for far too long."[5]

The cacerolazos united Argentines behind a political project for change. Sánchez remembers that "in the cacerolazos, we shared our anguish, our feeling of being protagonists and making our own history." The protesters had a simple demand: "*Qué se vayan todos!*" (Throw the bums out!) And they achieved it.

"And then the music was born," recounted Uruguayan writer Eduardo Galeano. "It began little by little, ringing out within the kitchens of some houses, serving spoons beating against cooking pots, and then it moved out to the windows and balconies. And it kept amplifying, from house to house, until it took over the streets of Buenos Aires. Sounds connected with other sounds, people connected with other people, and a concert of collective fury exploded in the night. From the sound of banging pots and pans, and no other weapons than these, arose the cry of indignation. Called together by no one, the crowd invaded the neighborhoods of the city, the country. The police responded by shooting. But the people, unexpectedly powerful, overthrew the government."[6]

In two weeks, the popular uprising had forced the resignation of four presidents. But few viewed this as a threat to democracy in the country. Instead, most observers, like Galeano, saw it as a patriotic and democratic act:

"The popular uprising that overthrew President De la Rúa was a demonstration of democratic energy. 'Democracy is us,' the people said, 'and we are fed up.' Or does democracy consist only of the right to vote every four years? The right of elections or the right of betrayal? In Argentina, as in many other countries, people vote, but they don't elect. You vote for someone but someone else governs. A clone governs. The clone once in government does the opposite of what the candidate had promised during the electoral campaign. . . . [I]n Argentina. . .many of the protestors wore their national team's soccer jersey, their innermost expression of identity, their happy pledge of allegiance. Wearing their jerseys they took over the streets. The people, tired of being spectators of their own humiliation, took over the playing field. It won't be easy to dislodge them."[7]

One rarely hears the din of banging pots and pans in Argentina today, but cacerolazos have spread to tell similar stories of injustice elsewhere. Silence does not mean the end of citizen vigilance. A participant wrote that "something changed during those days so that nothing will ever be the same as it was, and nothing is as it will be."[8] Another participant described December 20 as "the day the people of Argentina began to discover that rights are not just words on paper, but rather very precious and costly, that sometimes require struggle to achieve."[9] Buenos Aires homemaker Mónica Roveri de Fernández concludes: "The cacerolazo endures in the hearts of the population as a protest weapon. It was not in vain. When they try to adopt another anti-popular measure, more than one opponent will declare: 'Watch out! Our pots and pans are ready!'"[10]

JO ELLEN FAIR

A prominent South African artist working under apartheid during the 1970s and 1980s said of his calling, "what the arts can do [under authoritarianism] is to construct images by whatever means possible to expose the nature of tyranny, to support the struggle for freedom, and to give dignity

Jane Alexander's *Integration Programme: Man with TV* (1995) features a South African man sitting in a white room, peering uncomfortably at a white television. In the installation, the television streams a repeating clip of another uncomfortably dressed man, white, preening before a mirror.

and respect to the lives living and the lives lost."[1] This valiant statement also applies to the struggle to ascertain truths after the end of authoritarian rule. Art often exposes truths about a nation's violent past, contributes to the construction of social memories, and advances justice as a means of addressing past crimes of the authoritarian state.

Willie Bester's *Ox Wagon* (1994) calls to mind the great migration inland of South Africa's Afrikaaner Voortrekkers during the 1830s. In contrast to apartheid-era public monuments celebrating the great trek, Bester's assemblage indicts Afrikaaner ideology. It points to the corruption and terrifying technology that lay behind the putative heroism embodied in the Voortrekker myth.

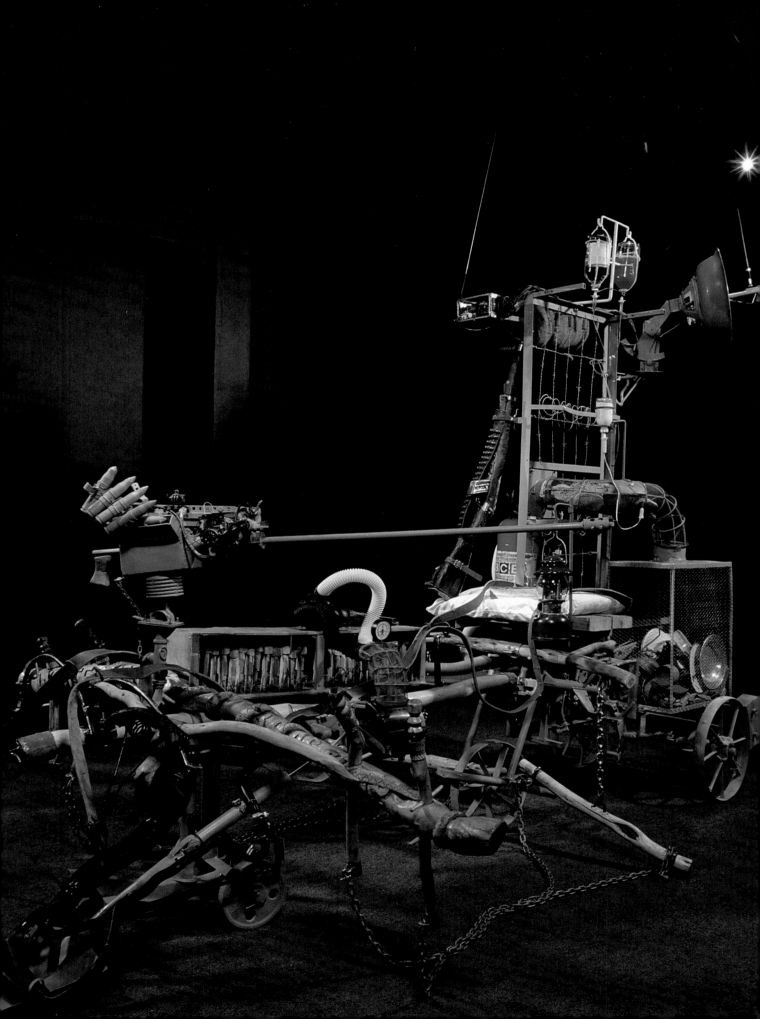

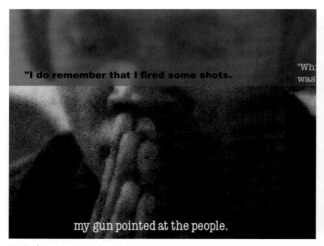

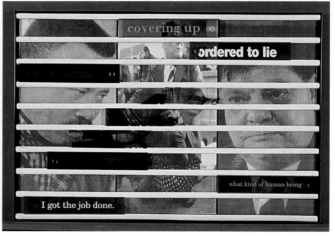

South African artist Sue Williamson's interactive *Truth Games Series* (1998) uses images taken from televised coverage of the Truth and Reconciliation Commission to engage the viewer in questioning how much truth the testimonies conveyed. Each piece features images of the victim, perpetrator, and the incident connecting them. Shown here are the TRC testimonies on the St. James Church Massacre carried out by the Pan African Congress and the use of torture by policeman Jeffrey Benzien.

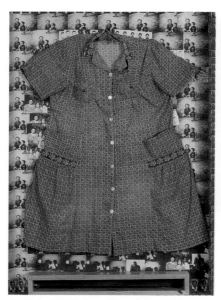

Our Mother (1998) by Senzeni Marasela is an artistic rendering of her mother's work dress, which has been pierced by bullets fired by supporters of South Africa's apartheid regime.

Documents of habeas corpus collect dust in government archives. This photo forms part of Marcelo Brodsky's project *Nexo* (2001).

Noemí Escandell's *Disappeared* (1999) presents a Pietà with the Virgin Mary's empty arms. On her head, she wears one of the kerchiefs of the Mothers of the Plaza de Mayo.

Art expresses the personal and the social, the mundane and the momentous, reflecting and challenging the lives people live and those they imagine. No matter their subject, and whether they are overtly political or not, works of art rely on broadly circulating and inevitably political narratives, metaphors, and images to animate them and give them their charge. The same is true of artworlds, the systems of production, distribution, consumption, and meaning in which all art is nested. Artworlds require political discourse to direct their energies, summon their producers and consumers, organize possibilities for expression, and mark the horizons of imagination. In short, political discourse is at the heart of visual culture; all seeing is political, as is the production and circulation of what is seen.

Truths, too, rely on political metaphors and narratives to make them recognizable and to set the limits of their debate. Like art, truths are political artifacts emanating from historical situations and negotiations.[2] Not all truths are morally equivalent. Yet it would be a mistake to think of truth as invariable, indisputable, or the exclusive claim of one group.

Art is, or can be, a claim to moral rectitude, a statement that this or that truth is just and should be acted upon. Some art, in other words, is moralizing, it pleads for public acceptance of one or another version of truth. Such art tends, intentionally or not, to limit the range of its possible interpretations and meanings. T. J. Clark, writing of propaganda but making a point true for all moralizing art, calls such art a radical simplification of reality and representation, which serves the interests of those who order it, but which also "tries to tune out or drown out contrary understandings. It says the facts — the ethical

facts, the facts of allegiance and human sympathy — speak for themselves."[3]

Thus, art and propaganda are not opposing fields of representation. Propaganda, like all moralizing art, is exceptional only for its political focus. Its public acceptance rests largely on the moral acceptability of the claims it makes. Such is the case for all art that asserts a moral position. Moralizing art can be subtle and contain multiple meanings. More often, however, it is flat: its meanings and interpretations are prescribed; its depth is hortative, not allusive; its technique is subordinated to its message; it is bound by its moral claim and by its historical moment.

Authoritarian regimes of long duration build systems of symbols and aesthetics that reinforce the state's values at a glance: its version of national history, its fabrication of national unity, its enemies, its goals, its policies of the moment. The state articulates its ideology and ambitions through official and officially sponsored art. Statues of Lenin and Stalin, posters of Fidel, Mao, and Ho Chi Minh, and urban billboards extolling the sagacity of Mobutu Sese Seko become the familiar images glorifying and personalizing power. They are moralizing art at its most coarse.

The success of the authoritarian state at exacting control over the discourses and works of visual culture, though considerable, is never complete. Artists in El Salvador, Argentina, Chile, Colombia, and other Latin American countries who produced semi-clandestine work exposing capital crimes of the state began to show their work publicly well before the demise of the repressive state, emboldened by international knowledge and outrage about the tortured, murdered, and disappeared.

Also interesting are the subtle, often encoded, ironic, and humorous critiques that emerge in the shadow of transitions from authoritarianism. Often calling on folk and popular imagery whose meanings are veiled or contestable, these artworks — graffiti, cartoons, drawings, paintings, posters, and sculpture — may have a longer public life, and a considerably longer clandestine one, precisely because their cleverness, humor, and occasionally their beauty are appreciated. Shortly after the 1991 coup d'état in Haiti that deposed Jean-Bertrand Aristide, one highly placed government official, who was not a supporter of the deposed president, observed smugly that Aristide would never return to the presidency because a leader deposed by a coup is like a recently laid egg: impossible to put back. When it seemed likely that Aristide would be returned to power in 1994, the region surrounding Cap Haitien sprouted dozens of murals showing the reinsertion of an egg into a hen. The pain associated with returning Haiti to democratic rule was sometimes

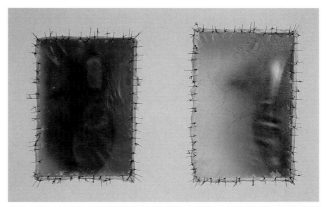

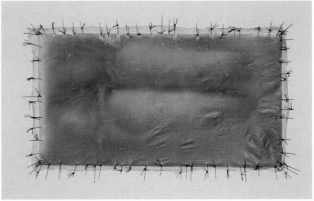

Colombian artist Doris Salcedo represents disappeared women by the shoes they wore in the series *Atrabiliarios* (1992). Salcedo displays the shoes in singles and pairs in a row in a wall alcove, but the view of the shoes is partially obscured by animal skins. The shoes remind the viewer not only of the person but also the family's loss and suffering of not knowing.

Doris Salcedo's *Untitled* 1990 piece consists of four stacks of white shirts. Each stack is pierced through, from top to bottom, by one or more vertical rods. The rods hold the shirts in place, marking the efficiency and order of state-sponsored violence. They also mark the trajectory of the bullets that may have passed through the torsos of those lost to violence.

Dreaming Recent History (1993) by South African artist Marc Edwards.

Silhouettes displayed by the Mothers of the Plaza de Mayo in Buenos Aires in 1983.
Source: Lyman Chaffee, *Political Protest and Street Art: Popular Tools for Democratization in Hispanic Countries,* 1993. Reproduced with permission from Greenwood Publishing Group, Inc., Westport, Conn.

depicted as negligible. Small eggs were easy to put back in. But more often, the eggs were large, and the mural showed hens, suffering but steadfast, saying, "Papa, make it go in."[4]

The movement from authoritarian rule to post-authoritarian democracy liberates society and its artworlds. Yet, liberation is not a simple transition for artists. State-sponsored artworks surrender their power and their meaning quickly and soon are only artifacts. Didactic anti-authoritarian art of the old regime — exhortations to resistance and action — loses its political underpinnings as well, especially as visual media (film, television, video, and Internet) are opened up to artists and others as alternative sites for expression. However, the forms and imagery of the old resistance art are not lost entirely. They often are translated into a new art of memory.

Memory and catharsis are the cultural and political context of a new instructive art. Stark, unfettered images of loss and remem-

brance, images finally unencumbered by the threat of state violence, say *nunca más*, never again. This art of memory informs and helps create a politics of memory, an accounting of the past, in the years after liberation.

Dreaming Recent History[5] by South African artist Marc Edwards shows apparent corpses, featureless, under a blanket. Their featurelessness recalls the ubiquity of state murder in the apartheid era; their covering shields the living from the brutality of death. Much of Argentinean Marcelo Brodsky's post-authoritarian work builds on stark, personal memories of brutality.[6] On a glass-covered photograph of schoolchildren, his own school class, he has circled the faces of his classmates who were disappeared. When present-day viewers peer into the glass, they see their own faces reflected in the circles, in place of those who are gone.

The body — dead and living — looms large in the art of memory and catharsis. Many contemporary South African artists, black and white, were preoccupied after 1994 with images of the living black body, signaling black survival of apartheid's brutality, and at the same time celebrating the corporeal reality of South Africa's newly uncovered, essential blackness.[7]

The art of memory and catharsis is often participatory. After the end of military rule in Argentina in 1983, human rights groups such as the Mothers of the Plaza de Mayo mounted in the streets of Buenos Aires silhouetted figures of men, women, children, teens, pregnant women, and couples. Reacting to the loss of loved ones through state-sponsored disappearances, family members and friends of those who were killed commemorated and personalized their loss by affixing a name, date of disappearance, and other personal information to figures whose physical characteristics corresponded to those they knew.[8] In post-Pinochet Chile, women continued to sew and sell *arpilleras*, colorful *appliqué* pieces denouncing the Pinochet regime's detention, torture, and murder of loved ones.[9] Graffiti artists in South Africa, who worked clandestinely under apartheid, began after 1994 to come together for socially sanctioned, locally sponsored graffiti expositions, their work often featuring the names and crimes of those recently accused or convicted of political terror.[10]

The passing of authoritarianism frees artworlds in many ways. Government restrictions end. Who can view art, who can be trained in art schools, who can produce art for public display, which artists can travel abroad, which artists have access to new art media and international trends in the arts — all are now largely a function of the market, not of state control.[11] Freedom from state control is generally enriching, though market realities

present impediments of a new kind. The passing of authoritarianism is also impoverishing, however, in another way, at least temporarily. The struggle against the state gave artists a sense of engagement and mission. The allusiveness, cleverness, humor, and daring of anti-authoritarian art imbued artists and the viewers of art with a common and compelling system of symbols and meanings that was uniquely theirs. With their political context redundant and their symbols passé, post-authoritarian artworlds, as Jane Taylor suggests, lose their sense of urgency and eventually their legitimacy, and must seek new contexts of meaning.[12]

Never independent of global artistic movements, artists in post-authoritarian states move through representations of memory and works of catharsis toward a fuller embrace of themes and ideas circulating in international artworlds.[13] Artists and those who appreciate art in the post-authoritarian state do not move together through phases of post-authoritarian redefinition. There are no phases. The scope of art simply broadens. A former general preference for the national and the political gives way to a multiplicity of preferences. In this way nodes of consensus, or of the appearance of consensus, are diminished or lost.

As authoritarianism recedes, so does moralizing art. All aspects of the human condition become fit subjects; viewers increasingly are invited to take from a work what they will.[14] Those accustomed to an overtly political art may question the relevance, morality, and seriousness of artworks that are far from didactic, not overtly political, not always national. Such critics form a rear guard, however, because art's progressive freedom from preoccupation with authoritarian repression signals society's long-sought break with the tyranny of the past. ∎

Making death an art form

By IVOR POWELL

ARTIST Werner Vermeulen entered into a bizarre and Mephistophelean contract this week. In a duly signed and witnessed document, he donated his corpse to fellow artist Wayne Barker for use in a sculpture.

The macabre bequest comes in response to a call put out by Barker as part of a current exhibition by artists working at the Fordsburg Bag Factory studio complex at Johannesburg's Civic Theatre gallery.

The notice, which hangs on the wall in lieu of a more conventional artwork, reads: "I am looking for donations to create a lifesize sculpture. I need cadavers — corpses."

Barker plans to coat the corpse then use a special process which will cremate the core of the body, the bones and flesh, but leave the shell intact. The shell will be used to create the sculpture mould, and eventually be cast in bronze.

Barker needs more corpses though. His proposed sculpture — provisionally entitled *Man Made Man Made Man* — is multifigured, with elements arranged in poses suggesting activities like "ballet, boxing and swimming".

t any old corpse will do: "Obviously I don't want car- victims or people missing major limbs. This is it to be a celebration."

t, he explains, that it's meant to be just a "fun thing". er admits he likes the textures of dead flesh, and the al paradox of using the cast of the cadaverous face in aying healthy leisure-type activities. But, beyond his intention is to highlight the contradictions in the we understand death.

want to question the value of being alive," he says. idea came one day when I saw a tramp's corpse in oad. People were throwing things at it to see if it d. It took the ambulance about three hours to get . At the same time, we have this sentimentalisation ath and this sentimentalisation of the corpse.

..id Vermeulen succinctly: "If you can donate your body to science, why not to art?"

Legally, though, difficulties might arise. The Tissue Act declares that the cadaver is the property of the state. The once-living tissue may only be handled by medical practitioners and other scientists.

If you have a spare corpse at home, or won't be needing yours in the future, or need more information about this unusual project, phone (011) 832-1660 or (011) 614-0166.

J. Wayne Barker's plan for *Man Made Man Made Man* (1989) would pose bodies in various activities from housekeeping to boxing. As all aspects of the human condition become fit subjects for art, those accustomed to an overtly political art may question the relevance, morality, and seriousness of artworks that are far from didactic, not overtly political, not overtly national, and which invite viewers to take from a work what they will.

Fragments of a Past
The Work of Zoran Mojsilov

KSENIJA BILBIJA

BROKEN HEART: Started in 1990 and finished in 1996, this sculpture by Yugoslav-born Zoran Mojsilov made of stone and stainless steel was purchased by the Minneapolis Arts Commission. The stone is broken like a heart, but steel holds it together, with violence, with love. Love hurts, the stone bursts and still continues to beat like a bleeding heart on the soil that has endured so much. Violence seems to come as lightning, as a flash of hatred swelling in human hearts. Resentment builds in the hearts of those who used to call the country Yugoslavia and in those who felt like Yugoslavs. Until one night it bursts into pieces. The outcome is still a heart, broken into fragments, and yet held together as a legacy of what it used to be.

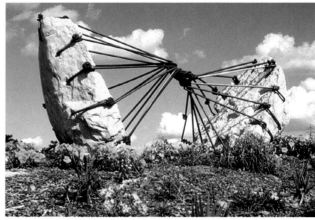

CUCKOO'S NEST: Part of the permanent collection of the Grounds for Sculpture in Hamilton, New Jersey, *Cuckoo's Nest* (1998) relates to cuckoos' well-known habit of laying their eggs in other birds' nests. This habit is metaphorically reproduced in the post-Yugoslav situation, as the work represents Mojsilov's native country as a nest deformed and invaded by the political agendas of various ethnic authoritarianisms.

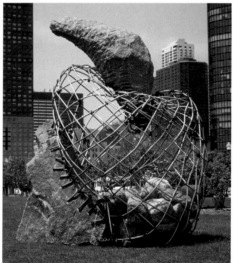

BALKAN: Part of a private collection, *Balkan* was made in 1996 from limestone and wood. The material is as old as the Balkan peninsula itself. Limestone, already broken and damaged by a vein of yellow stone imbedded in its white flesh, was taken out of a pile of rejected pieces from the quarry in France. Spikes piercing the limestone are from 13th-century beams used in the construction of homes. *Balkan,* the sculpture seems to say, is white, but not pure, yellow but not rotten; it is old and prone to crumbling. Mojsilov, through the rejection of the common plural form of the region's name Balkans, seems to suggest that in his eyes it is still one piece strongly held together by spikes of pain.

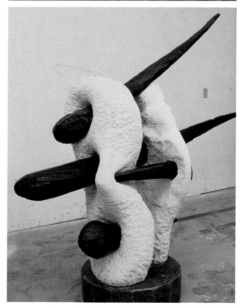

Reckoning with State Violence

NYAMEKA GONIWE
ARTWORK BY SENZENI MARASELA

My name is Nyameka Goniwe. I live in Cape Town, and I work for the Institute for Justice and Reconciliation. My work connects me still to Cradock, a small rural South African town where 16 years ago my husband, Matthew, and three of his comrades were assassinated.

There are so many things that made us think that his life was in danger. I received the threats and then he was under surveillance, constant surveillance, by the security police. He was being trailed. I mean we had the feeling he was being trailed wherever his car was seen.

The assassination squad intercepted the Cradock Four around 10 p.m. on the night of June 27, 1985. Their intention was to destroy any evidence linking them to the crime.

NEWS REPORT: *At Cradock in the Eastern Cape, tens of thousands of people gathered today for the funeral of four community leaders who died last month in mysterious circumstances: Matthew Goniwe, Fort Calatta, Sparrow Mkonto, and Sicelo Mhlauli. The four disappeared on June 27 after leaving a United Democratic Front meeting in Port Elizabeth, and their burnt and mutilated bodies were found four days later.*

matthew goniwe

Fearing exposure, the killers of the Cradock Four later sought amnesty from the South African Truth and Reconciliation Commission (TRC).

We went through the process of the amnesty hearings, which went on for months and months. And we were facing the killers the whole time. And each time I looked, looked at them, I was looking at the lies behind those hard faces and the facade. Is there a human being there? Is there somebody with emotions? But each time I looked for some explanation I could not find one.

If the many people who went through the process of the TRC manage to feel much better after telling their own stories, it is essential that the many people who fell out of that process do the same. What does this concept of reconciliation mean to me, to us? What does forgiveness require of me? We need to create a space for people to start to express their feelings, express their opinions about how they feel.

The killers of my husband were denied amnesty. This brings home to me that what is essential are the signals of humanity within those who killed our loved ones. I need to feel that they understand my suffering. I need some indication that they do feel at a deeper level. If I were confronted with this kind of humanity, I, as a viable human being, would be obliged to explore the possibility of reconciliation.

Extracted and adapted from the documentary film *Nyameka's Story*, directed by Mark Kaplan, Cape Town, 2001.

sicelo mhlauli matthew goniwe sparrow mkhonto fort calata

The Cradock Four (2001).

A Park for Memories

NANCY J. GATES MADSEN

William Tucker's *Victoria*

Source: Paula Di Dio

"No hay acto artístico que asegure la memoria"
"No artistic act can guarantee remembrance"
—Roberto Saraví, architect

The Parque de la Memoria that is currently under construction in Buenos Aires aims to call attention to some difficult truths regarding the recent years of state terrorism. Yet, it faces the daunting challenge of attempting to inspire reflection about a historical period that a vast portion of Argentine society would prefer to forget. Located on the banks of the Río de la Plata, near the dictatorship's clandestine detention center, the notorious Naval Mechanics School (ESMA), the completed park will contain a monument with names of dead and disappeared victims of state terror, as well as a sculpture garden designed to keep the memory of the dark years alive. To date, around one-fourth of the park has been completed — the access plaza and two of the sculptures — but debate over the politics of this memorial space continues. Perhaps fearing the park could evolve into simply another "invisible" monument, its advocates have attempted to ensure that the Parque de la Memoria becomes an active place for memory, rather than a forgotten space in the visual landscape.

The extraordinary burden borne by this memorial becomes complicated in light of the delicate relationship between monument and memory. As the historian Pierre Nora reminds us, "[t]he less memory is experienced from the inside the more it exists only through its exterior scaffolding and outward signs."[1] Once carved in stone, memory risks becoming fossilized, and many monuments to past triumphs or national heroes now stand as forgotten structures, ignored by passers-by. Furthermore, the reliance on exterior signs of memory to a certain extent spares the general public the burden of remembering. In a context of amnesia such as contemporary Argentina, the transformation of difficult memories into monumental form may unwittingly play into the hands of those who would prefer to simply forget the past and move on. This fear of forgetting perhaps explains why some artists and human rights groups, including the more radical branch of the Mothers of the Plaza de Mayo, refuse to participate in the project. The Mothers have even threatened to remove the names of their missing children from the *Monument to the Victims of State Terrorism,* believing that justice and accountability must precede any impulse to memorialize or mourn.

Such concerns about exterior and interior memory and monumental "invisibility" beg the question: how can a memorial commemorate past horror in such a way that the burden of memory

lies with the visitor? In his study, *The Texture of Memory: Holocaust Memorials and Meaning*, James Young suggests the "countermonument" as the most effective type of memorial to a country's own barbarity – "brazen, painfully self-conscious memorial spaces conceived to challenge the very premises of their being."[2] One example of such a construction includes the "vanishing monument" created by Jochen and Esther Gerz in Hamburg, a tall pillar which was gradually eroding as visitors carved their names into the surface, until nothing remained at the spot but a small plaque. According to Young, such structures negate the form of the monument but not its memorializing impulse. Rather, they preserve the onus upon the viewer to engage the difficult past. Expanding upon this relationship between form and space, the author asserts that the successful monument could be seen as "art confronting a space with its own invisible past, or an artwork that creates a tension between itself and the space it inhabits."[3] Considering the Parque de la Memoria within this framework of tension, neither of the two sculptures constructed to date, William Tucker's *Victoria* and Dennis Oppenheim's *Monumento al escape*, could be considered a true countermonument. While they use contemporary abstractions to invite viewer participation rather than "dictate" meaning, neither work negates the form of the monument to call attention to the slippery and impermanent nature of memory. One can only hope that the completed sculpture garden along with the monument to the victims will create the necessary tension between form and space that compels visitors to participate in a commemorative act.

The ability of the Parque de la Memoria to provoke memory and reflection ultimately relies upon the interaction between visitor and place. Memorial space always risks becoming dead space if no one visits. The overseers strongly believe that the park should not merely encourage passive contemplation, but also active use. Its location at the end of the *costanera*, a recreational walkway along the riverbank, attracts two types of visitors: those who consider the park sacred ground dedicated to the

forgotten victims of state brutality and those more "accidental" visitors who may use the space for more mundane activities such as picnicking or cycling. Yet, encouraging multiple uses of this memorial park could lead to unexpected consequences; after all, a space need not be abandoned in order to suffer from invisibility. In other words, if visitors to the Parque de la Memoria choose to picnic among the sculptures rather than reflect upon their significance, do they participate unconsciously in an act of memory, or have they simply converted a potentially sacred space of memory into a mere common place?

In the final analysis, the intricate relationship between form and function embodied in memorials to past horror recalls the architect Roberto Saraví's epigraph: "No hay acto artístico que asegure la memoria." ["No artistic act can guarantee remembrance."] Endowed with the extraordinary burden of provoking memory of past trauma, the Parque de la Memoria struggles against two types of silencing. On the one hand, it risks becoming a blind spot in the city's topography, one more invisible structure in the urban landscape. On the other, attempts to encourage active visitation may obscure the park's purpose as a place for solemn reflection about a difficult past. Only time will tell whether the completed memorial will inspire the desired response in the public, for ultimately the act of remembrance resides not in the outward trappings of memory, but inside each individual.

Dennis Oppenheim's *Monumento al escape*

Through the grapevine

CYNTHIA E. MILTON

Manila Times, February 28, 1999

Rumor is like a child's game of telephone: a message passes from player to player, changing as it goes, embellished here, simplified there. Soon no one knows the original message, but it hardly matters: in its repetition, rumor has a life of its own.

A rural region in the south of Chile had escaped the turmoil of the early 1970s. There had never been any real political conflicts among neighbors. People did their work, went to church, married, had children, and managed to survive. Barely.

But eventually the Pinochet regime located subversion in the area. It set out to expose, detain, and eliminate subversive elements. It succeeded. In a military trial held after government raids, Comandante Pepe and 11 of his followers were sentenced to death for attacking a police station in one community, Neltume. Rumors of other insurgents hiding in the mountains and woods spread to nearby communities and soon the region as a whole was reported to be subversive. The perception of violence was so persuasive that villagers believed that there was a guerilla presence in the area.

It is hard to know when villagers began to accept the regime's claim that it had uncovered a local insurgency. Was it when Chilean military arrived to fight the imagined insurgents? One resident said, later, "I have never felt so much fear in my life; every day they [the military] used to shoot their guns against the trees, into the air, into animals. They acted like in a war, but there was no war, they did not fight against anybody."

Today, some villagers remember guerillas who never existed, while others doubt this subversive past.[1]

Tito's Ashtray

Once Tito had owned many ashtrays. Rumors began to spread that Slobodan Milošević owned the last of Tito's ashtrays. Between September 24 and October 5, 2000, writer and artist Mileta Prodanović collected rumors recounting what happened to Tito's last ashtray as Belgrade residents waited for election results.

- Milošević threw an ashtray at Gorica Gajević, Secretary General of the Socialist Party of Serbia (Milošević's party), right before the elections.
- Milošević threw an ashtray at Gorica Gajević right after the elections.
- Milošević threw a vase at Gorica Gajević.
- Milošević threw an ashtray at Gorica Gajević on Sunday after she told him that there were a thousand Milošević supporters at the Square of the Republic when he only saw seven on TV.
- Milošević threw an ashtray and missed Gorica Gajević. The ashtray broke. He threw the ashtray because she smiled after he accused his campaigners of not working hard enough.
- Milošević threw an ashtray at Nikola Sainović, a high-ranking official of the Socialist Party of Serbia and the president of the Serbian Parliament. As of 2003, Sainović is on trial at the Hague Tribunal.
- Milošević did not throw an ashtray at Nikola Sainović in person because he was speaking to him on the phone.
- Milošević broke a glass table with an ashtray when he discovered that builders of a new bridge in the town of Novi Sad said they would not complete the bridge in time for the elections.

None of the rumors mentions whether there were any authoritarian ashes left in this ashtray. Perhaps there were. If so, this ashtray may have held the last ashes of authoritarianism.

Source: Cynthia E. Milton

Chilean animitas, like this one at the Ovens of Lonquén, marked sites where the authoritarian regime hid murdered victims, confirming rumors of disappearances. *Source: Pedro Matta*

In the telephone game, players can concoct an infinite assortment of messages; the game is best when the message is absurd. By contrast, rumors spread most readily when they are plausible, when they have some association with truth. A deliciously plausible rumor lives on and on. An unbelievable one titillates briefly, then dies.

Yet, the relationship between rumor and truth is muddled. Some rumors are entirely true. Others contain grains of truth; still others contain none at all. Plausible or implausible, truthful or false, rumors circulate because people are trying to get to the bottom of a matter. The acceptance or rejection of a given rumor in a given time or place depends on its ability to satisfy this need to understand.

Like messages sent in the telephone game, rumors may exhaust themselves when repeated tellings distort their content to the point of unbeliev-ability, but not every rumor reaches this stage. Some rumors remain believable; others circulate even when they appear to have lost credibility and connection with social reality. In those cases, rumors retain enough internal logic that they continue to resonate and circulate, even if only among a select group of people.

The rumor that circulated in southern Chile in the 1970s possessed its own logic. Though villagers only knew of a handful of poorly armed and untrained rebels in the region, many began to believe the military's rumor that this cell threatened the country. Even today some villagers continue to abide by this "truth" and justify the military's inter-vention in the community to eliminate the

In the book *The Flight*, former Argentine Navy Captain, Adolfo Francisco Scilingo, confirmed the rumors about the disappearance of the regime's victims on death flights. Following the 2005 trial in Madrid for his involvement in the flights, a Spanish court sentenced him to 640 years in prison.

subversives. What allowed villagers to distrust their own knowledge of their community and believe the military regime's version?

Why rumors are told

Rumors provide explanation. Rumors explain the unknown or the poorly understood, creating comprehensible narratives. They make sense out of ambiguous events. Sometimes even those who are the subjects of rumors are tempted to believe or at least repeat them because they throw a more positive light on events than the personal version would do.

Chilean villagers grappled with the incomprehensibility of violence in their isolated rural community. Even if the authoritarian regime's version did not reflect their own understanding of community life, it made sense of the disruption in their lives. It provided an understandable version of events that gave them clear cues about how to act to avoid more atrocities.

To explain the attack that left 200 Bosnian soccer players and spectators dead or wounded on the morning following the end of Ramadan, Muslim residents of Sarajevo fabricated a rumor. Someone within the community, it was said, informed militant Serbs of the match.[2] The rumor seemed illogical. Neither the time nor the location of the game were secret; soldiers stationed on the hill above the field easily could have observed the match and mounted the attack. The rumor served an ideological purpose, however: it discounted the probability that the attack was unplanned. Betrayal by a community member seemed less fright-ening than the uncertainty of future random attacks by a renegade enemy. The rumor gave the community a sense that by monitoring itself future violence could be averted.

In Argentina, rumors have circulated about military leaders smuggling suitcases of documents on the disappeared out of the country and into Swiss vaults. Likewise, South African rumors recount ballot boxes abandoned along remote roadsides, suggesting government attempts to rig elections. The missing ballots explained why the African National Congress (ANC) did not win in areas where black South Africans voted. Such rumors also provide hope: perhaps the names of the disappeared will be found. Perhaps black South Africans throughout the country really voted overwhelmingly for the ANC.

Rumors make fiction out of facts. When the truth is unknown, rumor replaces it, often with bits and pieces that distort the actual facts. The Chilean rumor greatly exaggerated the numbers and strength of the rebel forces, but an armed movement did exist. To justify counter-insurgency methods, the military had to invent a credible threat. The rumor transformed the small band of rebels into a revolutionary movement.

The cartoon depicts rumors of the wealth the Marcoses acquired during Martial Law
Philippine Daily Inquirer, Dec. 10, 1998.

In this cartoon, implicit references to the corruption of former Filipino President Estrada underscore growing popular dissent against his government, dissent that eventually led to People Power III (or EDSA III). *Manila Times,* June 5, 1999.

In the Philippines, where corruption remains an entrenched legacy of the Marcos era, rumors spread among confidants of a "midnight cabinet" composed of President Estrada's cronies, particularly his drinking buddies. While Filipinos lacked the power to bring Estrada to account for his corruption, they could tell stories about him. On the internet and through text messages, they spread rumors about his womanizing, drinking, and gambling. The rumors certainly had some element of truth, but each iteration embellished Estrada's vices to further malign him among his remaining supporters.[3] These rumors became "weapons of the weak," the most effective means for the politically powerless to challenge a corrupt dictatorship.[4]

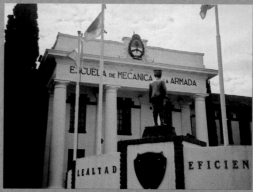

Source: Cynthia E. Milton

ESMA

Rumors still circulate about the Naval Mechanics School (ESMA), the site of a detention and torture center during Argentina's Dirty War.

One rumor has President Carlos Menem, a well-known Formula One fan, planning to tear down the ESMA and replace it with a racetrack. Perhaps the incident fueling this rumor was the demolition of the Club Atlético torture center by the military to build an overhead highway. The racetrack rumor implicitly suggests a close alliance between Menem and military personnel who wish to silence the past.

Another rumor, originating from the years of the dictatorship but still told today, holds that Montoneros, an armed leftist group, had planted a truck with explosives under ESMA during the World Cup Soccer games of 1978. Evidently, the explosives failed. Yet, rumor has it that a truck carrying explosives was found in the late 1980s when major flooding of the underground river made people wonder what was backing up the water. City workers allegedly discovered the truck and dug it out. No one knows how the Montoneros would have managed to bury a truck under ESMA, if there was ever really such a truck or explosives. Though this rumor remains unsubstantiated, other rumors say that *Página/12,* an Argentine newspaper, reported the event.

A third rumor circulating suggests that the military buried bodies in the backyard of ESMA. However, no bodies have been found. What is unclear is whether bodies have not been located because they are not buried there or because no one has been able to look for them. In March 2005 the ESMA was opened as a museum of memory. Perhaps now these rumors will be confirmed.

Rumors disguise lies. Just as rumors contain truths, they also hide lies. The Chilean villagers knew that a guerrilla insurgency did not exist in their community, yet some began to believe the military's lies. They assumed that guerrillas must have been organizing a rebellion in the woods, otherwise the soldiers would not have attacked the community. The distorted account produced by authorities endured because it was plausible.

Authoritarian regimes are not alone in disguising lies through rumor. Some political activists invent and circulate rumors to provoke people out of their passivity, to bring on moral outrage, and to mobilize action. Those Argentines who circulated the rumor that the government planned to raze a torture center and replace it with a racetrack may have intended to shock survivors into action. They hoped to memorialize the past before it was obliterated.

Rumors provide credible alternatives to incredible reality. Sometimes fact is stranger than fiction, and truth more outrageous than rumor. For Chilean villagers, it proved far safer, and even more plausible for many, to believe a far-fetched rumor of guerrilla insurgency than to blame the military for terrorizing the community on the basis of a story it had invented.

The investigators for the *Nunca Más* report in Argentina attributed accounts that the military had tossed bodies out of airplanes and into oceans to overwrought

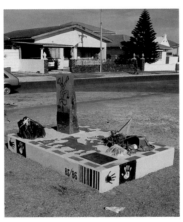

Police hiding in large wooden crates on the back of a railway truck fired directly into a large crowd of protesters in the colored township of Athlone, Cape Town, on October 15, 1985. Three youths, aged 11, 16, and 21, were killed and several others injured. The operation was planned and authorized by secret security forces. *Source: Cynthia E. Milton*

imaginations. Naval officer Adolfo Scilingo, however, later confirmed this rumor as truth. Similarly, Sarajevo residents discounted stories of unmarked mass graves as far-fetched rumors, until teams of investigators discovered the graves and the bodies in them. And the exaggerated rumors of the Marcoses' ill-gotten gains, or Imelda's shoe collection, paled in comparison with the facts that were eventually revealed.

Why rumors resonate

The source of the rumor matters. The believability of rumors depends on the relationship between the person who spreads the rumor and what the message says. Rumors gain credibility when the person telling them is credible. Sometimes the source of a rumor has so little credibility that the rumor is automatically dismissed. The traditional authority of the Chilean military, for example, led many to trust the rumor over their own experiences.

In stark contrast is the story of Winnie Madikizela Mandela. The apartheid regime, bent on discrediting the Mandela family, spread so many rumors about Winnie that her followers learned to discount them as fiction. When subsequent authorities revealed evidence of her criminal behavior, many of her followers continued to attribute those facts to the historic smear campaign.

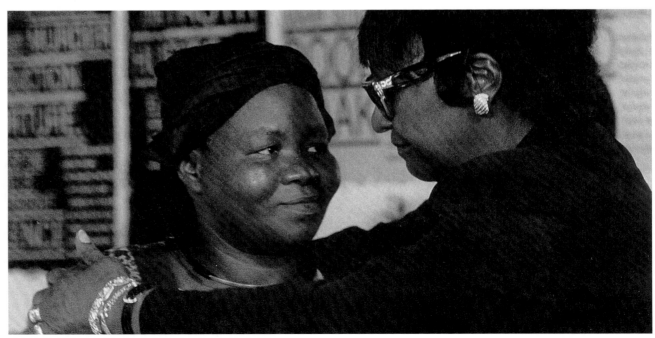

Winnie Madikizela Mandela at the South African TRC with Mananki Seipei, the mother of her victim Stompei Seipei.

Source: Truth and Reconciliation Report

Ambiguity is sometimes preferable to certainty. Rumors do not usually have a known source. They also tend to rely on stories that defy verification. Despite their flimsy factuality, or maybe because of it, they speak with authority. The teller manipulates plausible circumstances to produce specific outcomes. In Chile, the military played on the existence of a small band of guerrillas in the community and transformed them into a threatening band of subversives attempting to undermine law, order, and Christianity in the country. While it is not surprising that villagers believed the story during the dictatorship when the cost of doubting the military could be one's own death, why do villagers still believe it now?

While waiting for election results in 2000, Belgrade residents heard rumors that portrayed Slobodan Milošević as Tito's handpicked successor. In one rumor, Milošević, who had usurped Tito's power and moved into his old residence, threw the former leader's ashtray at a member of his own Socialist Party. This rumor not only confirmed suspicions that Milošević had authoritarian and violent tendencies. It also clinched his connection to Tito: who else but his handpicked successor would possess his ashtray?

Context enhances believability. Only when a rumor "rings true" does it spread. If a rumor seems false or irrelevant, then it falls out of circulation. Details of a rumor might make it seem unbelievable. Thus, the Chilean villagers today should reject the past rumor as false. Indeed, some villagers claim that they never believed the rumor. Some admit that they feigned belief to protect themselves and their families from military reprisals. But others remain steadfast in their adherence to the military's account. To deny that version of the past would call into question all of their beliefs and how they had acted on them.

A widely circulating rumor in Nigeria during the 1990s Oputa Commission hearings concerned a seven-year-old girl who testified that she was sexually abused in her "own room." But cross-examination challenged the plausibility of this Nigerian seven-year-old having her own room. The rumor that subsequently floated around was that shady forces pressured this young girl to give false testimony. The implausibility of the details cast doubt on the girl's account of sexual violence.

Nigerians have criticized the Oputa Commission for its pursuit of reconciliation in the absence of justice for the victims of the military dictatorship. In the cartoon, a victim of human rights abuse registers his displeasure by violently twisting the hand of his erstwhile tormentor, instead of giving a warm handshake and loving embrace as requested by the chairman of the Commission. *Source:* Bunmi Akinrujomu, *Tell Magazine,* November 27, 2000.

Rumors help define the self. As the teller repeats a rumor, she adds her own creative embellishments, making the story more real for the listener often by drawing herself into the story. One's own identity, therefore, becomes, in the telling, part of the rumor. Why you tell a rumor, what you tell, and to whom you tell it helps define for yourself and for others your own ideologies and concerns. The Chilean rumor is a story of good against evil. But in one version of the rumor, the teller identifies the soldiers as patriots who defended the nation against subversion. In a contrasting version, the teller identifies with the freedom fighters who took up arms to defend the country's oppressed people. In both cases the story is the same. How the teller situates herself makes all the difference.

There would appear to be no more rumors that could be told about the Thai Crown Prince. He is so infamous that rumors about him are generally believed to be true, no matter what their content. So why do people spread rumors about him? They continue to tell stories because the stories build solidarity, common cause, and political identity among the Prince's opposition.

Rumors predict the future. Rumors can have a prophetic quality. Some young Chileans probably took up arms and joined the clandestine forces precisely because of the rumors circulating about a strong local antigovernment opposition. In Argentina, rumors circulating before the infamous Dirty War anticipated its arrival. Argentine novelist Luisa Valenzuela recorded bits of conversations and rumors overheard in cafes just prior to the 1976 coup. These accounts, fictionalized in 30 stories in *Strange Things Happen Here,* capture the foreboding fear of the atrocities, which were about to occur.

Rumor performs a function. For that reason, even long after authoritarian regimes leave power, rumors told during that time continue to circulate, keeping conflict over the truths and lies of the past alive. Such was the case in the Chilean rural community. The rumors provide credible stories that define and re-define villagers' political beliefs and values today. More commonly, however, rumors generated at one critical historical juncture simply lose their passion and power after political transitions. New political realities generate new truths and new fictions that, creatively intertwined, will make their way through the grapevine. ∎

Recollecting the Dead

COURTNEY MONAHAN

The Argentine Forensic Anthropology Team or EAAF, founded in 1984, is an organization that is active not only in Argentina but throughout the world. For nearly two decades this team consisting of twelve people has been dedicated to using forensic science in the investigation of cases of persons who were disappeared during the most recent military dictatorship in Argentina, which endured from 1976 to 1983.[1]

It is painstaking work. Abandoned or unkempt pieces of land are slowly excavated and are often found to reveal a grisly number of hastily buried human remains that vary in both age and gender. These sites are scattered throughout the nation and were used as depositories during the Dirty War. Yet while the sheer number of cases alone may seem daunting, the lack of medical records coupled with a lingering fear of speaking out that continues to infect Argentine society has made the positive identification of remains impossible in far too many instances.

It is work that also can be unwelcome and unappreciated at times. Rumors of a large and threatening subversive force permeating every aspect of Argentine life that were once spread by the dictatorship continue to find a foothold today. To some, any excesses perpetrated by the armed forces can be justified as unfortunate but inevitable consequences of a war against urban terrorism. Others may no longer take stock in such a justification, but would prefer not to revisit memories that are laced with pain and fear.

Despite these obstacles, the EAAF continues to unearth what remains of the victims, and this forensic evidence serves to justify the rumors of disappeared people that circulated continually during and after the dictatorial regime. New sources of documentation continue to be found which allow for the resolution of more and more cases. Yet the disappeared continue to seem removed from our daily reality. It becomes difficult to recognize each individual among the mountain of bleached bones. We lack in many cases a personality with whom we can connect.

It is for this reason that former EAAF team member Eric Stener Carlson became determined to uncover the true life and identity of skeleton number seventeen, the remains of a young woman that he unearthed in the Avellaneda cemetery in July of 1991. "It is impossible, I think, to relate to statistics of mass murder or suffering," he revealed in an unpublished interview in 2002. "We need to know the murdered woman had a family, had a boyfriend, had a career of helping people . . . [my work]

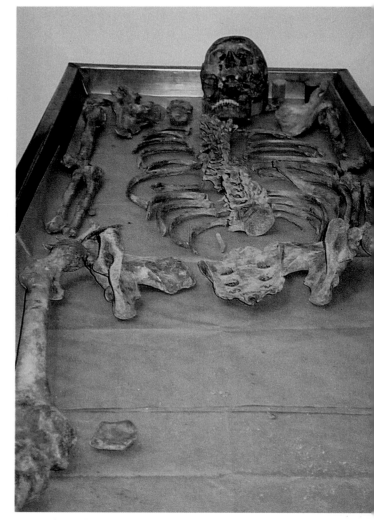

Source: Cynthia E. Milton

not only helped the larger audience outside of Argentina to feel a bit of the loss, but also it gave the people who actually suffered immediately because of her disappearance a way to tell their stories."[2]

The EAAF, therefore, is struggling to find a way to reconstruct the person out of the fragments of the body and of the rumors that remained after a disappearance. If the skeleton can be put back together, if its name can be rediscovered and its life unlocked, then perhaps the person will also reemerge from beneath the earth, no longer doomed to exist as just another number in a macabre garden of bones.

Source: Cynthia E. Milton

Source: Página/12

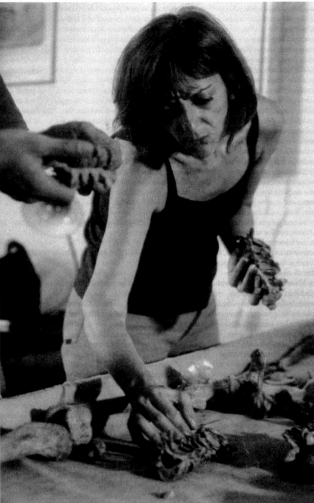

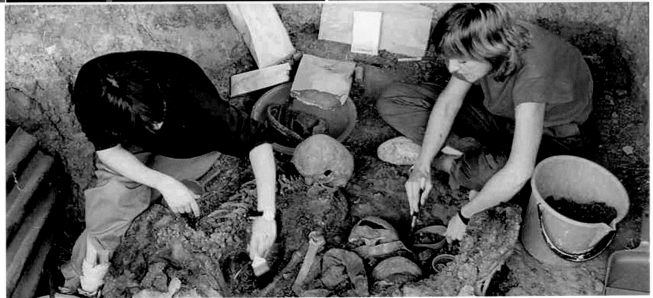

Argentine Forensic Anthropology Team (EAAF)

Source: EAAF

Alive, Until Truth Arrived

THONGCHAI WINICHAKUL

Lim and Jinda Thongsin at the symbolic cremation held at the 1996 commemoration. Behind them is their youngest son.
Source: Sarakadee Magazine

Jaruphong Thongsin

His son's name on the police "wanted" list gave him hope that he was alive. Jinda Thongsin came far away from his hometown to Bangkok and spent many days without success trying to find his son, Jaruphong, whose whereabouts were unknown since the massacre of October 6, 1976. The massacre was the culmination of tensions and confrontations between the radical student movement and the Thai state, which had polarized Thai society from 1973 to 1976. Jaruphong, a student leader, on that day was the last person to leave the student union when the armed police and the right-wing paramilitary groups reached the building.

Jinda and Lim, Jaruphong's mother, knew that their son was involved in the student movement, although they never understood what he actually did. To them, he was their eldest son and a good man with a kind heart. Jinda arrived in Bangkok the day after the massacre. At his son's apartment, Jinda found an unfinished plate of food and half a cup of cold coffee in the messy room. He then went back and forth among several police stations and hospitals, searching repeatedly the lists of the arrested and the injured students. Jaruphong's name appeared in none of them. Nor was he listed as one of the dead. The "wanted" list ironically gave Jinda the most hope that he would find his son alive.

But days of searching went in vain. He tried a few more times, sometimes with Lim accompanying him. The result was never different. At home, a small town in the "pink" (communist-infected) area, rumors spread both by local police and local communists that Jaruphong led a local guerilla unit attacking the government posts. Jinda and Lim's hope survived in these rumors. They even visited several police and soldier bases in the insurgent

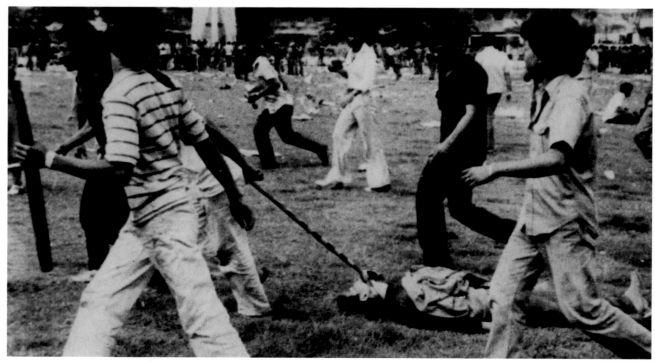

On October 6, 1976, Jaruphong Thongsin's body was dragged along the ground after he was shot dead.

areas, distributing the picture of their son, asking if anyone had seen him.

Among Jaruphong's friends, myself included, word had spread rapidly since the morning he was shot dead. Not long after, one of the photos of the massacre that was circulated around the world showed a young man being dragged along the ground by a piece of cloth hanging around his neck. Despite censorship, we saw the photo. We recognized him by his dress. Several years later, when we realized that Jaruphong's parents were still waiting for their son's return, we were speechless. We were also cowards: how would we tell them and more difficult, who would tell them? Since 1976, the Thai state successfully silenced those who tried to make noise about the massacre, virtually purging from the public the memory of the atrocity. But Jinda and Lim were still waiting while their son's friends were still heartless and irresponsible in not telling them the truth — for 20 years.

In 1996, the silence surrounding the massacre was broken. The commemoration of the incident 20 years earlier became a huge public event. A courageous friend of mine informed Jinda and Lim what they had suspected all along. The 20-year wait was finally over. On October 6, 1996, former radical students gathered in the early morning at the same time and place where the massacre had occurred for a symbolic cremation of all who were killed. Many of them, including Jaruphong, never received proper cremations because their bodies were never found. Finally, we former radical students accomplished one of the most significant tasks in our lives — to formally say farewell to our friends who died for their dreams of a better society. Jinda and Lim accepted the honor of being the first ones to light the fire under the urn.

This tragic story should find closure here. Yet, why could Jinda and Lim not find their son's body and claim it in all the time that they had spent in Bangkok searching for him? In 2000, while in Bangkok, I was told that Jinda and Lim asked friends of their son to help find his remains. At the time, coincidentally, I was in Bangkok examining for a research project 70 boxes of police documents I had found a year earlier about the incident. The complete autopsy reports were included. Jaruphong was indeed not listed among the dead. Among them, however, were six "anonymous Thai male(s)." Judging from the photos of these six dead men, one of them looks like Jaruphong, although I was not so sure because the face was badly beaten and the camera angle distorted his appearance. The clear evidence pointing me to

Jaruphong's identity was the piece of cloth around his neck and the mark of a strap on his neck. This anonymous Thai male was never identified, and so his body was never claimed. The police themselves did not recognize him either; they did not know that one of their "wanted" people was in fact under their control the whole time. Three months later, the police cremated him at a local Bangkok temple together with dozens or even hundreds of other unidentified bodies. These people were known and treated as the "dead without relatives." Their remains and ashes were simply dumped.

One afternoon in September 2000, I told Jinda and Lim everything I knew about their son and his body. "I wish I could find his remains," I ended, as they cried. I then asked Jinda if he had seen the photo of the dead during his search for Jaruphong. At that point, Lim literally pointed her finger at her husband and cried out, "I told you that was him! I told you that was him!" Jinda cried harder; his head was down; his body was lifeless. I was shocked, realizing what I had just done to them. Telling the truth was so cruel, too.

They did see the photo. According to him, for a moment he thought it might be his son. But he could not recognize him because the face was beaten and swollen so badly. Of course, at that time he knew nothing about the cloth and could not link the photo of a person being dragged on the ground to his son. Even now, he refused to see his son in the photo. Lim, still crying, mumbled, "I told you that was him. I told you."

Lim passed away in December 2002. Shortly before then, she said in an interview that she could not yet come to terms with the truth. Jinda remains at his home in a small town far away from Bangkok. The search for his son is over. But the pain of the search may never be.

The October 6, 1976 Memorial at Thammasat University, Bangkok, Thailand, inaugurated on the same date in 2000.

Source: Thongchai Winichakul

Rumors of War

MARINA ANTIĆ PHOTOGRAPHS BY ROGER RICHARDS

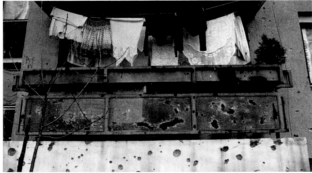

During the recent war in Bosnia, Sarajevo occupied a special place in Western understandings of the war. It was a place that embodied the Western humanist desire to withstand and outlast the violence of war and ethnic hatred. Unfortunately, Sarajevo in reality was far from this ideal. Its inhabitants, like so many other civilian war victims, were not fit to carry the weight of humanity. We succumbed to patterns of behavior far removed from the heroism expected of us. Fear and irrationality more often than not got the better of us. Rumors about the war, the city, and our life within it, testify to our fear. How rumors arose, faded away, or in some cases persisted over the years, tell a story of how we confront and compensate for irrationality and violence.

It is in the nature of rumors that their origin and truth cannot be easily assessed, and this is the case with many rumors that were circulating during the war in Sarajevo. Some of them are being assessed and answered in the Hague tribunal, but often I still find myself not knowing whom to believe. As I was reading the final report of the UN Commission of Experts on Former Yugoslavia, I came across a note from one of the testimonies that spoke of a prison in my old neighborhood in Sarajevo. The prison is described as being across from the local medical center, but the only thing I recall being there was my old music school converted into a dentist's office I visited during the war. The jail we knew about was in a different building, on the other end of the main boulevard, close to my own apartment. However, having heard so many rumors about the "Dobrinja jail," I began to question my own knowledge of the events. Maybe I dismissed these rumors as did so many others and made a mistake? Maybe the witness was lying, having never been in Dobrinja or the jail? Whatever the case, this little blurb in a UN report made me revisit the rumors circulating at the time and question my own experience and knowledge of the war in Sarajevo. And the rumors were many: rumors about enraged citizens pouring boiling oil on the invading soldiers (how did they get the oil to boil fast enough to pour it

on someone?); rumors about Serbs and others reporting the "coordinates" to the Serbian army with a flashlight and apparently sophisticated knowledge of the Morse code; and of course, the one about how we were winning the war. My own experience on two separate occasions testifies to how widespread the rumors were and how easy it was to start them.

Early in the war, when there was still a real fear of Serbs invading our neighborhood, one night after prolonged machine-gun attack, an apartment in my building caught on fire. It was two floors below us. At first, my family and I didn't notice anything. By the time we found out, the building was mostly evacuated and our hallway was completely filled with smoke. We couldn't get out. As the apartment filled with smoke we escaped to our balcony and were exposed to gunfire. My mother and father were passed a fire hose from the balcony next to ours and were trying to put out the fire. My sister and I were terrified from the bullets flying over our heads and around our parents as we crouched on the floor and screamed for help. The fire was eventually put out and we were rescued, but in the morning we found out that all that screaming my sister and I did on that fifth floor balcony caused people in surrounding buildings to evacuate thinking we were being overtaken by the Serbs. The rumors of yet another building "falling" to the Serbs were powerful enough to make people leave their buildings at night. They testified not only to our fear but also to how easily rumors got started.

Several months later, a sniper shot me in front of my apartment building. The sniper had shot others as well, and it was well known that this general area was open to such attacks. In fact, shots from this sniper position became everyday noise to most of us, as the sniper fired every couple of minutes or so, 24 hours a day, every day. However, when I returned from the hospital, everybody in my neighborhood was convinced that I was shot because I had been put on a blacklist of sorts. My mother worked in a government office before the war, and it was speculated that one of her disgruntled clients wanted her and her family dead. It didn't matter that my mom never spoke of any threats (and there were some, but they were commonplace and usually involved some high-ranking official threatening my mom with a report to the higher-ups in the party), nor that her position was insignificant, nor that the sniper could not even see me above my thighs, let alone identify me as her daughter, nor whether the blacklist existed. Most striking of all, this rumor flew in the face of the most obvious reality in Sarajevo, namely that people were shot daily. Even my family believed the rumor. The blacklist at least explained why a sniper would shoot their 14-year-old. But reality was resistant to reason, predictability, or a sense of justice. It is not surprising – my family clung to the most unbelievable stories that "explained" it.

All of these rumors attest to one persistent quality of life in wartime Sarajevo, namely, the struggle of its people to survive physically, emotionally, and psychologically. The traumas of war register only superficially in these situations, and not being able to resolve or discover their true meaning we constructed ways of explaining them to ourselves. Whether one believed all rumors or outright rejected them, the truth always being somewhere in between, they spoke of the necessity of bypassing reality for the sake of survival. Maybe they paint a picture of Sarajevo as less than the heroic city of Western journalistic accounts, but they do speak of the human in us and of the desire to make sense of the world around us, one way or another.

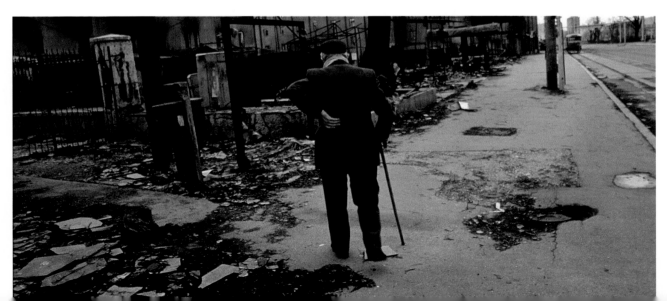

The power of song

MICHAEL CULLINANE AND TERESITA GIMENEZ MACEDA

The *cueca* is traditionally danced by couples. Chilean women dance it alone to symbolize the dead and disappeared during the dictatorship. *Source: Association of Disappeared Prisoners.*

When President Patricio Aylwin was inaugurated in Chile on March 12, 1990, he invited women to dance to traditional folk music. There in the National Soccer Stadium, where countless people had been tortured and killed during the Chilean dictatorship, women danced the *cueca*. Although a couples' dance, on this occasion the women had no partners.

They danced alone. Yet to those gathered at the event, the music and movement imbued the ghostly presence of the missing partners. The absence of the dance partners told a truth about the past regime's murder and disappearance of more than 3,000 Chileans. Though those partners were no longer present, they were still a part of Chile.

Source: Claudio Barrientos

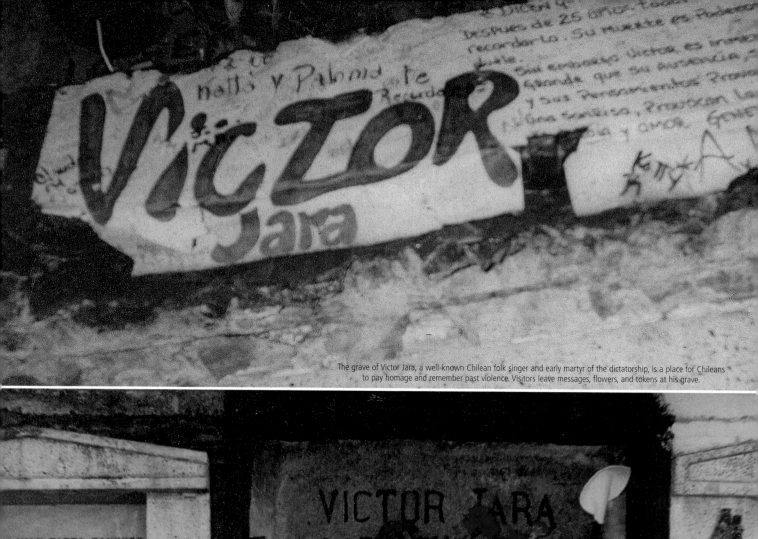

The grave of Victor Jara, a well-known Chilean folk singer and early martyr of the dictatorship, is a place for Chileans to pay homage and remember past violence. Visitors leave messages, flowers, and tokens at his grave.

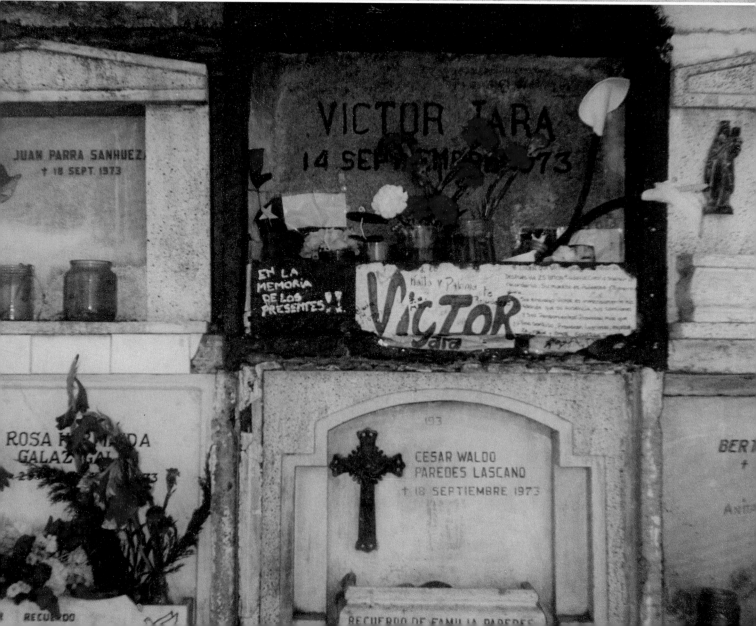

Bayan Ko

Lyrics: José Corazón de Jesus (ca. 1925)
Musical Composition: Constancio de Guzmán
Recorded by Freddie Aguilar (1978)

My country, the Philippines
Land of gold and flowers
Love has given her
Grace and tranquility

And her radiance and loveliness
Drew rapacious foreigners
My country, they have imprisoned you
Thrown you into sorrow and despair

CHORUS:
Even birds who freely fly
When caged will cry
What more a country endowed with nobility
Would it not strive to break free?

The Philippines, my cherished land
My home of sorrow and tears
Always I dream:
To see you truly free

CHORUS:
Even birds who freely fly
When caged will cry [*umiiyak*]
What more a country endowed with nobility
Would it not strive to break free?

Alternative Chorus:
Even birds who freely fly
When caged will struggle [*pumipiglas*] to escape
What more a noble people
Would they not strive to be free?

"Bayan Ko" is a national Filipino song dating back to a poem put to music. The song is of a Freedom Bird – a symbol for the Philippines – that is trapped in a cage. The lyrics evoke a beloved country whose beauty and freedom has been robbed leaving it with poverty, pain, sorrow and despair. This song is still widely sung and continues to elicit powerful responses.

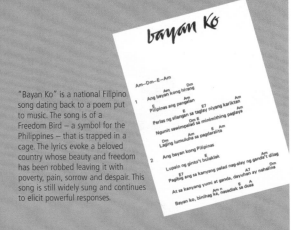

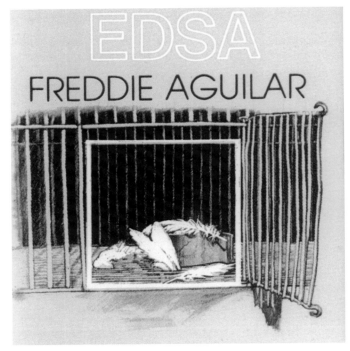

The *EDSA* recording by Freddie Aguilar has the classic image of a dove on the cover. In the post-Marcos dictatorship, the bird is no longer in the cage; the cage is now empty. After the dictatorship the bird is *malaya* or free.

The role of traditional music in telling truths about the past is not uncommon. How it is used varies from place to place and moment to moment. The *cueca* is an example of folk songs taking on new political meanings that they did not have prior to the Pinochet dictatorship. But in some cases, as in the Filipino "Bayan Ko," the political meaning behind traditional songs is constantly in flux. "Bayan Ko" is Tagalog poetry set to the music of traditional national love songs. It has been performed throughout Filipino history, each era calling for a new kind of liberation by incorporating new verses, and new political and personal agendas. In the 1930s, for example, it served as a peaceful protest song that expressed the persistent sentiments of Filipino nationalism and anti-colonialism. In the 1940s, it became a popular song to protest the Japanese invasion of the islands. It was revived during the radical student movement in the mid- to late-1960s to protest the Marcos regime and continued American influence in the Philippines. By the 1970s, "Bayan Ko" had become one of the most popular songs in the musical repertoire of the new Communist Party of the Philippines (CPP) and its emergent armed force, the New People's Army (NPA). The Marcos regime's efforts to co-opt the song notwithstanding, it became at the beginning of the 1980s mandatory singing in many circles to identify oneself in opposition to martial law. It was sung in homes and at political rallies – and funerals (most notably that of Ninoy Aquino, Marcos's assassinated political foe). It formed part of the People Power movements. Popular artists'

recordings of the song kept it in circulation through changes in political regimes, generating debate over favorite renditions that only thinly disguised ideological factionalism in the country.

"Nkosi Sikelel' iAfrika," or "Lord Bless Africa," is another song that has taken on political meaning over time. Written in Xhosa in 1897, it was first performed as a hymn, with additional stanzas added in Xhosa, Zulu, and Sesotho. Calling on God to blot out wickedness and to aid mutual understanding, the song became one of the African National Congress (ANC)'s freedom songs, adopted informally as the national anthem of the oppressed and sung in defiance of apartheid. With the election of Nelson Mandela to the presidency in 1994, "Nkosi Sikelel' iAfrika" became one of two national anthems for South Africa.[1]

The *cueca* dance, "Bayan Ko," and "Nkosi Sikelel' iAfrika" all draw on rhythms, movement, and lyrics that have deep local resonance. Though they each predate authoritarian periods of rule, it is authoritarianism that shaped their political meanings. Rooted in a given cultural milieu, songs can unite individuals and communities around a common story about authoritarian pasts and hopes for a better political future. Despite authoritarian tendencies to repress expression of all forms, dictatorships not only transform music, they also give birth to new music. Songs survive dictatorships because music performed in protest, even if clandestinely, becomes part of identity across generations. Songs from the past allow listeners to relive those moments, often with mixed emotions of pain and longing, suffering and pleasure. They become part of a present that keeps looking back in time.

Performers keep music part of the present by resurrecting songs from the past, particularly as musicians emerged from prison or returned from exile. Public performances give voice to a community of resistance to authoritarian rule. For example, when the Grandmothers of the Plaza de Mayo commemorated their 25th anniversary, they invited protest singers from the 1970s to perform. The music was the backdrop of their struggle to search for their children and grand-children. It was the music their children had listened to before they were taken captive and disappeared. The music marked the time. And playing it again demonstrated that the dictatorship would not be forgotten and their hope that authoritarian rule would never happen again.

Songs that challenge authoritarianism are not performed only in societies enduring such rule. Political songs and their messages move from one society to another. The chant "*el pueblo unido jamás será vencido*" echoes around the globe in a variety of political situations. It is chanted in its original Spanish throughout Latin America at political rallies. But it is also translated, if awkwardly, into other languages. Its English variant — "The people united will never be divided" — is used in political rallies throughout the English-speaking world. Local

Lord Bless Africa

Lord, bless Africa
May her spirit rise high up
Hear thou our prayers
Lord bless us

Lord, bless Africa
May her spirit rise high up
Hear thou our prayers
Lord bless us Your family

CHORUS:
Descend, O Spirit
Descend, O Spirit
Lord bless us
Your family
(repeat)

Nkosi Sikelel' iAfrika

Nkosi, Sikelel' iAfrika,
Malupnakanyisw' udumo
lwayo;
Yizwa imithandazo yethu
Nkosi Sikelela,
Nkosi Sikelela,
Nkosi, Sikelel' iAfrika,
Malupnakanyisw' udumo
lwayo;
Yizwa imithandazo yethu
Nkosi Sikelela,
Nkosi Sikelela,
Woza Moya (woza, woza),
Woza Moya (woza, woza),
Woza Moya, Oyingcwele.
Usisikelele,
Thina lusapho lwayo.

Dancing Pollada Skirt (to Technocumbia Music)

Come and dance with the undesirables
Come and enjoy the unforgivable
Come and have fun at the miserable party
With handsome rapists, rich torturers
Hilarious beggars, funny assailants
Come and enjoy your danceable pollada skirt.

Eat your rage, eat your misery
Shut up and kiss your own ass
Open your legs and shake a little
Close your legs and swing a bit
Come and enjoy the miserable party
Come and chat with the undesirables.

Tell your mom, tell your dad
Bring your sisters and whomever you want
The miserable party is just about to start
Come and dance with the undesirables
Come and enjoy the unforgivable
Come and have fun in your dancing pollada skirt.

By Juan Luis Dammert Egoaguirre, 2000, Peru

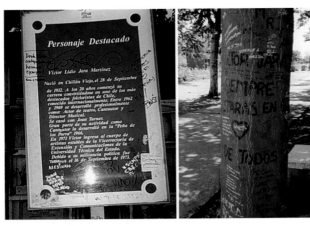

Visitors carve messages to Victor Jara in the tree in front of his grave, on a bench, and on the back of an information sign. *Source: Claudio Barrientos*

Sting performs with Mothers of the Plaza de Mayo in 1987. *Source: Plaza de Mayo,* vol. 18, n. 82, December 1991, p. 19.

languages, like Tagalog, have also taken up the chant: "Ang bayan na nagkakais·, hinding-hindi magagapí." Where these chants and songs come from are often not known to those who perform them. But at other times, their origin is their message. Protest songs by the assassinated Chilean songwriter and political activist, Victor Jara, for example, became popular in the Philippines both during and after the Marcos dictatorship, despite the government's efforts to silence the music.

International performers join communities in taking up the struggle against authoritarian rule and transforming opposition from the local to the global community. These songs persist beyond the period of the dictatorship through international CD sales, radio shows, and televised video clips. For example, pop star Sting, the rock band U2, and the cellist Yo-Yo Ma have all devoted music to mothers looking for their disappeared children. Sting's song, "They Dance Alone," was translated into Spanish as "Cueca sola," and when U2's lead singer, Bono, sang on stage at the Santiago, Chile, National Soccer Stadium in 1998, mothers holding photos of their disappeared children stood behind him.

Yo-Yo Ma dedicated his *Tango* CD to the mothers of the disappeared in Argentina.[2] International musical performances take up other themes of past repression as well. Peter Gabriel performed his song "Biko" at the unveiling of the monument to murdered anti-apartheid activist Steve Biko in East London on the 20th anniversary of his death.

Songs play with time, blurring the past and the present, the authoritarian period and beyond. In Brazil, the theme song for a soap opera on the student revolts of the 1960s, "Vale tudo," became part of the street protests against the democratically elected President Fernando Collor's corruption. Students and other young activists took to the streets singing the song "Brasil" as if they were resurrecting songs from the 1960s in their own protest. But the song was written in the 1980s, performed on television in the 1990s for a story about the 1960s.[3]

Reaching out to globalized youth cultures, musicians often borrow experiences from around the world to confront the past. Daniel and Ismael Serrano's song "Cuéntame otra vez" ("Tell Me Again") depicts a child's plea for a story about the past, but this time, the story is a sad one of all-too-common strife:

> Tell me again the pretty story of policemen, fascists and students.
> Daddy, tell me again the pretty story of the crazy guerilla they killed in Bolivia.
> Now the dead come, rotten from cruelty.
> Now they die in Bosnia
> those who died in Vietnam.

These songs also look at legacies of authoritarian pasts. Moving beyond authoritarian regimes' human rights violations, these new songs explore the enduring economic violence and political injustice that spawned liberation struggles and state repression to crush them. The hip, upbeat rhythm of the Natal (South African) singer Busi Mhlongo takes the troubles in the home as metaphor for the country and region at large in her 1998 Zulu-language song, "Awukho Umuzi Ongena Kukhuluma Kwawo" ("There Are Problems in Every Home"):

> Oh, my people! Family! Family was the core of heart's security and sense of belonging. Can you now look to your neighbor for help when the family pillar begins to chip and crumble? No! They, too, wear a mask of strained false contentment but cry for solutions to family troubles. On the streets, people take the lives of others, yet you remain silent. What holds your tongue? Your sisters and brothers across the borders, neighbors still, suffer tyranny, war, poverty and starvation. Yet you close your eyes to their faces of woe, close your ears to their lamentations of

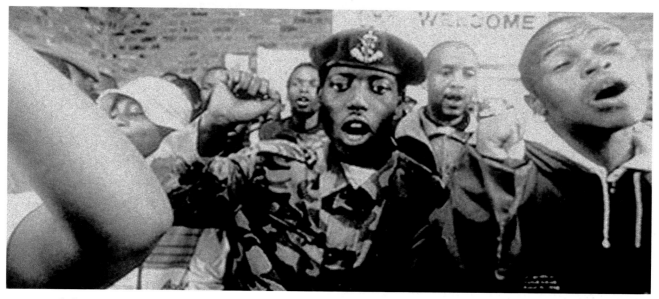

The Sowetan Community Choir, South Africa, in the film *Amandla! A Revolution in Four-Part Harmony*, directed by Lee Hirsch, 2002. Courtesy of Lion's Gate Films.

suffering, turn your backs to their hell, only to face the worries and pain in your own house and homeland. And where is your voice of intolerance to this reality?

Songs are seemingly fluid and portable. They can cross borders, be translated into many languages, change meanings, and span eras. Nourished by the spirit of solidarity among peoples suffering under authoritarianism, a resistance song is open to appropriation, adaptation, and reinvention. As a highly mobile form of truth-telling, songs are performed anywhere, individually or collectively, spontaneously or in organized fashion.

Music is often surrounded by controversy. Debates erupt over the performers and their interpretations, lyrics, and uses of song. Passionate fans on the left in the Philippines struggled to keep the Marcos regime from appropriating "Bayan Ko" as a symbol of its own. In Argentina, victims and survivors of the repressive regime questioned the performance by Carlos "La Mona" Jiménez of a song about the disappeared. Some disputed the music as too festive and popular a mode to remember the disappeared. Some doubted the performer's authenticity by questioning whether he had experienced personal loss, a

challenge that international singers such as Sting never faced. Critics also charged that La Mona Jiménez's lower class background and appeal made him unsuitable as a national and international representative for the disappeared.[4]

Song works as a form of truth-telling because of its great affective power. It can stir such intense emotions so as to bond people together and create among them a sense of shared identity. In the words of Argentine Bernardo Palombo of the group Canto Claro, songs can be likened to guns and flowers.[5] Where freedom of expression has been curtailed, song lyrics fire directly at authoritarian rule, exposing its true nature and thereby weakening it. But the songs are also roses offered to victims of violence and injustice, as well as assertions of the right of the poor to life and love. ∎

The cover of *Pagpupuyós* (Fire by Friction, Manila, 1981), the first, initially clandestine, cassette of Inang Laya (Liberated Motherland), an anti-Marcos women's folk group.

Ibong Malaya: Songs of Freedom and Struggle from Philippine Prisons (Hong Kong, 1981). The eagle and flag directly implicate the United States in the repressive Marcos regime. The eyes of the political prisoner look at *ibong malaya* (bird of freedom) flying over a musical score.

Exhuming Popular Memory

VICTORIA SANFORD

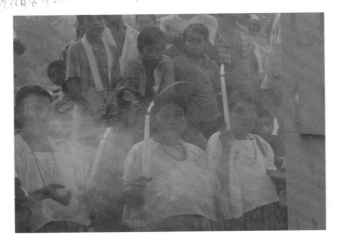

On May 28, 1998, twenty years after the Panzós massacre, I had the privilege of accompanying the Guatemalan Forensic Anthropology Foundation to return the boxed skeletal remains of the victims to their wives, mothers, fathers, daughters, sons, and grandchildren. This concluded the exhumation we began in September of 1997 for the Guatemalan Historical Clarification Commission to document the 1978 Guatemalan army massacre of Q'eqchi' Maya peasants in the plaza of Panzós.

As we entered Panzós, winding around the bend that passes the cemetery, there was chanting, applause and the honking of a hand-held horn. We were stopped in the middle of the road, surrounded by a cheering crowd. More than 400 people were waiting by the cemetery near the entrance to Panzós. Before we could take the bones to the municipal center to place them in coffins, the community wanted us to unload the cardboard boxes at the cemetery. Everyone wanted to help unload the trucks. The widows were laughing, smiling and crying. They embraced us. They kissed us. Each woman wanted to carry a box. The elder women performed a Mayan ritual until the sky opened in a heavy downpour.

In the rain, we all ran the half mile down the road to the church. The women ran with the boxes on their heads. When we reached the church, the women placed the 38 boxes at the altar. It did not seem to matter that the speakers were almost completely blocked out of sight by the boxes. Everyone was wringing the rain out of their skirts and shirts. Most everyone was smiling — even those with tears running down their faces. There was a collective sense of victory. These monolingual Q'eqchi' women had successfully stood up to those who threatened them, to those who killed their husbands, sons, fathers and brothers.

Several hours later, following survivor testimonies and a Catholic mass, the widows again insisted on carrying the boxes from the church to the municipal center. This procession was more than symbolic. The widows were carrying the remains of the victims across the plaza where the massacre had taken place. It was in this plaza 20 years earlier that several hundred Q'eqchi' peasants had gathered to protest the loss of their lands only to be greeted by machine-gun fire from the army. Like the exhumation, each step of the reburial ritual is at once a memorial to the victims and an act of empowerment for survivors.

Inside the center, the remains were transferred from boxes to small wooden coffins. The artifacts (clothing, shoes, personal items) were placed on top of the coffins to allow survivors an opportunity to identify a lost loved one. Though not scientific, these identifications are important to survivors because of their wish to carry the coffin of their loved one. The coffins were marked for burial the following day. As all of this was done, the widows performed a ritual for the deceased.

At six the next morning, some 1,000 people gathered outside Panzós at the site where the land protest had begun on May 29, 1978. Carrying the coffins, holding banners in memory

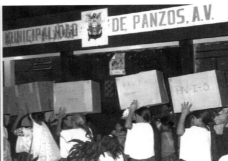
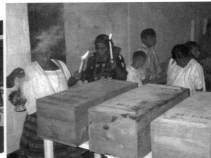

Source: Victoria Sanford

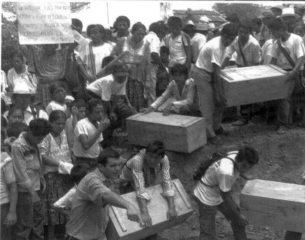

of the victims and proclaiming the rights of the Maya, the burial procession began at 10 a.m. For the next few hours, we slowly walked toward the center of Panzós in the harsh sun.

The participation of Maya beauty queens in the procession followed a community tradition of beauty queens speaking up for justice. On June 15, 1978, when Amalia Erondina Coy Pop was crowned Indigenous Queen of nearby San Cristóbal, she denounced the Panzós massacre, which had occurred just two weeks earlier. Her statements were not without impact or retribution. A group of local ladinos, angered that she did not give her speech in Spanish and furious that she had spoken about the Panzós massacre, pressured the mayor of San Cristóbal and the fair's beauty pageant committee to remove her title and crown.

When the burial procession reached Panzós, participants again filled the plaza where the massacre had taken place. For the next several hours in the searing heat, survivors gave testimonies, prayers were said, and calls for justice were made. Everyone was invited to speak.

By early afternoon, the procession slowly moved out of the plaza, down the street and up the hill to the cemetery.

After the holes were dug, the coffins were passed into the grave. Throughout the burial, signs denouncing repression were held and widows called for justice.

Throughout the burial, widows also continued their prayers for the husbands and sons they lost to the massacre two decades earlier.

The widows and survivors of the Panzós massacre organized their community to request an exhumation and ultimately succeeded not only in the exhumation, but also in the retaking of public spaces: the municipal plaza, the church, and the cemetery. As a community, survivors challenged these public spaces as mere reminders of Q'eqchi' loss and remade them into sites of popular memory contesting official stories. Further, these same survivors and widows seized the space they had created not only to publicly claim collective memory, but also to move forward with legal proceedings against the masterminds and perpetrators of the massacre.

Traces

JANET CHERRY

344 Strand Street, Sanlam Building, Steve Biko Building. Call it what you will, it is an innocuous, ugly old office block in downtown Port Elizabeth, on the south-eastern coast of South Africa. Opposite the railway station, the pavement in front is crowded with immigrants from other African countries, hawking counterfeit goods from wooden trestle-tables. A visitor can simply walk into Sanlam building, past a man who sits behind a desk, and into the cold, grubby foyer. If you look carefully, there is a crudely made sign behind the desk indicating "Steve Biko Building." Other than that, there is no indication of the historical significance of the building.

The building was owned by Sanlam, the big Afrikaans insurance company, and was used as Eastern Cape headquarters during the 1970s and early 1980s by the infamous Security Branch of the South African Police. It is an unassuming six-story office block. There is no visible sign that it was a place of terror. Indeed, it was not designed for that purpose, unlike the notorious Louis le Grange square which replaced it in 1985 as the venue for interrogation and torture in Port Elizabeth. Nowhere is it indicated that it was the place where at least two political detainees died in police custody or the place where two others were beaten, tortured, and subsequently died. These days, students rent the rooms on the sixth floor where the security police interrogated and tortured their captives.

Among those who care about such things, Port Elizabeth is known internationally for one thing only: as the place where Black Consciousness Movement leader Steve Biko died. It is commemorated in the Peter Gabriel song:

September 1977, Port Elizabeth weather fine
It was business as usual in police room 619…

This room is where Steve Biko's head was smashed into the wall, where he suffered brain damage before being shackled to an iron grid and left semi-conscious, before being put in the back of a police van and driven to Pretoria, where he died. Yet, the door has no number to indicate this, now. It is also possible to stand at the window of that room and imagine how Lungile Tabalaza felt before he fell to his death on the pavement below. To stand at the top of the stairwell in that same building and look down and imagine how George Botha fell to his death at the bottom of the stairs. Yet, none of these events of the period 1976–1978, carved into the minds of activists in Port Elizabeth, is commemorated here. Nor is the experience of the scores of activists who suffered torture here, including Siphiwo Mtimkulu, suffocated, shocked, and poisoned with thallium before being assassinated in 1982.

In 1997, on the 20th anniversary of Steve Biko's death, the Azanian People's Organization — the successor to Biko's Black Consciousness Movement — declared the building to be the Steve Biko Building and opened a memorial library. At present, a student occupies the room where Biko was brutally assaulted, a student who has no knowledge of these events, who has not even heard of Steve Biko or Lungile Tabalaza or George Botha. While currently there is nothing for visitors to the building to see or read about what happened there, it is hoped that in the future a human rights center and torture memorial will be established. One more way in which residents and visitors to Port Elizabeth will be reminded of some of the grimmest moments of our history, in the hope that similar events will never again occur.

Politics in the Raw

JELENA SUBOTIĆ

Source: Beogradski Sindikat

Serbian hip-hop band Beogradski Sindikat (Belgrade Cooperative) was founded in March 1999, when it brought together four rap/hip-hop groups, break dancers, and graffiti artists. The idea was to form a real hip-hop union – a cooperative and hence, the band name. Today, nine founding members still work under the name of Beogradski Sindikat, widely recognized as the most popular Serbian hip-hop band.

The main motto of Beogradski Sindikat is, as one of the members put it, "to nag at whatever we don't like." Seeing themselves as young, urban, working-class political commentators, the band uses the narrative hip-hop form to harshly criticize Serbian political and social environment. Their principal grudge against Serbian post-authoritarian government comes from a strong feeling of political disappointment, disillusionment, and cynicism. Instead of the strong, democratic, and economically successful Serbia they hoped for after the ouster of the authoritarian government in 2000, Beogradski Sindikat sees a country where only the "street names have changed." For them, rampant corruption and crime, and the disappearance of any social safety net signal the country's decline. Politicians, too, let down Serbs when they sugarcoat changes with liberal, "pro-Western" rhetoric: "Every morning when I read the papers, same old bullshit / I get sick to my stomach of all the monkey business / Fishy economics, all these changes are nothing but swindles."

For Beogradski Sindikat, everybody is a fair target, which is, in fact, their ultimate point. Nobody in post-authoritarian Serbia is of any worth or moral authority. Everybody is the same: corrupt politicians, neo-liberal economists, media moguls, and celebrities. "Let's go after everybody / The bosses who rule in tax-free channels / Who export weapons and raspberries / Happy bankers with electric guitars / Who are auctioning everything from the post office to cement factories."

Their populist message also deals with what they see is the wrong direction transitional Serbia is taking. Beogradski Sindikat attacks the cultural elite, human rights organizations, and gay rights activists. For Beogradski Sindikat, anti-nationalist activists and gay rights advocates are not unlike corrupt officials. They are fake, slimy, dishonest, and interested in nothing more than milking the West for grants and cash: "You're really cheeky, you embezzle funds / You talk empty words and keep double books / In the company of the cultural elite with the smile of a worm / You lie at business dinners / You pretend like you're English when the foreigners come / . . . / But you tolerate Croats and gay parades."

The message of Beogradski Sindikat is disturbing, as is their uncritical popular following. Yet, the hip-hop band truly represents all the contradictions characterizing post-authoritarian Serbia. Beogradski Sindikat fleshes out widespread citizen apathy and disenchantment with the process of transition. The crude, unpolished, and pungent lyrics point to the overwhelming feeling of disempowerment and lack of ownership in the political process. The scapegoating of minorities, gays, and their advocates is symptomatic of the more general social environment of severe economic hardship perceived as an imposition of Western neo-liberal policies and the government's uncritical "caving in" to unrelenting Western demands. It is this background against which Beogradski Sindikat has achieved mass popularity and almost cult-like status among urban youth. The power of their message is in raw populism, directed anger, and public derision. In cynical post-authoritarian Serbia, this message sells.

Moving images

KSENIJA BILBIJA AND TOMISLAV LONGINOVIĆ

The main character of Eliseo Subiela's 1989 Argentine film *The Last Images of a Shipwreck* says: "The mistake during all those years was to search for the great salvation." As the camera zooms out in the closing scene, the viewer sees the father addressing these words to his infant son. The newborn's body is shaped like a cross as it clings to his father, whose words he will never remember. "There is no such a thing. Great salvations do not exist."

Ultimas Imagenes del Naufragio

UN FILM DE ELISEO SUBIELA

Poster from the film *The Last Images of a Shipwreck* by Eliseo Subiela (Argentina, 1989).

Minnette Vári's REM

REM (rapid eye movement) is a physiological state during sleep most associated with dreaming. The figure in this piece is that of the South African artist, filmed while asleep. The phases where she was the most restless were selected, edited together and made to play in slow motion, looped indefinitely. All around her, images of historical and contemporary Southern Africa unfold: taken from post cards, newspapers, and books, historical, geographical, and political images of the last century: a hundred years of great change. The work engages the hopes and fears of those who have lived through the turmoil of an infamous history and now have to find the best possible future. *REM* can also be seen as a warning or omen communicated through a dream against the hubris of nations turning away from history in myopic negation.

Minnette Vári lives and works in Johannesburg, South Africa. Her work has included performance, sculpture, photography, and digital video, and it has been thematically linked to exhibitions and conferences exploring themes of identity, transition, politics, mythology, trauma, and history. Her most important exhibitions include Democracy's Images (Bildmuseet, Umeå, Sweden, 1998), Memorias Intimas Marcas (MuHKA, Antwerp, 1999), and Dislocación (Sala Rekalde, Bilbao, 2001). She was invited to participate in the 49th Venice Biennale in 2001. She has had solo shows in Johannesburg, Cape Town, Northampton (Massachusetts), and Zürich, and in 2004 she had her first exhibition at the Museum of Art in Luzern.

This one-way dialogue of disenchantment not only reflects the cinematic experience after the end of military dictatorship, but also marks the positioning of cinemas after authoritarianism across the globe. A century old, film retains its mass appeal. Although authoritarian regimes have often used the power of films to further their ideologies, post-dictatorship cinema has been used to voice the meaning and legacies of authoritarian rule and to envision alternative truths.

In South Africa, Ramadan Suleman, the director of the 1997 film *Fools* pleads for a better future for his people after the end of apartheid in similar terms: "They are not asking for the world, just for a drop of change!" For Suleman, it is the realm of small things in everyday life that needs to be recovered from authoritarian regimes that perpetrated so many crimes during the course of the 20th century. The political change *Fools* seeks reflects a loss of trust in the governments that used repression violently and arbitrarily to carry out their agendas, whether they be of the Left or the Right.

On the eastern periphery of Europe, Emir Kusturica uses the metaphor of the underground, the title of his 1995 film, to illustrate a split between two best friends and their families during and after the end of Titoism. One of the characters, Crni, is tricked into entering an abject underground cellar, a place where no time has lapsed since World War II. In the cellar, fascism has never ended and the trauma of Yugoslavia's treatment under fascism is still fresh. Crni's recurring cry of "you fascist motherfuckers" is aimed at the original fascists during the war, as well as to the ethnic enemies and the international community during the wars of Yugoslav succession from 1991 to 1995.

In Argentina, the metaphor of a dark and enclosed space shows up as an allegory for the most frightening of national fears, which are stored but yet can reappear at any time in any democratic situation. *Moebius*, the 1995 film by the Argentine Gustavo Mosquera, uses the disappearance of an underground train to remind viewers of the crimes that cannot remain stationed in the unconsciousness of the people. The train and its passengers stay forever in the system of underground rails as if on a Moebius strip, symbolic of crimes that may resurface at any moment in present-day Argentina.

Post-dictatorship film often portrays the blurred boundaries of guilt and responsibility as both individuals and societies must confront their moral failures. "We had to forget it all, as if nothing had happened," says a character in another post-dictatorship Argentine movie, *The Wall of Silence* (1993, Lita Stantic). The film concludes with yet another provocative statement: the claim that everybody knew what was happening during the dictatorship, and yet the majority remained silent. The question that the protagonist of Subiela's film asks with resignation, "Why did we let them mistreat us, why did we

accept this unhappiness?" could as well have been raised by one of Stantic's characters. It underlies an interiorized sense of guilt and opens for scrutiny public recognition of authoritarian evils.

Self-censorship that seemed like an adequate solution during the repression now comes back to haunt the minds of those who did not choose to leave the country and become exiles. As the protagonist's questions point out, the silent majority gradually accepted the rules of interior exile and lived a life of moral indifference. The silent majority's responsibility and behavior are also explored in the Argentine film *Olympus Garage* (Marco Bechis, 1999), where crimes happen in a garage, in yet another dark and enclosed space that haunts the society after the end of dictatorship.

One of the side effects of authoritarian rule is the emergence of the refugee, the exile, and the dissident. Those who are not willing or allowed to continue their lives inside the authoritarian system often find that they must move outside of the societies in which they have always lived. In doing so they are forced to negotiate between the foreignness of the adopted homeland and the memory of the native realm. The 1985 film *Tango: Gardel's Exile* by Fernando Solanas explores how Argentine intellectuals come to terms with their exile and the loss of the country by creating a hybrid performance – tanguedia – that reflects both the nostalgia for home and the horror of the Argentine authoritarian legacy. *Gringuito*, a 1998 film by Chilean director Sergio Castilla, also recounts the difficulties of the return and adjustment to post-dictatorship realities through the eyes of a boy for whom the idea of a homeland is not tied to Chile but to the country of his parents' exile, the United States. Jasmin Dizdar, on the other hand, portrays in his

Olympus Garage.

1999 film, *Beautiful People*, the destiny of Bosnian refugees in England. The title itself is ironic, since the film foregrounds the legacy of violence that the refugees seem to carry and spread like a virus in their host country. "Thank you for your hostility," mutters one of the characters in a tense social situation of meeting his British in-laws. The failure of linguistic translation, hostility instead of hospitality, is symptomatic of a cultural mistranslation as well: the refugee will always stay outside, and the beauty of people who do not belong by birth will remain farcical.

Ironically, the attempt of return to the native realm is as traumatic in Milčo Mančevski's 1995 film *Before the Rain*, where the plot revolves around a Pulitzer-prize winning photographer Alex Kirkoff who decides to return to his village in Macedonia. Confronted with the palpable ethnic tensions between the Macedonian Slavs and ethnic Albanians, he reaches for a memory chest filled with objects from the last years of Tito's Yugoslavia. As he smokes a cigarette from an old Drina pack, accompanied by the music of the Sarajevo band Indexi, the viewer is invited to participate in a ritual of mourning for all that Yugoslavia still means to those who did not witness its death from within. "I killed with a camera," Alex confesses while remembering his time as a war photographer in Bosnia. This statement suggests the complexity of identities of those who leave. Alex is based in London and works for the Western media industry. Metaphorically, he is playing the role of a native informant who is able to visually translate the despair and horror of a war-torn country to the Western viewer. How the West looks at societies undergoing violent change is also the subject of Michael Winterbottom's 1997 film *Welcome to Sarajevo*. An anonymous altar boy chased by an ITN media crew expresses a deep sense of

anxiety over being observed: "Why are you looking at me? Why are you following me? Why are you staring at me?" This explicit critique of the West and its peculiar form of political voyeurism is present in almost all the movies that tackled the problem of the post-Yugoslav authoritarianism.

While it is commonly held that communist political systems were steeped in totalitarianism, many films show a nostalgic longing for the days of stability and certitude in the face of the new ethnic authoritarianism and rampant capitalism. *Tito and Me*, a film by Goran Marković, portrays a bittersweet identification with Tito's cult of personality without any explicit critique of it. Released in 1992, as the war was spreading from Croatia to Bosnia, this movie offered cold comfort to the generations of Yugoslavs raised in the spirit of Titoist exaltation. Indeed, the cult of personality surrounding Tito makes him into a formidable film subject. *Tito for the Second Time among the Serbs*, a 1993 pseudo-documentary by Želimir Žilnik, presents an uncanny situation in which the long-dead father of the nation descends to the streets of Belgrade for a chat with passers-by. The crowd engages in a dialogue with a resurrected president, some longing for his rule, others blaming him for all the current problems. In the meantime, his political clones – Slobodan Milošević, Franjo Tudjman, Milan Kučan, Alija Izetbegović – drive the region into violence.

The Titoist legacy is also a subject of Srdjan Dragojević's 1996 film *Pretty Village, Pretty Flame*. The film is another pseudo-documentary about the inauguration of a brotherhood and unity tunnel in the mountains of Bosnia and Herzegovina. All the socialist iconography is present: a worker with a sledge hammer, Tito's pictures, cheerful pioneers and fat politicians with solemn gazes at a ribbon-cutting ceremony. The bulk of action takes place in the tunnel where Muslims have trapped a group of Serbs during the Bosnian

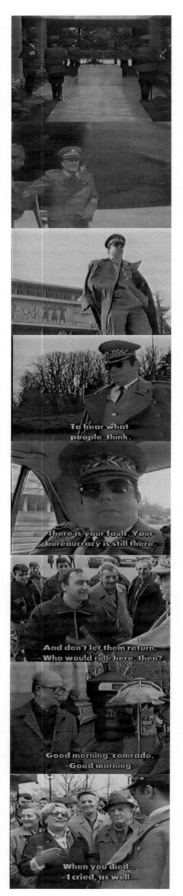

Tito for the Second Time among the Serbs.

war. The persistence of hatred and violence is tied with the legacy of Tito, whose images and name are repeated throughout the film. The movie ends with the reopening of the tunnel some fifty years later when global security forces of the UN and NATO have replaced the Socialist brotherhood and unity. Outsiders have become part of the physical landscape. One outsider, an American journalist, gets accidentally stuck with the Serbs in the tunnel surrounded by Bosnian Muslims. Trapped in a hostile environment, she slowly begins to desire to kill. As her wish grows, the violence and hatred are represented not only as endemic and natural, but contagious, too. The tunnel, just like the underground cellar or the subway featured in other films, becomes a space that can no longer hold back collective trauma.

The theme of excessive violence is a dominant characteristic of post-dictatorship cinemas around the globe, though it is not necessarily connected to authoritarian pasts. The collapse of the social system along with the impoverishment and ensuing disappearance of the middle class establishes new forms of social order, where marginalized characters come to the center of cinematic presentation. One such example, *Pizza, Booze, Smokes*, a 1997 Argentine film by Adrian Caetano and Bruno Stagnaro, focuses on the day-to-day survival of a dehumanized group of Buenos Aires youth; *Wounds*, a 1998 Yugoslav film by Srdjan Dragojević, is about coming of age in Belgrade during the transition from Tito's to Milošević's brands of authoritarianism; a 1998 Ukranian film by Vyacheslav Krishtofovich, *A Friend of the Deceased*, shows how the fabric of the old socialist system is torn by the new criminal gangs and professional killers. It is as if the weapons have been transferred from the authority of the state into the hands of those social elements that are most likely to use them to their advantage. Quite ironic, *A Friend of the Deceased* offers a picture of a society marked by the authoritarian past. "Before we had friend-

ships," a character comments. "Now we have business relationships." Paradoxically, the realities of market systems and the consequent alienation of post-dictatorship citizens now replace the solidarity forged during the Soviet regime.

Excessive violence destroys the very substance of human relationships. In the 1998 South African film *A Walk in the Night*, director Mickey Madodo Dube takes up Hamlet's tragic choice to reflect on the legacy of apartheid in the character of Mikey. The black man's own father is replaced by Uncle Doughty, an Irish drunk who befriends Mikey's mother. Communal violence is rooted in the deeply traumatized nature of identity borne out of racial division and oppression, with violence travelling from the white minority to the black community. A 1997 Russian film, *Brother* by Alexei Balabanov, is about the vigilante justice executed by a decommissioned soldier who comes to St. Petersburg, where his brother is a professional hitman. Unlike the previous films in this category, *Brother* is stripped of any moralizing and simplistic social messages.

A more critical look is presented in Janko Baljak's 1995 documentary *The Crime That Changed Serbia*. It features a group of tough guys who have grown up in Belgrade during the '90s, the Milošević years. In their testimonies the criminals themselves blame the war and the general militarization of society, as the viewer confronts the horror of random violence and organized crime in the wake of the breakdown of communism. By the end of the movie, all but one of the protagonists are executed in mutual turf wars. "Too many crocodiles in a small pond," concludes one of the interviewees, reaffirming both the dehumanization and the new predatory order established in the wake of past and current authoritarianisms. While this statement represents the war of Yugoslav succession, it also reflects a global new world order. Immersed in the constant struggle for resources, both the new political elites and tough guys with nothing to lose display a new form of predatory masculinity, a legacy of past authoritarianisms. Democratic change brings to the foreground men with guns who use excessive violence to achieve their aim.

Amnesia.

Violence is also treated from the side of the victim, although the extent of the victimization and its consequences vary. Documentaries, such as *Fernando Is Back* by Silvio Caiozzi (Chile, 1998), *Avellaneda's Land* by Daniele Incalcaterra (Argentina, 1993) and the 1999 BBC documentary *Srebrenica: A Cry From the Grave* by Leslie Woodhead, use a forensic form of narration with painful identification of the remains in depicting the mourning process of the families and friends of the disappeared and killed.

Those victims of the regime that managed to survive authoritarian repression are also portrayed in films that focus on the ethics of survival. Roman Polanski's 1994 feature film *Death and the Maiden*, based on Ariel Dorfman's play by the same name, is about justice and revenge. What should a victim of torture do if she thinks she has the torturer in her own house? Is she to take justice into her own hands or leave it to a society that would rather forget? *Amnesia* (1995, Gonzalo Justiniano) is another Chilean example in which a victim of Pinochet's dictatorship actually gets a chance within the new democratic government to take revenge against a cruel representative of the former regime.

The boundaries between victim and perpetrator of authoritarian violence are not always so clear. A documentary by the Chilean Carmen Castillo, (*Skinny Alejandra* 1994), raises the possibility of societal pardon for the victim of torture who became a collaborator of the authoritarian regime. Temptation to forgive is complicated because the collaborator betrayed the disappeared husband of the film director. The making of the film allows Carmen

Castillo to work through the trauma of her own shattered life as she tries to make sense of dictatorial power, while acknowledging the collaborator as another victim of the authoritarian regime. Frances Reid and Deborah Hoffmann's *Long Night's Journey Into Day* (South Africa, 2000) follows several Truth and Reconciliation Commission cases over a two-year period. Victims and perpetrators face each other in an effort to overcome the bitter legacy of apartheid. By examining the trauma from both sides of the racial divide, this film demonstrates that in order to heal, societies need to go through the painful process of truth-telling.

Though there are many different kinds of victims of authoritarian rule, several films — *Spoils of War* by the Argentine director David Blaustein (1999); *With These Eyes,* a 1997 Uruguayan documentary by Gonzalo Arijón and Virginia Martínez; and *Everyday Stories* by Andrés Haberger (Argentina, 2001) — explore what happens to babies born to the mothers held in captivity by military dictatorships. These movies look at the lost generation that was not able to make any choice regarding their heritage and parentage. The babies of the disappeared were conceived mostly by parents aware of the dangerous nature of their political ideas. The project of the torturers and their superiors was a form of political eugenics. Babies were handed over to families of government officials and business owners to "save" the future of the nation.

In contrast to the Oscar-winning feature film *The Official Story* by Luis Puenzo (Argentina, 1984), which offers a partly happy ending to the trauma of kidnapping and adopting children, these documentaries present a much bleaker vision. Today, more then 25 years after the dictatorships in Argentina and Uruguay have ended, the babies are students, workers, and professionals. They can speak for themselves and make their own decisions. These decisions are not always those that a viewer would consider a happy ending. Some children choose to separate from the families they always thought were their own blood, while others refuse to return to their birth families. As the film titles suggest, these youths truly are the war booty, the embodied legacy of authoritarianism.

The feature film *Welcome to Sarajevo* also raises the problem of orphans and their future in war-torn Bosnia and Herzegovina. Centered around a young girl in the Sarajevo orphanage, the plot questions the way in which the legacy of this city, at one point a showcase of European multiculturalism, is to be passed on. The girl ends up living with the family of a British reporter. When her birth mother turns out to be alive and finally has a chance to talk to her daughter on the phone, the girl refuses to speak her native language. Thus, once an orphan in Sarajevo, the girl now embraces her new identity. Because the traumas of victimization loom large, post-dictatorship films often leave open questions about the future of collective memory. Regardless of whether these films offer catharsis, they may act as a moral catalyst permitting societies often still in the throes of political uncertainty to explore many answers as to why repression occurred and to seek many paths of closure to that past. ◼

Skinny Alejandra.

Coming Back

CECILIA HERRERA

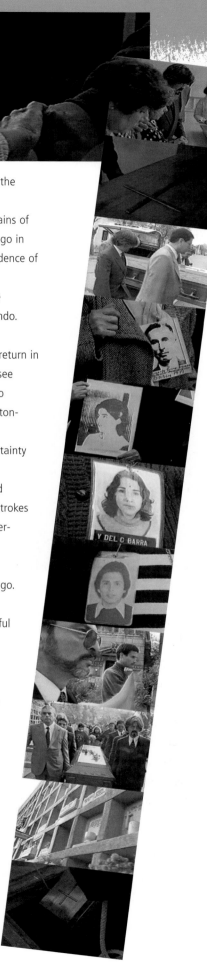

Fernando Is Back by Chilean director Silvio Caiozzi is a stunning documentary that examines the work of Chile's Forensic Identification Unit, specifically the endeavors of two women, a doctor and a medical anthropologist. The two use scientific methods to obtain definitive evidence so as to establish the identities of those who had disappeared.

Caiozzi's camera follows the forensic doctors in their efforts to positively identify the remains of Fernando Olivares Mori, found after excavations of Patio 29 in the General Cemetery of Santiago in 1991. He had been arrested, detained, and disappeared 25 years earlier. His body showed evidence of multiple fractures, torture, and several bullet wounds that ultimately caused his death.

Patricia Hernández and Isabel Rebeco, doctor and anthropologist respectively, analyze the remains until they conclude that the skull that was found four years earlier belonged to Fernando. They explain this finding to his wife, Agave Díaz.

Through the film's perfectly assembled scenes, one can witness the impact of Fernando's return in his family and the permanent mark that was left on them. It is overpowering, for example, to see Agave embracing her husband's skull while shedding a sea of tears. No words are necessary to empathize with the impotence of not knowing her husband's fate for such a long time. Yet, astonishing is the absence of rage and desire for revenge Agave shows under these circumstances. Moreover, she seems to be determined to close a circle, to escape from this limbo full of uncertainty and to be reborn.

Equally overwhelming is the presence of Fernando's mother. The depth of her sadness and suffering is more than apparent. She became physically ill after her son's disappearance. Two strokes paralyzed her body and she is not able to speak. She communicates using her daughter as interpreter. At this point in the film, in a close-up of her face the camera captures her murmurs, a perturbing mix of anger, disbelief, and helplessness. Her grandson, also named Fernando, later explains that his father was not the only one killed. His grandmother died with him 25 years ago.

All these testimonies not only portray the immense trauma experienced by Fernando's family, but also give us a glimpse into the sufferings of many other families who are still hopeful they will find traces of their relatives.

Indeed, one of the several themes addressed by Caiozzi is the legal status of the "disappeared." The term drips with vagueness. With no material proof of any death, legal pursuit makes no sense. At a family level, the consequences are quite dramatic. Life is torn between a faint hope and a fatal omen. The documentary successfully depicts this reality by showing viewers the relief experienced by Fernando's family after such a long and grievous wait. Now the family is finally able to have a proper funeral and to recover his lost history and identity. The scenes of a reunion where friends and family saying good-bye to Fernando while lighting candles end both the film and part of the history of the family Olivares Mori.

What is important about Silvio Caiozzi's documentary, *Fernando Is Back,* is that it gives the viewer a clear account of the impact of authoritarian regimes and the traumas originated by abuses of human rights, while providing the viewer a space for moral judgment, genuine empathy with the victims, and a sense of how collective memory shapes the present.

Alternate Visions

TOMISLAV LONGINOVIĆ

During the wars of Yugoslav succession (1991–1995) and the Kosovo intervention (1999), few in the media raised their voices against the blaring trumpets of local nationalism. One media alternative, Radio B-92, was a leader not just in professional news reporting, but also in its creation of a variety of documentaries and projects in the visual arts. Clashing authoritarianisms marked the years of 1991–2000: the old post-Tito Yugoslavia versus the rising star of the national scene incarnated in Slobodan Milošević. After the official ideology of interethnic tolerance and development of a mutual Yugoslav bond disintegrated into war with other ethnic groups, the cultural transformation of the visual space was also occupied with images of high patriotic value.

B-92 became almost a state of mind inside Milošević's Serbia. B-92 activists took on the burden of responsibility for a future Serbia they were trying to imagine as a peaceful part of Europe. By overcoming legacies of Titoism and Slobism, the authors engaged in visual productions that challenged the boundaries of the nation and race and gender. For example, Žilnik's feature film, *Marble Ass,* deals with the return of young soldiers from the war in Croatia, who are traumatized and prone to outbursts of violence. The surprise comes with the protagonist's partner, a transvestite who embraces love instead of violence, and in doing so reveals the wounded masculinity in need of love as a source of healing. The anti-war sentiment of

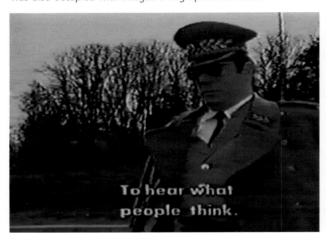

Tito for the Second Time among the Serbs.

Tito for the Second Time among the Serbs (1993), a film by Želimir Žilnik, takes one of the supreme icons, Tito in marshal's uniform, to confront the public with both the recent and the current life under the sway of father figures. Although ironic, this film requires an encounter with the past as it was produced for a Belgrade street audience. The film uses the format of a reality TV show to reintroduce the dead father of the Yugoslav nation to its national leftovers, mainly the Serbs. "How is it going?" asks Tito, with his typical paternal care. Most men challenge Tito's rule asking him about the health of Stalin and other dictatorial figures, while women tend to remember socialism with nostalgia, clinging to a memory of a secure past. Retirees carry on entire political tirades about the suffering of the Serbs under Tito's government, blaming the actor for all the past, present, and future disasters.

the film is complemented with the gender-bending performance of a real life Belgrade transvestite and male prostitute. The performance invokes images that were strictly taboo for the patriotic times of war and nationalism, images predicated on heroic masculinity embodied in the soldier, the policeman, and the gangster.

Janko Baljak's *The Crime That Changed Serbia* (1995) also documents how violence from "outside" ethnic conflicts, those in Croatia and Bosnia-Herzegovina, seep into the very close "inside" of Belgrade suburbs in the culture of criminal gangs. Following the life and death on the streets of the Serbian capital, this documentary features the changes in the appearance of the "Diesel Boys," a new breed of gangsters with short, paramilitary haircuts, heavy gold chains, and designer sweat suits. This side effect of transition, embodied in the overly masculine body of the

gangster, signals a new age of uncertainty after the end of the first wave of Yugoslav conflicts, when many in the international community still regarded Milošević as a guarantor of the Dayton peace accord. The small minority who profited from the war needed enforcers with this new image, boys who refused the miserable life under international economic sanctions and the encroaching poverty by taking up guns to get what they wanted. Hooked on the intensity of flouting the laws of civilization by murder and plunder, the new male stands in as the dark underside of the new political elites who remain in the shadows.

As political tensions rose during the Kosovo intervention in 1999, the Serbian government ordered B-92's closure as police occupied the premises and detained Veran Matić, the editor-in-chief. Confronted with the desperate situation, the station went underground and broadcast from a secret location. After the ensuing year of Milošević's rule, B-92 created its own television program to counter official propaganda emanating from TV Serbia channels. Focusing on the ethics of professional journalism the program began broadcasting spots in a series called "For Responsible Journalism." After the return of democratic institutions in 2000, this program tried to preserve the memory of the excesses from the Milošević years. One of the spots featured the invincible flying train, which was first broadcast by Bosnian-Serb TV as a war propaganda effort. The spot shows an excited journalist in front of this almost science-fiction invention explaining how the train will fly across enemy lines not unlike the vehicles of cartoon superheroes.

The disappearance of Ivan Stambolić, Milošević's predecessor as Serbian Communist Party leader, is also a recurrent topic of preserving memory of the previous repression.

The murder of the journalist Slavko Ćuruvija is remembered in another spot currently on B-92 TV. One of the most controversial videos produced in the post-Milošević period was Janko Baljak's *Anatomy of Pain 1* and *Anatomy of Pain 2*. Both documentaries show NATO's bombing of the TV Serbia building in which 16 civilians were killed. While the bombing of the non-military objects clearly represents a possible war crime, NATO maintains that it was a legitimate target. The documentaries focus on the responsibility of Bratislav Milanović and others who were informed of the attack ahead of time. The families of the survivors are asking why their loved ones were sacrificed, while the others were evacuated.

B-92, which now has its own TV station, has also secured exclusive rights for the live broadcast from the Hague War Crime Tribunal, featuring the former president as the main protagonist. This visual confrontation with a president turned prisoner creates an uncanny effect among Serbian audiences. Ratings soared at the opening of the trial, and they are still quite high when interesting witnesses testify. Otherwise, the Serbian public seems to believe that their former president will be found guilty no matter what and that watching the trial is a waste of time. Facing issues of responsibility for the war crimes and working towards reconciliation is one of the main agendas of future B-92 productions. During spring 2003, the station broadcasted the 10 installments of a serial, *Good People in a Time of Evil* (based on the book by Svetlana Broz), which depicts the efforts of civilians to help each other across ethnic lines during the Bosnian war.

The Crime That Changed Serbia.

Batas Militar

LIDY B. NACPIL

The Philippine documentary *Batas Militar,* or *Martial Law,* chronicles the history of President Ferdinand Marcos's dictatorial rule. Featuring more than 50 interviews with both the architects and victims of martial law, the controversial film uses photos, video footage, film, and television clips taken from both local and international sources to show the depths of Marcos's plunder and the courage of resistance. Produced by the Philippine-based Foundation for Worldwide People Power in 1997, the documentary is targeted to Philippine youth who may have forgotten or have never known of their country's tumultuous past.

Indeed, many young people say they possess few memories and little understanding of their country's past. In an on-line forum at the University of the Philippines, young people recount their memories of the Philippine dictatorship under the discussion rubric of *Mga gunita ng batas militar* (Memories of martial law). One political activist, Lidy Nacpil, recalls:

When Martial Law (ML) was declared in 1972, I was 12 years old and in first-year high school in UP. I didn't fully understand the implications of ML at that time. What was noticeable was, from a situation when there were frequent student demonstrations taking place (classes were always being suspended when I was in grade school in Manila), colorful posters and streamers on campus in UP, and lots of student activities, after ML was declared and after three weeks of suspended classes, we came back to a school that was strangely quiet and subdued. Sometime later, we heard some whispers that a few students from fourth-year high school were arrested. But this was never discussed aloud.

I belonged to what was called the Martial Law Babies. We were too young to remember clearly what society was like before ML. When we reached the age when we were supposed to be more aware of and care more about society beyond our immediate milieu of home, school, family, and friends, the Philippines was already under Martial Law. We were politicized in the late '70s, when the mass movement was already starting to regain ground, after the terror of the first few years of ML. It was then that we came to know more about the impact of ML – from the loss of basic democratic rights and freedoms, to the arrest of tens of thousands of people including very young students, to the tortures, disappearances, and savaging.

There are many things we take for granted now – democratic rights we were not able to exercise for many years under Martial Law. The right to information, the right to express opinions contrary to the "official" view, the right to criticize government and government policies, the right to your own beliefs, the right to organize and be part of an organization, the right to assemble and protest, the right to publish, to free press, and to disseminate public information, the right to student councils, to trade unions, to various forms of associations. These were democratic rights we regained by daring to go beyond the limits imposed by the dictatorship, by asserting, fighting, and struggling hard. These are democratic rights we could not have won without many sacrifices not only in terms of time, energy, and resources, but also more importantly in terms of futures and even of lives. Thousands dedicated their lives for freedom. Many students even gave up their studies to work for the democratic movement full time. Many experienced arrest and detention, some for a number of years. And many also died.

I hope remembering Martial Law and learning about ML (for those who are too young to have experienced even its last years) will never become a dull ritual. It is crucial for us to recall and learn vividly and sharply, the images, the sounds, passions, and most especially the lessons. Not just to give justice to the struggles and sacrifices, not just to give tribute to those who fought and especially to those who gave their lives, but most especially so that the experience will never be repeated.

Our generation and those who went through this period will be forever marked by the experience of ML. It will be hard for us to take our rights and freedoms for granted. It is our responsibility to teach the generations after us to value and cherish these freedoms. It is our responsibility to teach, motivate, and inspire them by our continued example, to resist when there are threats to take back these freedoms, and to continue to struggle as ours is not yet a truly democratic society.

Unfortunately, remembering and learning about ML is not just looking at the past; it is also an exercise of taking a critical look at the present. Our present bears the legacy of the ML experience with presidential decrees from that era still in effect in various forms, with continued militarization, with the strong and pervasive presence of the military in almost all aspects of society, with the government's quick and easy resort to bring in the police and military when there are problems to be solved. And our present suffers from the threat of the full return of Martial Law, perhaps in another form.

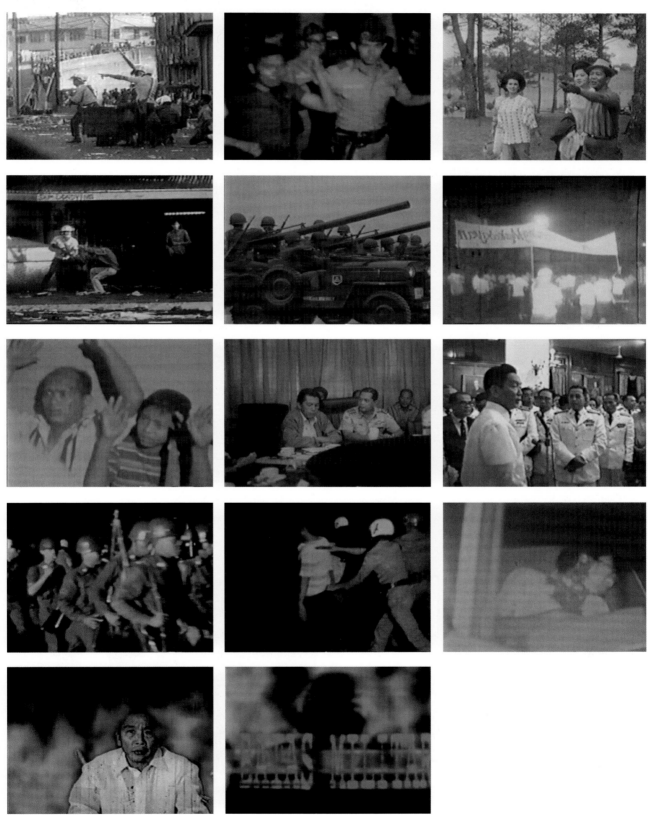

Source: The Foundation for Worldwide People Power

Humor that makes trouble

LEIGH A. PAYNE

Two Jews are about to enter the gas chamber in Auschwitz.
One of them turns to the SS guard to make a last request for a glass of water.
"Hymie," says his friend, "don't make trouble."[1]

Humor makes trouble. It makes trouble both for authoritarian regimes and for the political systems that replace them.

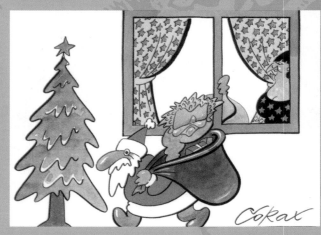

Former Yugoslav President Slobodan Milošević steals Santa's bag while his wife, Mira Marković, watches in compliance.

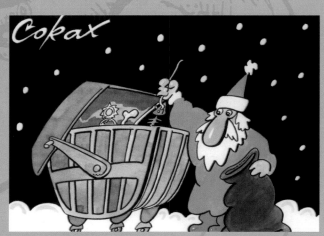

Even Santa Claus must dig through garbage to find goods in Milošević's regime.

A poster mounted in the Association of Families of Disappeared Detainees in Santiago, Chile in 1999 calls for the imprisonment of former dictator General Augusto Pinochet: "One more for the Punta Peuco jail."

There is a statue in East Berlin memorializing fallen soldiers of the Red Army during "The Great Patriotic War." Locals refer to it as: The Tomb of the Unknown Rapist.

Source: Anders Thorsell, www.ffagency.com

There are, of course, innumerable statues of Lenin throughout the former Soviet Union. One particular monument in a square in Kaunas, Lithuania has him standing in a heroic, patronly pose with one hand outstretched toward the people and the other resting behind his back. Repeatedly, militiamen have had to remove loaves of bread placed in the hand behind his back, and pieces of excrement placed in the hand outstretched toward the people.

The danger of humor for authoritarian regimes has even generated its own humor, as in this joke from the Soviet Union:

> Two Muscovites were discussing the prospects for intellectual freedom under the new General Secretary, Mikhail Gorbachev.
> "I hear he collects political jokes," said the first.
> "Not quite," said the second. "I hear he's just like his predecessors. He collects the jokesters."[2]

Because of its disruptive power, humor often evolves underground during authoritarian regimes. Intimate friends and kin share political jokes only in the safety of private conversations. Songs and skits mock the regime through disguise and veiled metaphors. Anti-regime cartoons circulate through clandestine social networks.

At the end of authoritarian periods, humor surfaces and voices out loud the criticisms of the old regimes. But unleashed political humor does not just attack the past authoritarian order. It also makes trouble for the transitional government. Anti-government jokes circulate in public. Newspapers publish political cartoons ridiculing the new political leaders and their decisions. Comedians taunt politicians on television, radio, and in clubs. Humorists even establish websites that deride the new regime. This humor at the expense of the transitional government comes not only from the old defenders of authoritarianism. Those who embrace democracy turn to humor to push transitional governments to further the goals of truth and justice.

The trouble humor makes for transitional governments stems from its truth-telling. Political humor tells a different version about the past, one denied by the old authoritarian forces. This truth makes trouble for transitional governments because humor ridicules them for upholding the authoritarian version of the past either through conviction, neutrality, or fear. By exposing transitional governments' failed efforts to bring truth, justice, and reconciliation for past crimes, humor's political role in this later period is almost indistinct from its authoritarian predecessor. Humor builds solidarity among an opposition, subverts government authority, and demands justice.

Solidarity humor unites individuals. During authoritarian periods, when overt forms of political union become dangerous, humor provides the means for people to identify themselves as part of the opposition. They discover through humor that they are not alone in opposing the regime and its acts. A social bond develops when individuals share anti-regime jokes, cartoons, skits, and ditties. Passive consumption of humor creates an outlet for oppositional political expression while simultaneously disguising the political intent behind the act. Solidarity humor, then, appeals to those who are actively engaged in politics, as well as to those who have become alienated from political life out of fear or disillusionment or both.

Milan Kundera illustrates the power of solidarity humor in *The*

Joke, his novel about life in Communist Czechoslovakia. In one scene the black insignia group (non-Party soldiers) are forced into a relay race with their Party commanders. They agree among themselves to spoil the race by trying to lose, but they hide that goal behind feigned effort. While they appear to be struggling to win, they happily fall behind. This joke, at the expense of their commanders, strengthens the unity within the black insignia group, which Kundera makes obvious through the character of Alexej. In his effort to distinguish himself from the black insignia group and please the commanding officers, Alexej refuses to play along with the joke and instead runs the relay seriously. The commanders single Alexej out for particular punishment, costing him not only the recognition he sought, but also his chance at playful solidarity against tyrants.[3]

Solidarity against authoritarian regimes, like that forged within the black insignia, lingers after the authoritarian regime ends. At least some part of the opposition remains vigilant against the authoritarian forces that do not disappear but hide, sometimes under new democratic guises. A Chilean cartoon shows the depth and endurance of authoritarian political identities. A traveler is asked whether he would like to be seated in the pro-Pinochet or anti-Pinochet section of the plane, calling on him to make clear his own political alliances and comfort level after the dictatorship. Solidarity humor provides the means to maintain oppositional identities beyond the authoritarian period. A bond forms around how the past will be remembered and how accounts will be settled with that past. Identifying oneself with the opposition during the post-authoritarian period indicates a desire to remain vigilant against future threats of authoritarian overthrow.

To build solidarity, this form of humor emphasizes the power of authoritarian regimes and the need for opposition. Authoritarian leaders are caricatured by their excesses and obsessions, particularly their violence and corruption. This joke from the Nazi era, typifies the kind of humor generated about the immorality of authoritarian leaders:

Candidate for Chilean presidency with a reluctance to admit connection to Pinochet says:
— A ticket, please.
Smoking or non-smoking section?
— Non-smoking.
Pro-Pinochet or anti-Pinochet section?

A roundtable sponsored by the new Chilean democratic government brings sectors of the community together to chart the path to democracy, but Justice is left out of the discussion.

"So? How about a second set?" Justice asks former Chilean dictator Augusto Pinochet.

The Senator states: "I repeat, I have never tried to influence the judiciary."

"Political responsibility, yes. Penal responsibility, no. How was I to know what was going on behind my back?" asks former Chilean dictator Augusto Pinochet.

Former Chilean dictator Augusto Pinochet, his armed security agents, and the words "hurray for change," cynically capture the continued control over the political transition by old authoritarian forces.

Chilean politicians attempt to spell "transition" and "reconciliation" with too few blocks and behind a wall keeping civil society out of the process.

Hitler wants to know what kind of weather there is in Heaven, and he sends Goering to St. Peter. When Hermann does not return, Hitler sends Goebbels up too. Josef does not come back either. Now Hitler goes himself and asks what happened to Goering and Goebbels.

"I sent them to Hell," St. Peter declares.

"But why?"

"Goering stole one of my stars immediately and Goebbels seduced one of my angels."[4]

These images of omnipotent authoritarian leaders remain after the end of authoritarian rule. In Chile, for example, jokes and cartoons continue to depict the former dictator, General Augusto Pinochet, as all-powerful. In one cartoon Pinochet has his back to a lever on a torture machine that he is operating, while claiming that he cannot be held responsible for the things that went on behind his back. Such humor allows for individuals to unite in their opposition to Pinochet, not only as a political identity from the past, but as part of the *Nunca Más* project, vigilance against future authoritarianisms.

Subversive humor raises the ante by making humor a political act that undermines government authority. Subversive humor under authoritarian rule provides people a forum to express political opinions that are otherwise censored by the authoritarian regime. When direct political action is too dangerous, humor may become a way to "do politics" by other means. "Gallows humor," like the joke that opens this essay, circulates within and about life in concentration camps, prisons, and repressive regimes. It becomes a way to laugh at authority and, by so doing, reducing its power. Subversive humor, therefore, depicts authoritarian leaders as powerful but bungling. It finds the humorous chink in the authoritarian armor. This joke from the Soviet Union illustrates the irony of rule by repressive numbskulls:

The head of the South African Truth and Reconciliation Commission, Archbishop Desmond Tutu, leads a victim, a perpetrator, and the press corps on a mapped-out route to truth, but a precipice prevents them from reaching reconciliation.

A citizen was running through the streets of Leningrad shouting, "Chernenko is an idiot! Chernenko is an idiot!" He was immediately apprehended.

> *The People's Court sentenced him to 23 years in a labor camp.*
> *"Why 23 years?" the perplexed citizen asked. "The sentence for slander is only three years."*
> *Three years for slander," the Prosecutor replied, "and 20 years for revealing a state secret."* [5]

Subversive humor at the end of authoritarian rule continues to undermine the strength of former dictators and their entourage. But wit also turns against the transitional governments whose unwillingness or incapacity prevents them from stripping authoritarian forces of their power. In a political cartoon from Chile a truck with a bumper sticker heralding political change harbors ex-dictator General Pinochet safely inside while his security guards remain vigilant outside. The cartoon questions the capacity or willingness of the democratic government to change anything but political labels.

Subversive humor attacks the transitional government's capacity to settle accounts with the past. A Chilean cartoon depicts the democratic government as incapable of working together to spell the words TRANSITION and RECONCILIATION, much less implement those processes. A South African cartoon portrays the Truth and Reconciliation Commission as having arrived at truth, but without any means of bridging the chasm to reach reconciliation.

***Vigilante humor* advances popular justice in retribution for authoritarian crimes.** It enacts public judgment and sentencing through rhetorical, illustrative, and performative humor generated by and for those excluded from political power. In the authoritarian era, it indicts regimes for illegal acts, including murder and cover-up as in this joke from the Soviet Union:

> *"How did the poet Mayakovsky die?"*
> *"Suicide."*
> *"What were his last words?"*
> *"Don't shoot, comrades!"* [6]

But it also portrays acts of symbolic justice meted out by powerless individuals, even if only apocryphal. This joke from the Soviet Union illustrates that kind of "active popular justice" through humor:

> *In yet another paean to himself, Stalin ordered the printing of a postage stamp bearing his image. He instructed that no expense be spared and that the best materials be used. Soon, however, complaints filtered back that the new stamps were not sticking to envelopes. Stalin was furious and ordered an immediate investigation. After a short time the secret police reported back to him. "Tovarish Stalin," a commissar said humbly. "The stamps are in excellent condition. The glue is of the highest quality. The problem is that people are spitting on the wrong side."* [7]

While we were in we thought we would check his [Pinochet's] conscience, but we couldn't find it.

Vreme, 30. XI 1992.

PREDRAG KORAKSIĆ

The travesty of Yugoslav justice during Milošević's regime is personified by a pirate who carries a truncheon to reinforce the scales.

Opinion Today – April 12, 1999.

The plight of apartheid's victims in post-apartheid South Africa is aggravated by the lack of funds available for reparations from the Truth and Reconciliation Commission. *Zapiro.*

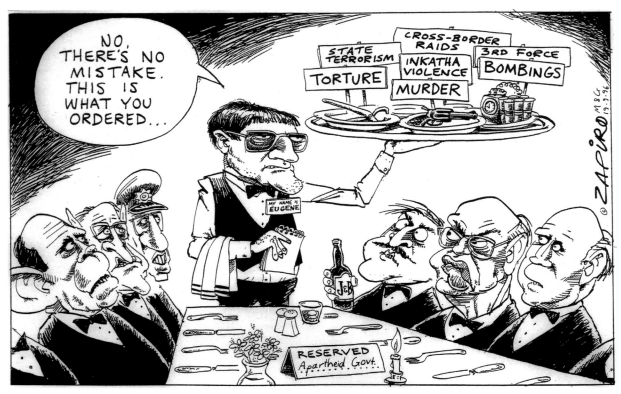

South African policeman Eugene de Kock, known as "Prime Evil" for his torture and murder, serves up the orders he received from the apartheid era State Security Council.

Two ostriches, representing the dictatorship of Ferdinand Marcos and the democratic government that followed it, bury their heads during "exploratory talks," a commentary on their lack of willingness to see the truth. *Manila Times*, October 11, 1998.

In the aftermath of martial law in the Philippines, Justice is depicted as blindfolded and maimed. *Manila Times*, October 8, 1998.

At the end of the authoritarian order, humor castigates former authoritarian leaders for their violence and corruption. A cartoon from post-dictatorship Chile, for example, shows surgeons searching in vain for Pinochet's conscience. A South African cartoon depicts a perpetrator as a waiter serving up torture, murder, bombings, etc., to his commanders and stating that he is certain this is what they ordered.

Vigilante humor also indicts transitional governments for protecting authoritarian crimes through their own complicity or inaction. A cartoon, for example, portrays the democratic government in the Philippines as helping Imelda Marcos escape justice with her ill-gotten gains. A cartoon from South Africa mocks the Truth and Reconciliation Commission's amnesty process by depicting a famous perpetrator swearing that he will provide as much information as necessary to keep him out of jail.

The twisted treatment of victims of authoritarian rule further challenges transitional governments' justice. A cartoon shows a wounded victim of apartheid stating that he would gladly accept symbolic reparations, instead of financial ones, if he also receives symbolic medical bills. Another South African cartoon evokes a world upside down in which perpetrators appear in the Truth and Reconciliation Commission as victims of the apartheid era.

In the absence of any, or any effective, institutional efforts to settle accounts with the past, vigilante humor may become the only form of justice, albeit symbolic. Not surprisingly, much humor emerges around the absence of justice. A cartoon from the Philippines provides an example. In it, justice falls apart with the acquittal of Ferdinand Marcos. Portraying the transitional government as an ostrich hiding its head in the sand to avoid knowing or doing anything about past crimes provides an effective metaphor for vigilante humor.

Despite these three important ways that humor makes trouble for politics, humor has its limits. It is rightly termed "a weapon of the weak,"[8] but it is a fairly weak weapon, unable to deal the fatal blow to authoritarian regimes or definitively alter the practices of the transitional governments to settle past accounts. Humor is storytelling that has the potential of creating solidarity, subverting political power, and meting out symbolic justice.

Like other stories, humor migrates to various audiences to make political commentary. It travels within countries from authoritarian periods to transitional governments. This recycling is evident in the following jokes told during two different political moments in Yugoslavia:

When Tito died, the state organized a ceremony in which citizens waited in line to pay respects to his body. A man approached the line and asked the first person he encountered: "What are you in line for? Are they selling something here? What are they selling?"

"No, man," responded one woman, "Don't you know? Our President has died. We are waiting our turn to pay our respects."

"Oh, I understand," said the fellow. But he walked a hundred meters down the line and asked the same question: "Why are you standing in line? Are you waiting to buy something?"

Again, he got the same answer about Tito's death. But this didn't end his questioning. He kept moving down the line and every hundred meters would ask the same question and get the same answer. Finally someone realized what he was doing and said, "Are you mad? We have told you over and over again that Tito has died."

"No, I'm not mad," he replied. "I'm just very happy to hear it."

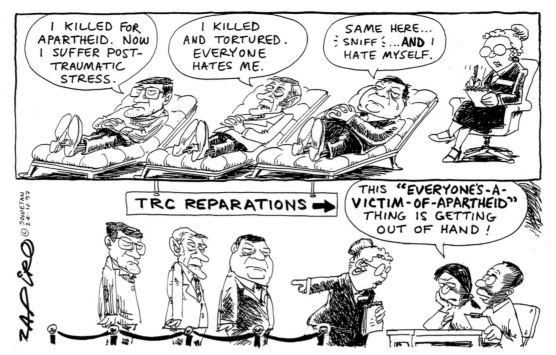

Apartheid's perpetrators Eugene de Kock, Gideon Nieuwoudt, and Jeffrey Benzien make a farce of the Truth Commission's victim hearings by claiming victim status.

At the time of Croatian president Franjo Tudjman's death, a man tried to get to the coast for a little rest and relaxation. But he was stopped at the Croatian border. He explained that he was trying to get to the beach.

"I'm sorry, sir," said the customs official. "We're closed today and you will not be able to cross the border."

"Why are you closed?" asked the traveler.

"Our president has died and this is a day of national mourning."

"Oh, I understand," said the traveler. And he left. But only five minutes later he returned and tried again to cross the border. He received the same news that the border was closed due to Tudjman's death. But this didn't stop him; he kept returning, receiving the same news, and was turned away. Finally, after the fourth or fifth attempt to cross the border, the customs officials realized they were speaking to the same person.

"Are you mad?" they asked, "We've already told you that we are closed to mourn our deceased president."

"No, I'm not mad," the traveler replied. "I'm just glad to hear it."[9]

Humor also travels between countries, even those with different political histories, as these two jokes from the Soviet Union and Egypt illustrate:

Khruschev was furious with the joke tellers:

"It's a disgrace! Jokes and then more jokes! Who makes them up? Bring me just one joke writer!"

They bring a joke writer to him. The joke writer pauses in the doorway of Khruschev's home and looks around, with great admiration.

"What are you looking for?" Khruschev asks him.

"I'm just looking. I see that you don't live too badly."

"Well what of it? In twenty years we'll have Communism and everybody will live like this!" says Khruschev.

"Aha!" says the joke writer. "A new joke!"

President Nasser was furious when some of the "nuktas" (jokes) making their rounds reached him.

"Track down the author of these stories," he shouts to his security guards. Soon enough a frail old man is brought before the president.

"Aren't you ashamed of spreading these lying jokes about your country and your president? Isn't it unbecoming in a man of your years?"

The old man said nothing.

"Here I am, trying to build this wonderful country, instituting agrarian reform, spreading the rule of law, fighting for justice, for equality, for the happiness of all our people. . . ."

The old man interrupts him:

"Excuse me, Mr. President, but I swear to Allah that that joke isn't mine."

When humor travels through time and place, it takes on very local and temporal flavors. Sometimes this humor becomes unintelligible to those unfamiliar with the political nuances of the moment. When the Philippine supporters of People Power II told the familiar "Why does the chicken cross the road?" joke, it included the usual replies from notable international figures like Aristotle ("It is the nature of chickens to cross roads."), Marx ("To help liberate the animal working class and fulfill a historical inevitability."), and

Martin Luther King Jr. ("I envision a world where all chickens will be free to cross roads without having their motives called into question."). The Philippine version of the joke injected a response from its own notorious president, the democratically elected and subsequently ousted corrupt Erap. But the response makes no sense to those unfamiliar with the details of the president's demise: "To prove that my chicken can lay golden eggs, why do I need jueteng money? Note that Lucio Co.'s Duty Free gets very cheap chicken parts from the US." The joke also included responses from figures unknown to those who have not closely followed recent Filipino political events, for example Chief Justice Hilario Davide ("Unless there is an objection, the chicken can cross that road.").[10]

Humor is a pliant political weapon that circulates and makes trouble for any regime it encounters. It tells truths about political affairs in a way that renders them funny. These truths percolate from below; they are not official truths generated by governments or political institutions. Citizens generate jokes, cartoons, and comedy; governments are the brunt of them. Humor speaks a truth silenced by official channels. It raises a mirror on society that reflects an image very different from the one promoted by the old authoritarian order and its transitional successor. Humor cannot and should not replace politics; it adds to, enhances, and embellishes politics. It confirms opinions already circulating — although not among the powerful in society. Ultimately, humor gives voice to individuals and ideas excluded from the official political discourse. It is a way of making trouble, doing politics, by other means: an alternative form of truth-telling. ■

I will make you out to be the fool, PW

OPEN LETTER TO PW BOTHA

Your re-appearance on the national and international news is like a recurring nightmare.

I spent most of the 1980s studying your face, your mannerism and sharp tongue. I knew that face very well. It was my Bread and Botha.

I saw your first stroke in the mid-80s before it became the stutter of rumor. Your second stroke — or was it your fifth? — in 1989 took you out of my chorusline and made way for FW de Klerk. Someone, you will be happy to know, I couldn't come to grips with, satirically speaking. I left a blank space and people laughed at that.

But here you are back again. And with a vengeance. With the same wagging finger and the same lolling tongue, although in all fairness to your age and fragility, they are not always in the right places as in the old days of your *kragdadigheid*.

Imprisonment

I'm very sorry to see you in court. I think you deserve imprisonment without trial, as you so lavishly decreed during the 1980s. But then being a sentimental Afrikaner performer, I see you as a relic from a successful show, long ago packed away with Vorster's golf cap and Verwoerd's guile.

"Love your enemy: it will ruin his reputation!" It works. The Truth and Reconciliation Commission (TRC) is a living example of the folly of forgiveness.

For there was a time when people feared you.

There was a time when you were all-powerful.

Demolishing hope

You could demolish hope and you did. You could rewrite the alphabet of logic and you did.

I think the TRC has made a mistake by playing your game.

They should have taken your trite refusal to appear in front of them as an admission of guilt.

Anger is never an answer to the question: "How does he get away with it?" Humor is the only weapon left and it is with that weapon you will be felled.

…

You owe it to history to leave the political stage as a professional and not a fool. Because if I have my way — and I can now, because you and yours are no longer here to stop me as you tried — I will make you out to be the fool.

I will make people laugh at you. I will remind the world that what you did for South Africa was just a small crime committed by a small man. A bizarre footnote to our history: "PW Botha: ambitious, greedy, arrogant!"

So welcome back to the chorusline, Ou Krokodil. It is 10 years since I last did you on stage as an item of real news.

Source: Benny Gool

Ironically, as they warned me in the 1980s, I've ended up even looking like you!

But my offer still stands: I'll go in your place to the TRC in my PW-hat and glasses and at least you'll make the cartoon pages as a joke.

And not the editorials as a loser. Or the obscene graffiti on lavatory walls where old farts belong.

PIETER-DIRK UYS
Darling, Western Cape
Sowetan, April 22, 1998.

Pieter-Dirk Uys is an actor, comedian, satirist, author, and playwright. He has written more than thirty-five plays, published fifteen books and plays, and produced more than thirty videos. His plays have been performed throughout Africa, the United States, and Great Britain. He is perhaps best known for his character of the outspoken Boer "Ambassador without Portfolio" Evita, a one man-woman satirist show and political commentary, which won him Women's International Center Legacy Award for being a Renaissance man.

Teasing Out the Truth
The Work of Zapiro

JONATHAN SHAPIRO

Excerpt from Truths Drawn in Jest, *pp. 154–155; Wilhelm Verwoerd and Mahlubi "Chief" Mabizela, eds. (Cape Town: David Philip, 2000)*

I think a cartoon can be many, many different things. The easiest kind of cartoon to do is the kind where you wake up in the morning, you are outraged by something you hear on the news – so you have a subject and a strong passionate feeling about it. There is, furthermore, an angle to that subject that you are able to take, and you have a device, a metaphor whereby you are able to show all the things that you are feeling. If you have all these elements in place you can really satirize or attack something in a cunning sort of way and make an interesting connection for the reader. This is the easiest and best kind of satirical cartooning.

When you don't have all these elements in place there are different ways a cartoon can go. When you are not 100 percent passionate about a subject, because it is very complicated, when you are not necessarily attacking something, but showing the poignancy or the contradictions or the dilemmas people face when they are trying to do something as difficult as the Truth Commission has been doing, that leads to a different kind of cartooning. The one cartoon that comes to mind is where I had Tutu coming up to the top of this cliff. He had this map in his hand, and they have managed to get to a certain element of truth, but I show the victim and the perpetrator with unhappy expressions. There are all sorts of nuances to this cartoon. So you've got the truth of the one side, they haven't been able to get to reconciliation, and there is this kind of "oops" situation. It is a dilemma, and the cartoon is showing some empathy with the process, but also some analysis and nuance. It does becoome a different form of cartooning. This form is unique to the TRC process – there are often situations all over the world where cartoonists have to get to these things if they are the kind of cartoonists who are trying to search for interesting meanings.[1]

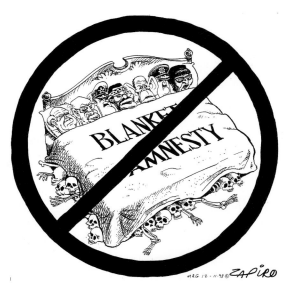

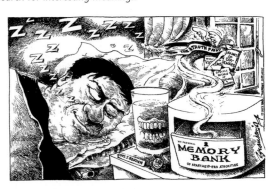

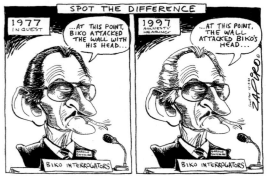

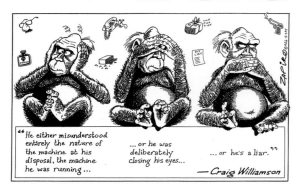

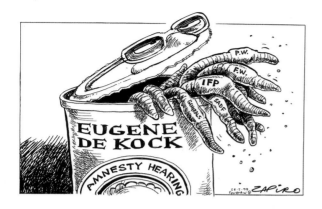

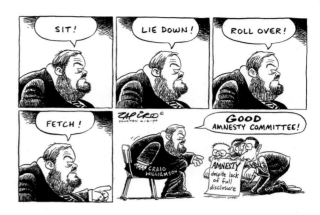

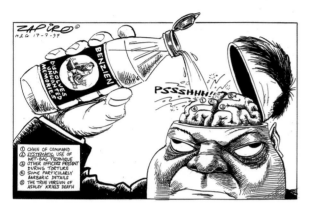

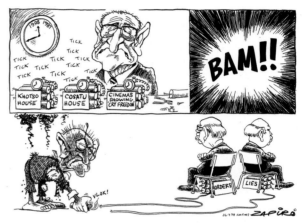

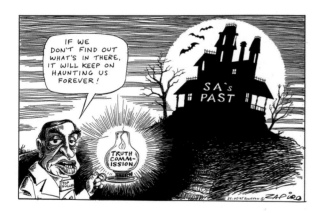

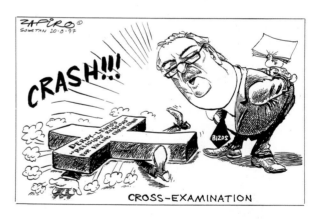

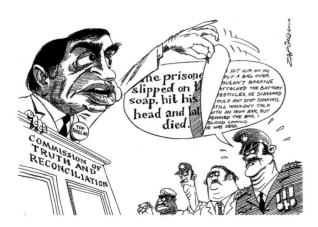

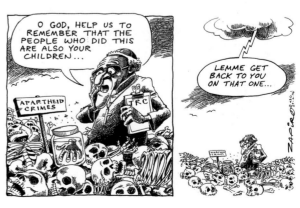

Laughing at Power
The Work of Corax (Predrag Koraksić)

JELENA SUBOTIĆ

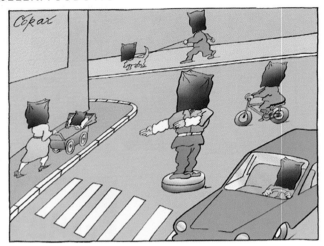

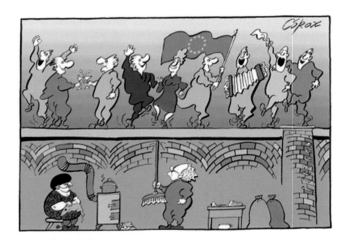

Predrag Koraksić, or Corax (born 1933), has been a professional cartoonist since 1950. He worked for a number of Serbian newspapers and magazines, most recently for the important Belgrade publications *Danas* and *Vreme*. He is also the author of nine books of cartoons and has exhibited extensively in Yugoslavia and internationally. Corax is widely regarded as the finest Serbian political cartoonist. His sharp, cynical, and extremely funny political commentaries have made him immensely popular over the years. During mass anti-Milošević civic protests in Serbia in 1996–1997, quite a few protest banners called for "Corax for President!"

What made Corax's cartoons so appealing to the Serbian public was his emphasis on the grotesqueness and personal vulnerabilities of former Serbian authoritarian leaders — Slobodan Milošević, his wife, and the couple's closest entourage. By persistently portraying them as power-hungry, security obsessed, irrational, cowardly, and paranoid, Corax's images refused to reify the oppressive regime and surrender in apathy and disillusionment. They provided an immediate, visual avenue for the mobilization of popular dissent, protest, and challenges to authoritarianism.

The enduring success of Corax's cartoons also lies in the uncompromising criticism he directs at absolutely all participants in the political arena. His most sustained and devastating critique has, of course, been directed at the former Serbian authoritarian establishment, but even after the change in regime Corax relentlessly continues to comment on Serbia's painful and troublesome political transition. By taking on pressing current issues such as bitter political fragmentation, denials of war crimes, breakdown of the separation of church and state, rise of intolerance, and criminalization in Serbian society, Corax remains a superb and irreplaceable commentator on Serbian politics and society.

Seriously Funny

ERICA NATHAN

To draw or not to draw? This question is one of many that Miguel Repiso, an Argentine illustrator and graphic humorist asked himself after the fall of Argentina's most repressive authoritarian regime. Following 1983, as news of the horrific events of the country's Dirty War slowly began to unfold, Repiso, or Rep, found it difficult to use comics, his usual mode of communication, despite the lifting of censorship. He wondered whether this genre could ever be considered appropriate for the treatment of such an extreme topic.

One of Rep's drawings poses this question but does not seem to be able to provide an answer. He captions the illustration "Dilemma for humorists: Can humor be made with the desaparecidos?" The cartoon shows two mothers as Mothers of the Plaza de Mayo with pictures of the children around their necks and the symbolic white shawls on their heads. The two women look with anguish into the dark, black sky for their own answers to the whereabouts of their loved ones, as they circle the Plaza on what appear to be wheels, possibly indicating the almost robotic, routine Thursday walks. Rep directs this question to himself as a humorist, while simultaneously presenting it to his entire audience: will they accept this drawing, the artist's rendition of this topic? *Can* humor be made in the case of the desaparecidos?

Similarly, the legacies of authoritarianism manifest in other Argentine graphic humorists after the advent of democracy exhibit themes that allude to the magnitude of the military rule. They, too, display a careful, fragile tone, respectful of the immature democracy still in the process of formation. One such humorist is Joaquín Salvador Lavado, otherwise known as Quino, author of the world famous character, Mafalda. After returning to Argentina from exile in Italy, he produced a book of drawings in 1983, titled *Let Me Invent*.[1] The title itself can be seen as a reaction to his resumed artistic freedom, which becomes even more evident when perusing the book. The reader immediately notices the multiple effects of military rule in this collection, including themes that express the loss of freedom of choice and intellectual liberty, the inability to produce change in one's society and the double voice that the reader recognizes as a stamp of authoritarian government.

In one particular drawing we can see the need to hide ideas outside of the "norm." Quino presents four strips in this comic that reveal the norm as square and rigid. In strips one and two, all the members of this society, with one exception, converse in square language, receive their radio and newspaper information in square messages, and read square billboard advertisements

throughout their daily routine. In the third strip, Quino shows the non-conforming individual secretly communicating with a suspicious man dressed in black, reaching into his pocket, we assume for money, in exchange for a mysterious case. It appears as though he is motivated to hurry home for fear of being caught.

As soon as he is safely locked inside, he throws himself onto the floor to allow the circles, the "abnormal," to flow out. The content of the secret case is revealed: a compass with which he draws circles as fast as he can, seen in the numerous papers surrounding him. This sense of fear is a characteristic of the earlier authoritarian period. The nonconformist needs to flee from the rigid, square environment, emblematic of the military world to be able to feel human or "round" once again.

Another renowned Argentine cartoonist, Roberto Fontanarrosa illustrated many immediate remnants of authoritarianism in his 1983 compilation of comic drawings, *Fontanarrosa and Politics*. Similar to Quino's work, the topics in this book refer to the country's previous brutal events but have been softened to accommodate the country's frail democracy. One frequent theme deals with the lack of honesty and the insignificant value placed on truth in the Argentine society. Lying is passed on from generation to generation:

I had taught my son that it's not enough to be honest. You also have to appear like it. But now I have told him that it's not important to be honest. It is enough to seem like it.[2]

This comic can be read as evidence of the societal attitude after the military dictatorship. The speaker suggests a lack of honesty on the part of the country's leaders, the putative models of societal behavior, and therefore questions why the rest of Argentina should be truthful if they are not honest themselves.

These humorists show that repercussions of Argentine authoritarian rule on the country's graphic humor production are evidenced in a variety of issues and in a number of artists, all with the intent of publicly releasing the repressive dialogues associated with a complex and unbelievable set of occurrences. This discharge function empowers the illustrators and thus their drawings turn into forceful weapons both resistance and collective memory. I would like to encourage Rep, and all the humorists of the world, to please draw.

Performing truth

LAURIE BETH CLARK

Perhaps because authoritarianism is performative, performance has been and continues to be a preferred mode of "speaking truth to power" in authoritarian regimes. The authoritarian state fashions symbols, ceremonies, and institutions partly as a performance of power – asserting, communicating, and celebrating its hold over the apparatus of the state and its control of society in political performances large and small. Groups in opposition to the authoritarian state are often equally performative. Throughout history, people have taken to the stages and the streets to voice, either explicitly or implicitly, their hostility to repressive regimes. Such performances produce counter narratives that challenge power by inverting the authoritarian regime's version of the present or past, representing the regime as the threat to the nation and its values of life, liberty, and morality.

I 1995.
II 1996.
III 1997.
IV 1998.
V 1999.
VI 2000.
VII 2001.

Centar za kulturnu dekontaminaciju
Centre for Cultural Decontamination

želi Vam srećnu Novu
wishes You a Happy New

2002.

CZKd

The Center for Cultural Decontamination in Belgrade, Yugoslavia,
created masks to be worn for the celebration of the New Year in 2002.

Source: Ruphin Coudyzer (www.ruphin.com)

JANE TAYLOR *Ubu and the Truth Commission*
Cape Town: University of Cape Town Press, 1998, 29
Production by William Kentridge and Handspring Puppet Company

PA UBU: (Eating; muttering aloud) First thing
tomorrow, we'll remove the evidence and blow up
his arse.
MA UBU: Well, at last! And then you can bury the
bones.
PA UBU: (Startled, looks up at Ma Ubu) What?
MA UBU: I said, you can dig over that patch at the
back and clear out the stones.
PA UBU: Aaah, of course.
Ma Ubu and Pa Ubu begin to help themselves
from the Spaza shop, and eat. Ma Ubu examines
the price on one item.
MA UBU: I see that prices are still rising.
PA UBU: What uprising?
MA UBU: Today, everything costs an arm and a
leg.
PA UBU: I had nothing to do with it!
MA UBU: Pass me the salt.
PA UBU: Who said it was assault?

Performance is any art that requires the presence of a performer, often but not always demonstrating a skill, and reception by an audience, even if the audience consists only of the performer.[1] The consciousness of doubleness that underlies all performance suggests that what differentiates performing from being is a framing of the performed action. The term "performance" refers to creative activities that take many forms, from subtle choices about how to walk and what to wear to massive spectacles and social dramas. Under the heading of performance we may consider conventional plays and experimental theater, state-orchestrated performances such as truth commissions, alternative testimonial performance including story-telling, agitprop political action, cultural performances including traditional and contemporary ritual forms, performance art, site-specific installations, and performances of self in everyday life.

In reviewing these modes, it is important to keep in mind that not only does performance tell history, performance also makes history. The events that spectators witness enter into the consciousness of a culture *as* history. They provide not only pictures of turbulent cultural life but are themselves part of that turbulence; they are not merely documents or reflections of culture but events with cultural efficacy.

Ideas of all kinds — factual, fictional, and in between — may be channeled through performance, but the openness of the medium to multiple uses introduces awkward negotiations in post-dictatorship societies where recounting the facts of history has its own presumed merit. Indeed, reconciliation has been given theatrical form worldwide as government commissions stage public, orchestrated confessions, with protagonists, supporting actors, and spectators. These events give a voice to previously neglected persons, and center stage to the formerly marginalized. Moreover, the recounting of trauma is widely believed to have therapeutic value, not only for the individual teller, but also for the collective psyche of the listeners. In Chile and Argentina, as well as in many other countries whose past has been marked by dictatorship, there are regular commemorations of the victims of state terror. The audience hears a performer read the names — call attendance — of those who did not survive. Instead of silence marking absence, another voice, that of a surviving spouse, relative, or friend says, "Present."

After authoritarianism recedes to the past, scars still remain visible and continue to cause pain. Probably the most common perfor-mative cure has been to tell the story of one's wound. However, in all confessional performances, credibility is both socially and institutionally constrained. Because such stories are intended to produce empathetic responses from spectators, they are limited: the process favors certain kinds of stories (possibly the most horrific ones), certain kinds of simplifications of the story (so that listeners' loyalties are not dimin-

ished by ambiguities and complexities), and certain kinds of storytellers (those with effective and culturally specific acting skills as well as identity positions familiar to listeners). Furthermore, insistence on humanizing atrocity through *individual* narratives carries with it a reduction of the importance of collective identity and collective responsibility. Finally, it may be that issues that receive most attention are those that give power to the new state. Yet, while it seems almost self-evident that truth commissions and other forums for confessional performance favor victims, there is actually some indication that such forums sometimes favor perpetrators. As "narrative depend[s] on agency, the stories of those who 'do' are generally more compelling than those who are 'done to.'"[2] With the possible exception of Steve Biko or Amy Biehl, Jeffrey Benzien's confession about, and reenactment of, his "wetbag" form of torture in the South African police stations has arguably received more coverage in the press, television, and even art pieces than any single South African victim or survivor's story.

During authoritarianism, performance can be an especially effective protest art because performers often find it easier to evade censorship under the disguise of art. A script that conforms to the letter of the law may still be performed subversively, so that its images and gestures allow audience members to read between the lines. One common strategy is to stage permissible texts, from Shakespeare or Greek tragedy, in which the audience could be helped to read social critique allegorically through choices of costume or gesture. Similarly, indigenous rituals and Christian religious rites have been used as camouflage for political critique in Latin America, Asia, Africa, and Eastern Europe.

In post-dictatorship societies it may no longer be necessary to be surreptitious. Often, plays that were forbidden at home, but have been acclaimed abroad, make their first appearances in the now liberated societies. However, having emerged from an era of clandestine production and cryptic communication, audiences may be unreceptive to didactic works of overt protest. *Death and the*

In *Good Memory* and *Memory Bridge* Argentine artist Marcelo Brodsky reworked a photograph of his 1967 Colegio de Buenos Aires class inscribing personal stories of survival and disappearance during the dictatorship and reflections on this past among current students.

Cape Town security policeman, Jeffrey Benzien, received headlines in 1997 when he testified to and reenacted the "wetbag" torture in front of the South African Truth and Reconciliation Commission. *Source: Benny Gool*

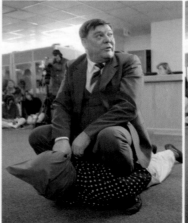
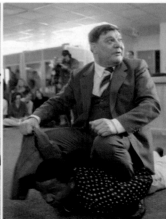

SINDIWE MAGONA *The Necklace*

Excerpt from *Mother to Mother* (Cape Town: David Philip, 1998).

A new phrase was coined. Verb: To necklace. Necklacing. Necklaces. Necklaced. A new phrase was born. Shiny brand new — necklace. More deadly than a gun. The necklace. That is what we chose to call our guillotine. Necklace. What an innocent-sounding noun. Who could imagine its new meaning? Just as we kept on calling, insisted on calling, the people who did the necklacing "children," "students," "comrades," we called a barbaric act the necklace, protecting our ears from a reality too gruesome to hear; clothing satanic deeds with innocent apparel.

Not many of our leaders came out and actually condemned the deed. Indeed, there were those who actually applauded the method, the innovative manner of killing a human being, of doing away with those with whom one was in disagreement. They said it would lead us to freedom. However, to this day, I have never heard it said that even one of the oppressors was necklaced. I had not known that it was our own people who stood in the way of the freedom we all said we desired.

Meanwhile, soon others were similarly garlanded. All those singled out for this form of execution were thus adorned with the quick, flaming and caressing colors. Without benefit of trial, with neither judge nor jury. No due process. No recourse to defense or appeal. Human beings were summarily murdered. No, necklaced. Quite different that is to saying someone has been murdered or killed. Necklaced. Is it more palatable?

The mighty police appeared impotent. They did nothing about the necklacing or did so little as to make no difference. Justice was on holiday. Or busy with more deserving matters: terrorists who, at the instigation of foreign meddlers, especially communists, were planning to overthrow the government. And, of course, always there were the pass offences.

A war was going on, the children said. They were fighting the apartheid government.

Maiden by a Chilean playwright Ariel Dorfman has been enormously successful with European and North American audiences, but it met with disapproval from Chilean audiences. The play explores how complicated the process of forgetting may be when torturers still share the streets of Santiago with those they tortured. Dorfman's life in exile may have also shaped Chilean audience reaction to the play, evoking criticism of the nation's sons and daughters who "abandoned" the homeland.

There is often a thin line between spectators and performers in performances of truth and memory in post-dictatorship societies. The theatrical structure calls on spectators to take the role of witnesses, yet their very presence imposes on them the role of political actor. This is true of some of the best known performances of both authoritarian and post-authoritarian eras, which have taken the form of political actions, such as the weekly Thursday marches of the Mothers of the Plaza de Mayo, which persist after the fall of the dictatorship as the women continue to demand state accountability for the disappeared.

Even the homes of former repressors and their supporters are the sites of political performance. *Escraches* in Argentina and *funas* in Chile are grassroots movements organized by the families of the disappeared. In Argentina, for example, a group called H.I.J.O.S. (literally sons and daughters) organizes public outings where well-known collaborators with the authoritarian regime

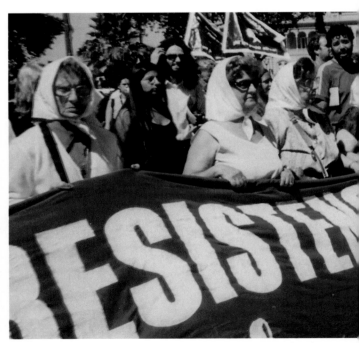

Every Thursday afternoon in Buenos Aires, Argentina, the Mothers and the Grandmothers of the disappeared walk around the Plaza de Mayo in front of the government palace to demand justice for crimes committed by the dictatorship.
Source: Paula Di Dio

are publicly denounced, their shameful history blasted through powerful speakers, and at the end paint thrown on the walls of their houses. In this way, neighbors find out who lives among them and in many cases, the collaborators and supporters of the regime are publicly shamed. During the *escrache*, all participants form a closed circle, and those who are watching from the sidewalks are not allowed to remain as passive bystanders. They are asked if they are with the group or not, and after the affirmative answer, they become part of the circle. In that sense the separation between the audience and performers ceases to exist.

Visits to the sites of trauma, often guided, are an important aspect of the performance of truth and memory wherever horror has occurred. Site-specific performances allow the place to "speak" its own memory of the atrocity that happened within its walls and convey that feeling to the visitors. Such works blur the boundary between monument and performance, either through the perform- ances by guides and by "actors" (sometimes even costumed reenact- ments), but also by the performances of the body of the spectators who engage corporeally with the site of memory. Guides at the Robben Island museum, formerly a prison for black opposition to South African apartheid, are ex-prisoners who often engage visitors with stories of their own pasts. The Robben Island "experience" will forever be changed when the aging prisoners can no longer lead these tours and are replaced by guides who were never imprisoned there. Furthermore, the use of a spatial idiom to perform truth extends beyond the site of trauma to other works that are "off site," such as the Vietnam Memorial in Washington, D.C., or the many Holocaust

Former political prisoners lead groups through the Parque por la Paz (Peace Park), located on the site of Chile's notorious clandestine torture center, Villa Grimaldi (Cuartel Terranova). *Source: Louis Bickford*

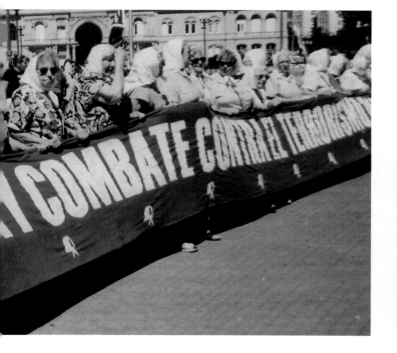

H.I.J.O.S., the sons and daughters of the disappeared in Argentina, hold *escraches,* or public rallies to identify perpetrators from the military dictatorship and demand justice. *Source: Enrique García Medina*

In her *Rights of Passage* performance piece, Coco Fusco stopped those entering the 1997 Johannesburg, South Africa, Biennale to check and stamp their "passbooks," representing the laws that had controlled and oppressed black South Africans during the apartheid era. *Source: Sue Williamson*

Nelson Mandela's Cell, Robben Island Museum.
Source: Mayibuye Archives, Cape Town

Toyi-toyi is a march used by the South African liberation movement in exile that continues to be used in demonstrations and protests today. *Source: Benny Gool*

memorials throughout and beyond Europe. Whether site works are permanent like the Robben Island museum, or transient like Coco Fusco's reenactment of the "passbook laws" with a subversive twist. The artists who use this mode to tell truth find it efficacious to perform truth with reference to the geography of terror.

Performance art, from monologue to tableau vivant, has proved a particularly fertile site for the engagement of difficult and alternative content. Many performance art strategies globally resemble avant-garde European and North American practices. For example, *Ubu and the Truth Commission* draws on the French *Ubu* stories developed by Alfred Jarry.[3] It would be a mistake to assume that such works are derivative because they draw upon other cultural forms of expression. In fact, many "first world" artists have borrowed strategies from elsewhere or have been deeply influenced in their work by their Latin American, Asian, and African counterparts. The profound influence of Brazilian Augusto Boal's "Theater of the Oppressed" provides just one example.

In societies with surviving independent forms and viable indigenous communities, "western" experimental strategies intersect with "non-western" performative practices. Thus, traditional ritual forms continue to function alongside syncretic practices as effective strategies for the performance of cultural truth. Sometimes such traditional forms are "nationalized" as a way of providing a symbolic unified identity for the new post-colonial nation. In other cases artists who have lived in exile during the authoritarian regime return to produce work in the countries they were forced to abandon. Their diasporic and intercultural perspectives contribute yet another dimension to the complex truths of post-dictatorship societies. The rhythmic toyi-toyi march, so closely identified with South Africa's liberation movements and current struggles for equality in that country, originated outside of the country in places such as Zimbabwe and North Africa, where liberation fighters trained.[4]

Because identities shape and are shaped by material culture, even most ordinary everyday activities must be thought of as performances, and sometimes these performances are subtle but significant acts of resistance.[5] In such day-to-day activities as shopping, dressing, and eating, there is a poetics of resistance towards homogenizing cultural forces, through a recombination of images and objects. For example, the Tide laundry detergent logo became the design for the Yugoslav radio station B-92, one of the few forces openly opposed to the Milošević's regime. Replacing the word "Tide" with "Free B-92," nonetheless linked the radio station with the struggle to cleanse the nation of Milošević's stains. In Argentina, the *cacerolazo* has become a powerful form of popular protest in the post-dictatorship era. As a non-violent performance, it calls on large

numbers of citizens to take up their empty pots and pans and bang on them in unison, as loudly as humanly possible, moving forward or standing still, in collective protest.

While many performances serve progressive functions, performance itself is not inherently progressive. In both fascist and democratic societies, performance has had a long and secure history of serving the interests of the state. This includes everything from military spectacle to musical theater. Not only may performance take conservative forms, it may also incorporate repressive content into progressive forms. Marking themselves as the new marginalized, residual right-wing groups around the world now use strategies long associated with the left to promote regressive agendas. Even some of what is done in the name of truth-telling may have anti-progressive intentions or deployments. What impact, for example, will "apartheid tourism" have on the future political policies and practices of South Africa? How can we know what pleasures spectators find in the review of atrocities? Can we really be any more sure of their motives than we can of those of the collectors of Nazi memorabilia in Europe or racist statuary in the United States?

It remains a troubling question whether pain can ever be adequately or appropriately represented by a body on stage, and more so whether such representations do more to reinscribe violence than contradict it. Performances that expose the details

The South African Truth and Reconciliation Commission granted amnesty to policeman Brian Mitchell, ending his life sentence in jail for murdering eleven anti-apartheid activists at a prayer vigil. *Cartoon by Zapiro*

of torture and terror may even eroticize it, as critics of the performance of Eduardo Pavlovsky's 1990 play *Paso de dos* in Argentina have contended. To this day, the question remains: is the play about torturer's perversity or an offering to the society fascinated by eroticized violence? Moreover, stories of activism and resistance are not told nearly as often as stories of victimization. Whether this is because they are statistically fewer or because they are believed to be less dramatically compelling, the effect is the same, the reinscription in the cultural imaginary of a constant state of political victimization.

Along with the exposure and reiteration of atrocities, one of the greatest contributions that performance makes in post-authoritarian societies is the insertion into the popular psyche pictures of the complex forces that make social change possible under even the most unthinkable circumstances. Since political change often is not followed immediately by economic change, the violence of poverty and unequal social relations persists in the post-dictatorship era. It may be that performance in post-dictatorship societies will continue to offer a critique of the new state, even as it celebrates liberation. The more complex and multifaceted these performances are, the more they realize performance's promise as an integral component in ongoing social change. ■

The independent media outlet B-92 created a T-shirt parodying a laundry detergent (Tide) logo to demand a new and clean government after Slobodan Milošević's control.
Source: Jelena Subotić

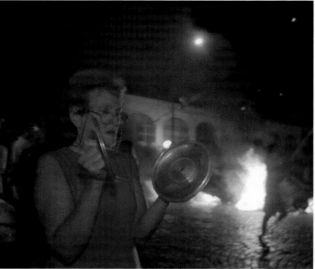

To protest the economic crisis, Argentines resurrected past method of civic protest by publicly banging pots and pans in *cacerolazos*. *Source: Enrique García Medina*

Unearthed Truths

TYRONE SIREN

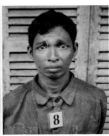
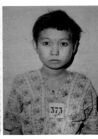
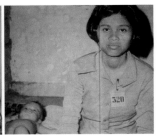

Tuol Sleng Genocide Museum

S-21 is the code name the Democratic Kampuchea regime (the Khmer Rouge) gave to their central prison and interrogation center between 1975 and 1979. After the DK regime was driven from power by its neighbor and longtime enemy, Vietnam, in January 1979, the prison — a former suburban high school — was converted into a museum named Tuol Sleng. The prison's name refers to the hill of the poisonous sleng tree, a fitting name since more than 10,000 adults and 2,000 children prisoners entered and only 7 made it out alive.

Each time I visit the Tuol Sleng museum, the functions of the different sites within the compound become more apparent, but the same stench of death hangs in the makeshift prison cells — yellow painted classrooms — as the first time I toured it. On my first visit, I was struck, as are all tourists, by the thousands of black and white interrogation photos of prisoners hanging on the walls — a dignified man with graying hair, a beautiful young woman, a terrified middle-aged man, a young girl holding her baby, a silent eight- or nine-year-old boy. I return to these photos, like visiting the graves of friends, every time I go to Tuol Sleng, getting to know each face better.

On other visits, I have begun to notice details like the holes in the bottom corners of each cell, which served as drains to the outside, making cleaning the blood from the inside of the cells easier. The walls on the outside of the building are still stained red. As Judy Ledgerwood writes, "[it is] as if the buildings themselves had bled." I also noticed the steel posts in the floor and metal beds where "enemies" were shackled and beaten and the wood frame in the courtyard from which prisoners were hung by their arms and tortured.

With only a short pamphlet and virtually no explanations in any of the rooms in the museum, I still try to make sense, to put into place, the incomprehensible acts of mass torture and death.

The final room a tourist usually visits in Tuol Sleng prison contains the "Skull Map." The skulls and bones of 300 people who were exterminated at S-21 were arranged by the Vietnamese regime to make up the shape of a 12-square-meter "map" of Cambodia, including a blood-red lake in the middle that represents Cambodia's great fresh water lake, the Tonle Sap.

After much controversy the Skull Map was removed from the museum in March 2002. There are plans to replace it with a map created by using global positioning system (GPS) technology which will show the location of the more than 20,000 mass graves thus far discovered in Cambodia. The reasons for removing the Skull Map are contested. Some claim the skulls were deteriorating. Others claim that displaying the skulls was disrespectful to the people and the families to whom they belonged, and argue that the skulls should be cremated in a proper Buddhist ceremony. Still others speculate that it was the Cambodian people symbolically taking back "their heads" from the Vietnamese who designed the map, giving the Cambodian people control of their history and, ultimately, their destiny.

"The Killing Fields"

Choeung Ek is located about 10 miles from Phnom Penh, Cambodia's capital city. It was created in 1977 when the S-21 cemetery in Phnom Penh became too full. Choeung Ek was not only a mass grave; it also became the site where many prisoners from S-21 were "smashed." In total, about 9,000 bodies have been exhumed. In the early 1980s the Cambodian government, which was then

supported by Vietnam, erected a stupa — a monumental structure usually found in a Buddhist temple compound — in which the skulls of the victims were placed.

Even with the sanitization that comes with tourism, pieces of bones, skulls, and clothing are still visible in the grave pits, sometimes being turned into souvenirs. When I first visited the killing fields in 1997, no fences surrounded and no shelters covered the grave pits. An international tour group, led by an American NGO worker, was touring the site in front of me. Like most tour groups — caught in a neo-imperialistic momentum — they were snapping photos of the stupa, the graves, and each other standing in the graves.

The tourist in front of me stumbled on a bone — what looked like a human femur — that broke up from the ground. He shouted to the group leader, "Look what I have found. What should I do with it?" The tour leader replied, "Dig it up. Take it home with you. There are lots of them. My son comes out here on weekends to gather them. He almost has a complete human skeleton put together in his bedroom."

At first I thought this man was making a tasteless joke, caricaturing the insensitivity of tourists and tourism — ironically pointing out what they (and I) were actually doing at the killing fields. But looking at this fat man sweating through his khaki shirt with an adventurer's hat on his head, I realized that irony was probably not in his conceptual vocabulary. With the guide's encouragement, all the tourists jumped in the graves and began digging for bones. The exclamations, the shouts of joy and excitement when each person found a complete bone, have been etched into my memory. I finally shouted, "Stop! These bones don't belong to you." The fat American yelled, "Don't pay attention to him." He then looked at me with these

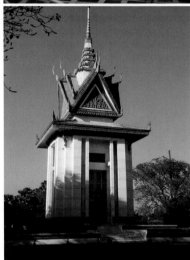

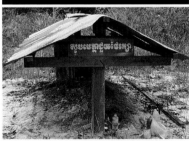

THE SECURITY REGULATIONS
1. YOU MUST ANSWER ACCORDINGLY TO MY QUESTIONS. DON'T TURN THEM AWAY.
2. DON'T TRY TO HIDE THE FACTS BY MAKING PRETEXTS THIS AND THAT. YOU ARE STRICTLY PROHIBITED TO CONTEST ME.
3. DON'T BE A FOOL FOR YOU ARE A CHAP WHO DARE TO THWART THE REVOLUTION.
4. YOU MUST IMMEDIATELY ANSWER MY QUESTIONS WITHOUT WASTING TIME TO REFLECT.
5. DON'T TELL ME EITHER ABOUT YOUR IMMORALITIES OR THE ESSENCE OF THE REVOLUTION.
6. WHILE GETTING LASHES OR ELECTRIFICATION YOU MUST NOT CRY AT ALL.
7. DO NOTHING, SIT STILL AND WAIT FOR MY ORDERS. IF THERE IS NO ORDER, KEEP QUIET. WHEN I ASK YOU TO DO SOMETHING, YOU MUST DO IT RIGHT AWAY WITHOUT PROTESTING.
8. DON'T MAKE PRETEXTS ABOUT KAMPUCHEA KROM IN ORDER TO HIDE YOUR JAW OF TRAITOR.
9. IF YOU DON'T FOLLOW ALL THE ABOVE RULES, YOU SHALL GET MANY MANY LASHES OF ELECTRIC WIRE.
10. IF YOU DISOBEY ANY POINT OF MY REGULATIONS YOU SHALL GET EITHER TEN LASHES OR FIVE SHOCKS OF ELECTRIC DISCHARGE.

words slithering from his mouth, "I have been in this country for five years. I think I know what is best for Cambodia." But did he know what was best for the bones of Cambodians?

The Site of Pol Pot's Cremation

The last Khmer Rouge stronghold in Cambodia, held until 1999, was Anlong Veng. Near Cambodia's border with Thailand, it is also close to the grave of Pol Pot, the leader of the Khmer Rouge who is sometimes called Brother Number 1. In 2001, the prime minister of Cambodia decided that Anlong Veng town, Pol Pot's grave, and his house should be turned into a tourist zone. However, even the most developed Cambodian tourist destinations remain underdeveloped, and Anlong Veng still does not have electricity. Finding Pol Pot's grave is nearly impossible, which seems strange since his regime was responsible for the deaths of approximately 1.7 million people.

There are no signs directing tourists to Pol Pot's grave, and local people either do not know where it is or are reluctant to tell tourists. Only after drinking beer with soldiers for several hours, on top of a mountain, did the soldiers reluctantly lead me to the grave, which was less than 100 meters from where I had sat with them for two hours.

Pol Pot died in 1998, reportedly in his sleep. His body was cremated on a pyre of old tires which are still scattered around the area. His gravesite is small and unassuming. It only has a tin cover and a blue — the official government color — sign marking it. The sign says, "This important place is where Pol Pot was cremated. This place is considered to have an abundance of history." The man who led me to the gravesite prayed and lit incense. Indeed, an abundance of history.

Outing Perpetrators

SARAH A. THOMAS

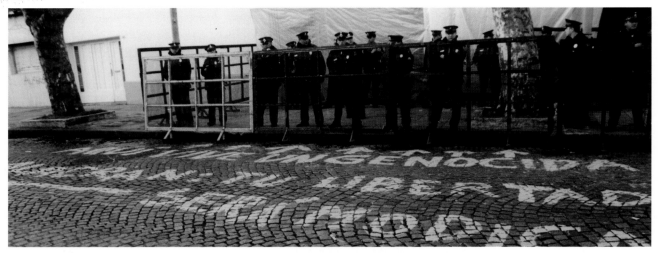

Source: Sarah A. Thomas

Imagine witnessing the brutal kidnapping of your parents, growing up in their eternal absence, and knowing that the perpetrators freely walk the streets. This sequence of events is part of the real life story of some Argentine children of detained, disappeared, exiled, and murdered activists. Many of these children, now men and women, have united to form an international organization called H.I.J.O.S. *Hijos*, which means children in Spanish, stands for Sons and Daughters for Identity and Justice against Forgetting and Silence. In 1996, H.I.J.O.S. invented a unique type of political performance to call attention to the impunity of the military, state, and medical personnel responsible for the atrocities surrounding the country's last dictatorship. H.I.J.O.S.'s carnivalesque demonstrations have proven to be a powerful tool against silence and the obliteration of memory in contemporary Argentine society. These outings of pardoned criminals, donned *escraches*, have in fact been so successful that other groups all over Latin America often adopt the *escrache* idea for economic and political means.

The outing name *escrache* has its roots in Italian-Argentine slang, meaning an ugly and unpleasant person. The term's Latin cousin signifies to expectorate, or to throw something with force. For the Sons and Daughters for Identity and Justice against Forgetting and Silence *escrachar* means to bring to light something that has remained hidden in society.

The H.I.J.O.S. national organization made its first public appearances during the marches for the 20th anniversary of the 1976 coup d'etat in Argentina. The

Sons and Daughters for Identity and Justice against Forgetting and Silence now count 13 chapters in its national network, two others that do not belong to the network, and seven groups abroad. The organization's efforts have evolved considerably since 1996, maturing from spontaneous and aggressive tactics to more planned, cooperative, and broad-based work aimed at civil society. In the *escrache* boom year of 1998, H.I.J.O.S. received a lot of press coverage and significant police repression. Members of H.I.J.O.S. have been incarcerated, threatened by telephone, filmed and menacingly followed. Their antagonists made bogus flyers and websites and often appeared as instigators during the outings. Although *escraches* have lost some of their novelty, they continue to be polemical and have increased in popularity.

Several months after their 1996 anniversary march, H.I.J.O.S. debuted an *escrache* against Dr. Magnasco, nicknamed the "child appropriator," who delivered kidnapped women's babies in the basement of the Naval Mechanics Military School (ESMA). The negative publicity succeeded in getting Dr. Magnasco fired from his top position at a Buenos Aires medical facility and he was asked to move out of the building where he lived. During the first few years, H.I.J.O.S. conducted up to two *escraches* per month, on Wednesday evenings in the downtown areas of Buenos Aires and other cities. Nowadays, their political performances are carried out on Saturday afternoons in neighborhoods where the residents likely do not know that one of their neighbors is a former torturer or

Source: Kerri Rentmeester

kidnapper. Rather than try to surprise the press, a new alliance of human rights organizations has joined H.I.J.O.S. in its well-organized preparation of each *escrache*.

Escrache planning generally begins several months before the event and involves many aspects. Of utmost importance is the research and confirmation of facts about the perpetrator's past. This information, which includes an alias, place, type, and duration of clandestine activity, is revealed along with a photo on posters, flyers, newspapers, and pamphlets that H.I.J.O.S affiliates disperse weeks before their outings. Escrache Table, the alliance that prepares *escraches*, consists of groups called La Mariátegui, Libertarian Socialism, dancing and singing *murgas*, the Mariano Acosta student center, and the Street Art Group. To help smooth the way for each *escrache*, the Sons and Daughters go door-to-door to explain their goals and ideology to the residents in the criminal's neighborhood. Similarly, the groups post signs and rehearse their short performance in the area where the outing will take place.

On the day of the *escrache*, the sequence of events is now fairly standard. The demonstrators, who often include the Mothers of the Plaza de Mayo and Relatives of the Disappeared, among others, gather near a well-traveled intersection about a mile away from the *escrachado's* home. They hold their banners high, purchase food to support the H.I.J.O.S organization, listen to music, dance, sing chants to gear up for a lively *escrache*. At the *escrache* against Ricardo Scifo Modica, alias the Scorpion, a man dressed up as a scorpion on stilts also participated in the demonstration. Accompanied by drums, costumed *murguistas,* and a truck with a megaphone, the activists march and chant on their way to the repressor's home. One of their popular chants is, "It is going to happen to you, just like it did to the Nazis, wherever you go, we will come look for you." Another can be translated as, "Come neighbor, come to *escrachar*, come down and join the collective *escrache*." The H.I.J.O.S. try to invent a new chant specific to each outing.

While the *escrache* participants march, members of the Street Art Group post their warnings, similar to traffic signs, that call for trial and punishment and announce the distance to the criminal's residence. At some point during the *escrache*, everyone stops to watch a short performance that pokes fun at the atrocities committed by the target of the day's events. Near arrival to the *escrachado's* home, the environment becomes tenser, as armed police appear and demonstrators' emotions intensify. The participants link arms while listening to a short speech about the *escrachado's* crimes and H.I.J.O.S.'s goals, and witnessing the marking of the repressor's home. First, the organizers paint the road with the word "murderer," and then they throw balloons full of red paint at the house or building. The red marks symbolize bloodstains. The H.I.J.O.S. promise that the *escrachado's* crimes will not be forgotten, nor continue to be overlooked.

The Sons and Daughters for Identity and Justice against Forgetting and Silence organization invented *escraches* because its members saw that no judicial action was going to be brought against the functionaries of the dictatorship. H.I.J.O.S. considers its outings to be a type of collective justice, a social condemnation in the absence of a judicial punishment. In describing his objectives in an *escrache* on March 24, 2002, one organizer explained that "we are convinced that memory, just like justice and politics, is action, it is construction, that we must do from the bottom up, and therefore we are constructing social condemnation."[1] Similarly, the H.I.J.O.S. Tucumán chapter describes *escraches* as a tool that promotes the social construction of justice. In the national network newspaper, the organization uses a definition that is closely related to the origin of the word: "*Escrachar* is to mark, to allow all the genocides that power protects to be discovered, to shed light on the names and faces that impunity hides."[2] When the H.I.J.O.S. and their partners come together in front of the homes of the functionaries of state terrorism, their purpose is to educate the community about the truth of their neighbors' past, encouraging that very community to take action against the repressor.

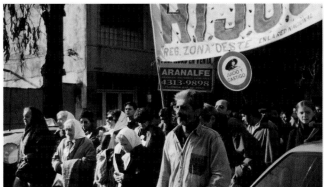

Source: Sarah A. Thomas

After the Fall

KSENIJA BILBIJA AND TOMISLAV LONGINOVIĆ · PHOTOGRAPHS BY MILETA PRODONOVIĆ

Throughout the '90s these two towers dominated downtown Belgrade, revealing the split nature of Serbian political reality. While the Presidency of Serbia (formerly the court of the Serbian king) bore the star of a passing communist era, the City Assembly building was crowned by the double-headed eagle of the new/old Serbia. After October 5, 2000, the day when the people of Serbia took power away from the regime of Slobodan Milošević, the star was removed. The space remains empty, as people sort through multiple layers of authoritarian legacies and their symbols.

The visual culture used in political campaigns by the Milošević regime manifested both authoritarianisms that have plagued Europe in the past century: Stalinism and Nazism. The red banner with a friendly face and a signature of Slobodan Milošević is accompanied by a fragmentary quote: ". . . not to betray the ancestors, not to disappoint the descendents!" This message evokes the classical agitprop aesthetic of communism, of family values associated with a bygone era, of honest working-class life and the bright red future. Nazi aesthetic was used in the last public relations campaign of the Milošević regime to label the popular resistance movement OTPOR as Madlaine Jugend. The name of Clinton's Secretary of State, Madeleine Albright, was associated with Hitler's Youth Movement, while the swastika that used to be on the helmet and the armband of the Nazi soldier was substituted by the upraised fist symbol of the oppositional OTPOR movement. The traumas and the simultaneous identification with the aggressors testify to a cultural schizophrenia as a legacy of past authoritarianisms.

Parallel street signs in the former Marshal Tito Street carry two new names, neither of which recalls the lifelong communist leader of Yugoslavia. The top sign, Street of Serbian Rulers, shows its

new name inscribed in stylized Cyrillic letters designed to look archaic. This resurrection of the medieval orthography during the Milošević years is paired with the bottom sign, which bears the name of the street before the communist takeover: King Milan's Street. While deliberately repressing the communist past, the new Serbian identity reaches still further, to reinvent both the monumental past of medieval monuments and the actual past of the street before World War II.

A billboard for a Pioneer candy bar portrays solidarity among the communist youth in a nostalgic manner. "Good and faithful friend" is displayed in grade-school handwriting above the subliminally hazy figure of a gray-haired man in front of the national flag. The phantom of the national father, Milošević, transformed into a specter of consumer satisfaction, emerged after October 5, 2000, as a parodic quote of a very recent authoritarian past.

A poster produced by SCANDAL, a boutique specializing in designer brands of Western perfumes owned by Slobodan Milošević's son, Marko, wished a happy International Women's Day (March 8) to the women of Belgrade with a giant red star

against a blue sky. The woman portrayed as Tito's partisan warrior, least likely to wear the Western perfumes, carries a child in one arm and a gun in the other, while the other figure reveals a "woman of the people." This leftist posturing manifested the nepotism and hypocrisy of the Milošević regime. The department store became a focus of hatred for most Belgraders toward the end of the Milošević era.

People spontaneously broke into the SCANDAL boutique. OTPOR activists posted decals on the store windows of all downtown businesses owned by the financial empire of Slobodan Milošević and his wife, Mira Marković. They read: Closed Because of Robbery. The ambiguity of the phrase indicates not only that the store has been closed because it was robbed, but that the store is closed because the owners have been robbing the Serbian people for the past decade. One should not forget that the photographer captured the moment when Serbian people were actually breaking into the boutique, enacting a symbolic revenge on the Milošević family.

After demolishing and emptying SCANDAL on October 6, 2000, an anonymous graffiti writer used red and black spray paint, the symbolic colors of communism and fascism, to voice his rage in crude street language. "Where are you now, daddy's pussy?" asks the red message, while the black one thrives on ambiguity between "Write to your dad" and "Suck your dad's . . ." The other wall features yet another red graffiti message stating: "Complain to your dad." A bleeding red star punctuates the end of an era in which communist ideals were transformed into an instrument of authoritarian terror.

"Guilty" reads the decal designed by OTPOR activists in order to confront the Serbian public not only with the fact that Milošević is a war criminal suspect, but that he is actually guilty of those crimes. The official Serbian media *never* interpreted the crimes committed in Croatia, Bosnia and Herzegovina, and Kosovo as related to Milošević's politics. Only non-governmental organizations like OTPOR, as well as B-92 and Belgrade Circle, tried to confront the public with the responsibility of politicians for the pariah status of their constituents at home and abroad.[1]

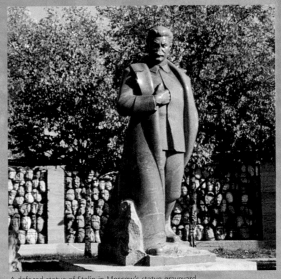

A defaced statue of Stalin in Moscow's statue graveyard.
Source: Catherine Weaver

Public monuments, memorials, and museums shape the physical landscape of collective memory. They are "memoryscapes" that contest official truths of the authoritarian era and give voice to its victims and survivors. From statuary and war memorials, to public art commemorating past events, to roadside historical markers, to plaques highlighting the heroes or villains of history, to museums designed to remember but not repeat the authoritarian past, memoryscapes recapture public spaces and transform them into sites of memory and alternative truth-telling about the authoritarian past.

Source: Tyrone Siren, Tuol Sleng Museum

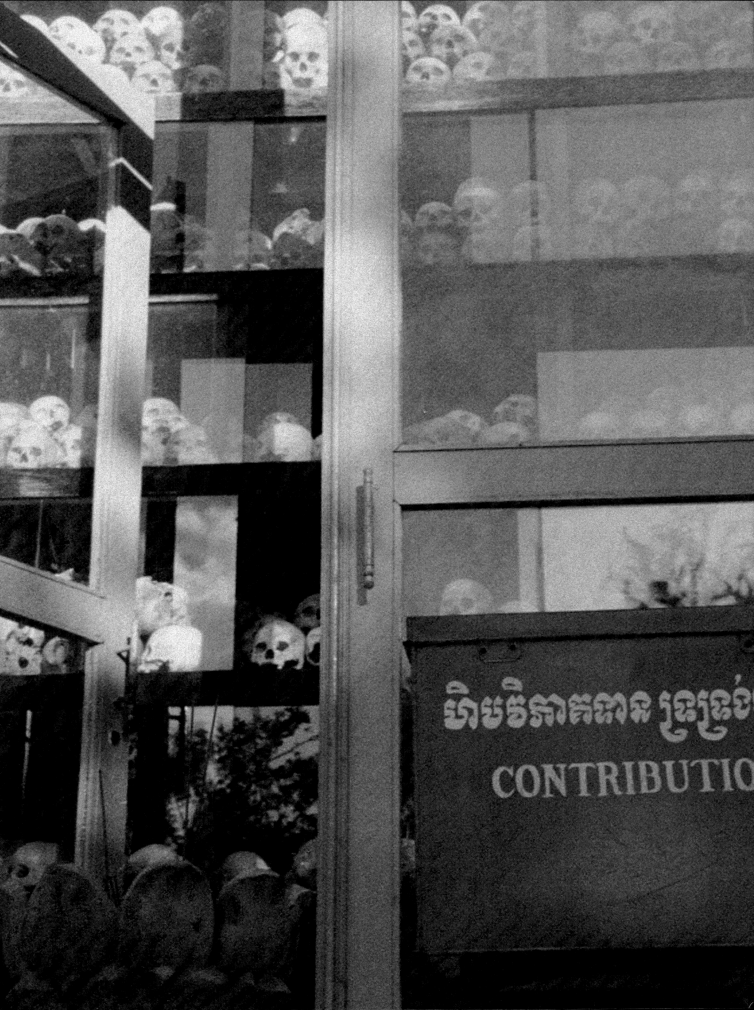

Source: Leigh A. Payne

Victor Jara's grave, Santiago, Chile.

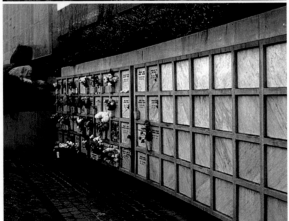

Wall of tombs in the National Cemetery Santiago, Chile. Source: Louis Bickford

Memoryscapes take a variety of forms. They do not always involve creating new spaces or constructing new buildings. Sometimes memorials use conventional means – such as gravestone markers – to honor heroes of past wars. But these conventional memorials can be transformed and made into **reconfigured memorials** that tell new truths about the past. For some, these gravestones remain the traditional way of honoring fallen heroes, but for others they are used to acknowledge authoritarian violence, with single grave markers identifying a martyr of the authoritarian regime's atrocity. For example, visitors to the gravestone of Victor Jara, the famous Chilean protest singer murdered by the Pinochet regime, leave flowers, poems, postcards, and other messages both to honor the memory of a popular artist and to protest the violent suppression of political expression in Chile during the 1970s and 1980s.

Beyond remembering the life of an individual on a single gravestone, memoryscapes can commemorate the lives of thousands on walls of names. The Vietnam War Memorial in Washington, D.C., perhaps the most famous of memorial walls, possesses layers of meaning. Is the wall about the heroism of the dead or about the loss of young lives in a discredited war? The names of those who died under authoritarian rule around the world also appear on memorial walls that represent atrocity rather than celebrate heroic wars of the past.

Sometimes size or scale of memorials reflects which groups have the right to represent the past. Memorials to particular heroic figures

This headstone from the Hornos de Lonquen (Lonquen Ovens) serves as a symbolic gravesite for 15 individuals disappeared under different circumstances by the Chilean military dictatorship in 1973 and found in this rural area outside Santiago in 1978. *Source: Pedro Matta*

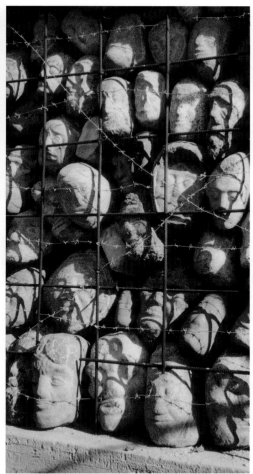

who struggled against authoritarian rule look very different from the official public memorials to heroes of national wars. One important juxtaposition is that of South African monuments honoring apartheid's opponent Steve Biko and that of Cecil Rhodes. Biko, a towering figure in the anti-apartheid struggle, is memorialized in a lone sculpture in East London, while Rhodes, a founder of white South Africa, towers on a mountain top above Cape Town.

Memorials built by authoritarian regimes are sometimes defaced. Covering statues with graffiti, placing them in a new location charged with meaning, or reproducing them in distorted form, inverts memorials, forcing them to tell very different truths about the authoritarian past. Rather than destroying these monuments, these efforts undermine the official version of the past by standing them on their head. A graveyard for past Soviet monuments, for example, became an impromptu art protest of the censorship of the Soviet regime by transforming the majestic statues of Stalin and others into political protest pieces.

Existing museums have also been transformed into sites of public contestation over official memory of the past. For example, severe criticism of the South African Museum's dioramas of "the Bushmen and Bantu-speaking tribes" in Cape Town has challenged official (degrading) versions of black South Africa. The exhibition that portrayed Bushmen as specimens in a natural history museum was closed after 42 years as a result of controversy.

Reconfigured memorials generate controversy regardless of the form they take. Many critics have questioned whether public memorials — particularly those on which names are engraved into lifeless stone — are the best aesthetic forms to remember the past and to struggle against an authoritarian future. Moreover, critics say that public monuments fail to acknowledge the everyday forms of heroism

TOP: Stone skulls representing the victims of Stalin's purges, are tightly trapped behind barbed wire. *Source: Catherine Weaver*
MIDDLE: Cecil Rhodes Memorial, Cape Town, South Africa. *Source: Sue Williamson*
BOTTOM: The Military Museum in Buenos Aires, Argentina, exhibited a Ford Falcon with the title *People Transport, Capacity Five People*. Used to abduct and transport people to torture centers, this car became a potent symbol of the dictatorship's repressive apparatus. *Source: Ksenija Bilbija*

Source: Benny Gool

Robben Island Museum, South Africa.

District Six Museum, Cape Town, South Africa.

Tuol Sleng Museum, Cambodia. *Source: Tyrone Siren*

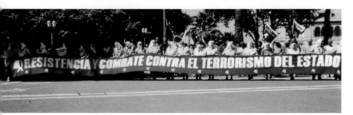

Every Thursday afternoon in Buenos Aires, Argentina, the Madres (Mothers) and the Abuelas (Grandmothers) of the disappeared walk around the Plaza de Mayo in front of the government palace to demand justice for crimes committed by the dictatorship. *Source: Paula Di Dio*

of survivors who bear physical and psychological wounds of the past. For example, how can **inverted public memorials** acknowledge the countless, nameless, faceless, unknown youths — the traumatized survivors — who were kidnapped and tortured in Argentina, Brazil, Chile or Uruguay?

Museums of conscience are sites created to remember both the bad and the good, perpetrators and victims. They commemorate heroes, just actions, and victories, but they can also memorialize the infamous and shameful. District Six Museum recalls the eviction of between 30- and 35,000 predominantly "colored" and Indian South Africans from a neighborhood in Cape Town. Museums of conscience aim at using history to foster social change, linking the past with present citizenship. For District Six, one aim is the healing of memories. In contrast, the Project to Remember in Argentina, started but not yet finished, builds a museum from a former naval school used as a clandestine detention and torture center during the dictatorship. Its aim is not reconciliation but remembrance of violations. Similarly, Tuol Sleng seeks not to reconcile with Khmer Rouge past but to show violence committed, especially in the absence of a state-sponsored "Never Again" memory project or tribunal.

What these museums do is to document events, particularly the identities of victims and survivors, and they invite visitors to experience repression vicariously through an emotionally charged tour. Despite efforts by museums of conscience to catalog and record the experience of repression for visitors, atrocities remain so complex that they cannot easily be represented. For example, the East Timorese plan to have visitors pay to spend a night in prison as part of a memory experience. Yet only the prison walls exist. Gone is the experience of pain encountered by the tortured. In Chile's Villa Grimaldi Peace Park, visitors read markers about torture that occurred on that spot, but all that is left of the mansion-cum-torture center is the aromatic rose garden, lovely floor tiles, and stories that tour guides might evoke. Robben Island Museum has depended on former

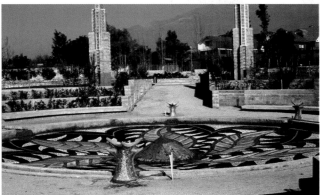

Villa Grimaldi Peace Park, Santiago, Chile. *Source: Louis Bickford*

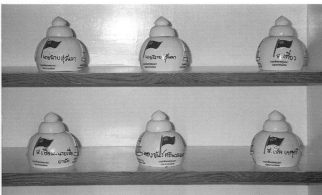

At Nangrong Shrine, a temple in Buriram in northeast Thailand, survivors of the 1976 Massacre place urns containing the remains of their killed comrades. *Source: Thongchai Winichakul*

tour guides to lead visitors through the cells of the prison that housed leaders of the black liberation struggle in South Africa. But as these former prisoners become unwilling or unable to lead tours, what will happen to the visitors' emotional experience on Robben Island?

Memory tours have become ways to make memoryscapes more visible for local and international groups. Western Cape Action Tours — led primarily by former leaders of the liberation movement — guides visits to key sites of apartheid terror in South Africa. Pedro Matta, the former Chilean political prisoner, accompanies groups through various spots of violent repression in Chile, including the Villa Grimaldi Peace Park in Santiago. Controversy surrounds these tours, as some critics view them as exploiting past violence for personal gain. Others perceive them as voyeuristic and devoid of any deep understanding about the past.

These public memorials and museums of conscience are also criticized for their reliance on government funds and approval.

Western Cape Action Tour leads groups to sites of memory in Cape Town, South Africa. *Source Louis Bickford*

Folk memorials, in contrast, spring up without intervention from the state or local government. Roadside shrines, or *animitas*, throughout Chile remember victims of repression. Small markers in the jungles of Thailand commemorate where comrades fell in the struggle against the dictatorship. These folk memorials are built by and for community members. Few guidebooks list information about how to find them. And without inside knowledge most passersby will not recognize their existence, origin, or meaning.

Very similar to folk memorials are **reconstituted spaces** of public memory. These memoryscapes were not purposefully created to serve as memorials.

Rather, through time, they form part of the memory of the past for individuals and communities traumatized by the authoritarian regime's repressive apparatus. Their meaning often proves opaque to passersby. For example, the site of a still-standing clandestine torture center or prison evokes powerful memories in a local public but is likely to be all but invisible to others. The National Soccer Stadium in Santiago, Chile, and the

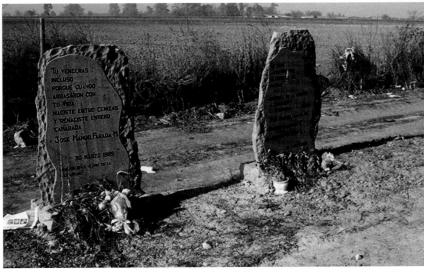

An *animita* (roadside shrine) on the side of the highway in Quilicura, Chile, remembers the location of the murder of three men (*degollados*) by the dictatorship's security force in 1985.
Source: Louis Bickford

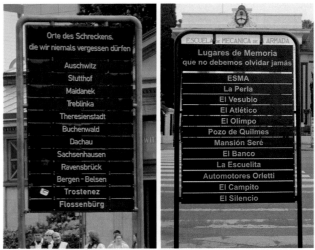

In *Los Caupos I* and *II* (2001) Argentine artist Marcelo Brodsky identifies Argentinian concentration camps using the same sign as in Germany.

Street name marking date of military coup 9/11/73, Santiago, Chile. *Source: Louis Bickford*

International Film Center in Manila, Philippines, are reconstituted spaces. These buildings predated the authoritarian regime, but have since become emblematic of the regime's terror because of the atrocities committed there. Under the quickly poured cement supporting the Film Center, an unknown number of workers lay buried, victims to Imelda Marcos's hurry to finish the structure in time to host the Manila International Film Festival in 1981–1982. Each year on the anniversary of the accident, relatives of the workers place candles on the steps to calm the souls of the deceased who died violent deaths.

Reconstituted spaces may also mark the spot where a spirit of public resistance rose. The Plaza de Mayo is probably the best example of these sites of resistance memory that co-exist with sites of atrocity. In that place, as in others, the spirit of resistance persists through the weekly march by the Mothers and Grandmothers of the Plaza de Mayo, wearing their signature kerchiefs and carrying placards to protest the disappearance of their children and grandchildren.

These reconstituted spaces provide sites for graffiti, performances, and public art installations that contest official versions of the past. Rallies often originate or end at these sites. They

represent authoritarian regime terror in visual art, film, performances, stories, and song. It is the potential power they possess that draws out communities to protest democratic governments' initiatives to destroy these symbols of the authoritarian regime. Their existence creates the possibility of constantly "talking back," or contesting, that version of the past. Chile's Villa Grimaldi might have been destroyed and replaced with a high rise condominium complex without the mobilization by a community of former prisoners. Such success was not achieved in Uruguay, where a former torture center is now an exclusive shopping mall.

Memoryscapes also include ***commemorative activities*** in the struggle for alternative truth-telling. Particular dates become imbued with significance, such as the Chilean coup of September 11. Anniversaries of particular events such as coups, deaths, births, uprisings, or the founding of resistance groups produce public responses as part of the process of producing new truths about the past. Political rallies and marches, public art and concerts, and street theater commemorate past events on these anniversaries. New dates are founded to keep memory of the past alive: March 21 is Human Rights Day in South Africa chosen to commemorate both the victims of apartheid and those who struggled against it; since 1999, May 26 is Sorry Day in Australia to reconcile the historic mistreatment of the aboriginal peoples; and the Philippines "seasons of remembering" the dictatorship are framed by the anniversaries of Marcos's downfall (January) to People Power I (February) and Ninoy Aquino's murder (August) to the declaration of martial law (September).

By themselves and isolated from their context, monuments, memorials, and museums have little effect. Their power is generated by place, by the meaningfulness of their location during the authoritarian period, and perhaps even more importantly by the meaning brought to them through the public discourse they inspire and provoke. They represent in the present a wound opened by a historical act. But they bear the promise of a future scar when the healed wound is remembered. ■

Immediately after the coup, the military rounded up, tortured, and killed alleged "subversives" at the National Soccer Stadium in Santiago, Chile. *Source: Claudio Barrientos*

Gen XX

SANJA IVEKOVIĆ

Nada Dimić
Charged with anti-fascist activities.
Tortured and executed in Nova Gradiška in 1942.
Age at the time of execution: 19.

Sisters Baković
Charged with anti-fascist activities.
Tortured and executed in Zagreb in 1942.
Age at the time of execution: 21 and 24.

Dragica Končar
Charged with anti-fascist activities.
Tortured and executed in Zagreb in 1942.
Died at the age of 27.

Nera Šafarić
Persecuted for her anti-fascist activities.
Arrested in Crikvenica in 1942 and taken to
Auschwitz concentration camp, from which she was
freed in 1945.
Age at the time of her arrest: 23.

Ljubica Gerovac
Charged with anti-fascist activities.
While being captured she committed suicide.
Died at the age of 22.

Project GEN XX is a series of photo works designed in the form of magazine advertisements, published in the period 1997–1998 in Arkzin, Zaposlena, Frakcija, Kruh i ruže, and Kontura in Croatia.

The women in the photographs are fashion models whose faces are familiar to the general public. The women represented in the text (all of whom were officially proclaimed "National Heroes") were well known to members of those generations who matured during the Socialist period in the former Yugoslavia. For the young Croatians of today, those women are either unknown or have been erased from collective memory. The artist's mother, Nera Šafarić, is represented by an original photograph of herself, taken two years before she was captured and sent to Auschwitz where she remained until the country was liberated.

The documentation referring to "women heroes" was published in the book *Žene Hrvatske u narodnooslobodilačkoj borbi* ([Croatian Women in the War of National Liberation]. Zagreb: Grafički Zavod Hrvatske, 1955).[1]

Naming

CYNTHIA E. MILTON

Nothing will remain of you; not a name in a register, not a memory in a living brain. You will be annihilated in the past as well as in the future. You will never have existed. —George Orwell, *1984*

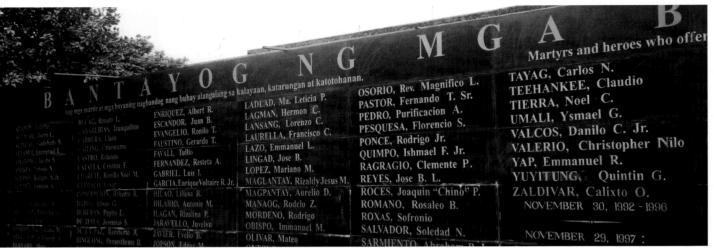

Source: Cynthia E. Milton

Source: Cynthia E. Milton

ABOVE: Bantayog Memorial Center, Quezon City, Philippines. Wall of Remembrance. With a long-term lease in the heart of Quezon City near Quezon Avenue and EDSA, this memory site commemorates well-known martyrs, such as Ninoy Aquino, Cesar Climaco, Edgar Jopson, Manny Yap, Macliing Dulag and Evelio Javier, as well as 102 other heroes. A research and documentation committee selected the names from the 50 to 60,000 individuals imprisoned, tortured, killed, and disappeared during the first few years of the martial law. Each year, more names are added to the Wall of Remembrance as the committee chooses who to honor next.

LEFT: From 1979 to 1990, when the military occupied Santiago Atitlán in Guatemala, thousands died. In the town cathedral, the names of those who died are inscribed on small crosses where visitors light candles in their memory.

BELOW LEFT AND RIGHT: Marcelo Brodsky photographs the names of disappeared that hang from tree branches.

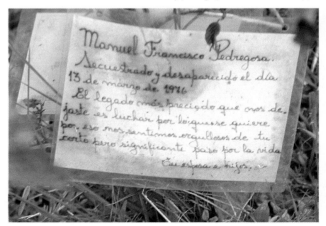

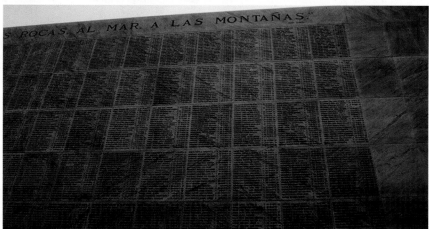

Memorial to the Disappeared and Politically Executed, General Cemetery, Santiago, Chile.

The Memorial Wall and Sculpture Garden, located in the General Cemetery in the Recoleta neighborhood of Santiago, is an imposing and visually impressive commemorative space to those killed or disappeared during the authoritarian period. The memorial includes a wall of stone and marble with the names of victims inscribed on it, a rock garden, an open area for quiet reflection, and a series of sculptures. The effort to create the memorial began with congressional discussion in 1990 from the combined work of human rights groups and the Ministry of the Interior. The memorial was inaugurated in February 1994 as an homage to the fallen.

Source: Louis Bickford

On October 7, 1973, government officials detained male members of two agricultural families in the town of Lonquen, near Santiago, a total of 15 people. During the Allende government, these *campesinos* had formed farmers' unions and worked to organize agricultural cooperatives. As such, they were seen as a threat to the landholders in the region. After their detention, all of the men were disappeared. During the next five years, military authorities denied the detention of these men. According to the military, they had abandoned the country for Argentina. In 1978, someone stumbled across the human remains of these 15 farmers in the bottom of two old ovens near the town of Lonquen. It was the first time that the "Official Lie" — that is, that disappearances did not occur in Chile — was uncovered. The ovens where the remains were found were converted into a site of popular pilgrimage. The owner of the ovens, a landowner who supported the Pinochet regime, destroyed the ovens to end the pilgrimages. Despite their destruction, Chileans continue to visit today.

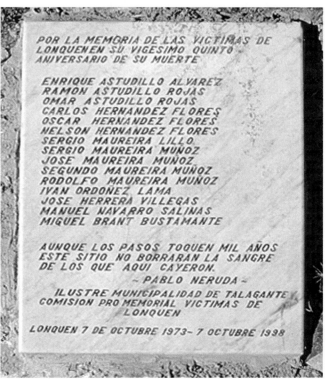

Source: Pedro Matta

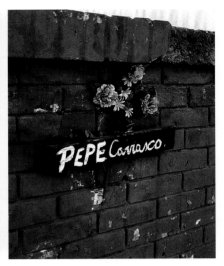

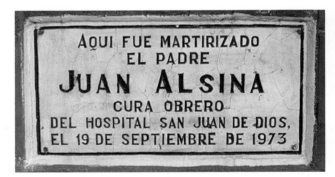

Source: Louis Bickford

This small memorial in La Reina, near Tobalaba, Chile, is known by a few people, who pass it regularly in their middle-class neighborhood. It commemorates a particular neighbor who was disappeared.

Chile: A homemade plaque placed on a bullet-pocked wall of a cemetery (Parque del Recuerdo) in the northern part of Santiago to honor Pepe Carrasco, who was killed there. This small memorial is frequently removed and then re-installed by family members and human rights activists.

Chilean cartoonist mocks attempts to wash from memory the names of 1,198 disappeared Chileans. Pinochet is assisted in his efforts of whitewashing walls by the political party UDI.

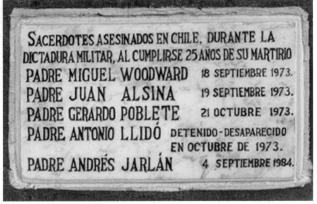

Source: Pedro Matta

Puente Bulnes: In the days following the coup of September 11, 1973, the Bulnes Bridge over the Mapocho River in Santiago became one of the places where detained people were transferred and then killed. At least 20 Chileans were shot here, their bodies falling into the water of the Mapocho River, taken by the current, and disappeared. The youngest was a 14-year-old girl. Another victim shot at the Bulnes Bridge was Juan Alsina, a Catholic priest taken on September 19 from his place of work at the Hospital of San Juan de Dios. He was shot along with other hospital workers. According to one of the soldiers who participated in the shooting of Padre Alsina, the priest refused to be blindfolded because he wanted to see those who were going to shoot him so that he might forgive the soldiers for their act.

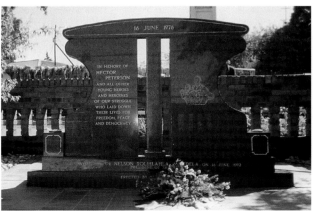

Source: Cynthia E. Milton

A memorial stand in Soweto to Hector Peterson, one of the children shot by police in 1976 when a protest of the use of Afrikaans in schools was met with state violence.

PAGE **106**

Name	Date of disappearance or death	Age at time of disappearance or death	Year of graduation from High School
Abal Medina, Fernando	07/09/70	24	64
Adjiman, Jorge	07/09/76	26	68
Adjiman, Leonardo	07/09/76	28	66
Adur, Claudio César	11/11/76	25	69
Aggio, Enrique Jorge	31/07/76	29	65
Aisemberg, Luis Daniel	20/03/77	23	72
Bekerman, Eduardo Horacio	22/08/74	19	73
Berardo, Amado	17/07/76	30	57
Bercovich, Martín Elías	13/05/76	21	72
Binstock, Guillermo Daniel	20/08/76	20	23
Bronzel, José Daniel	27/07/76	29	65
Burucúa, Luis Martín	14/07/76	22	71
Calvo, Jorge Donato	11/09/77	27	68
Campiglia, Horacio Domingo	12/03/80	30	69
Camps, Alberto Miguel	16/08/77	29	66
Cancela, Mirca	14/06/75	27	66
Casenave, Jorge	22/04/77	25	70
Castillo, Norberto José	13/07/77	22	73
Cesaris, Ramón Gerardo	06/09/72	18	72
Conte Mac Donell, Augusto M.	07/07/76	21	72
Corazza, Silvia	19/05/77	27	68
D'Alessio, José Luis	28/01/77	29	66
Dricas, Benjamín Isaac	21/08/76	20	73
Dubcovsky, Pablo Andrés	07/07/76	17	76
Dunayevich, Gabriel Eduardo	29/05/76	18	76
Epelbaum, Lila	04/11/76	20	73
Epelbaum, Luis Marcelo	10/08/76	25	68
Faimberg, Pablo Antonio	18/10/75	24	69
Finguerut, Pablo	14/06/76	22	73
Franconetti, Adriana	11/09/77	27	68
Franconetti, Ana María	17/02/77	20	74
Franconetti, Eduardo	17/02/77	19	76
Friszman, Nora Débora	02/12/76	19	74
Galarza, Martín	24/02/78	16	79
Gallardo, Magdalena	08/07/76	15	79
García, Alfredo Mario	05/07/78	25	71
García, Hebe Noemí	09/06/77	23	72
García Gastelú, Horacio Oscar	07/08/76	21	74
Gelman, Marcelo Ariel	24/08/76	20	74
Giménez, Luis	10/09/76	22	72
Goldar Parodi, Alejandro	07/07/76	18	76
Goldar Parodi, Eduardo	17/09/77	31	67
Goldemberg, Carlos	10/08/76	24	70
Grassi, Gustavo Enrique	23/09/77	26	68
Grynberg, Enrique	26/09/73	34	57
Guagnini, Diego Julio	30/05/77	25	69
Gutman, Alberto	28/09/76	19	74
Hazarn, José Luis	03/08/79	24	73
Hoffman, Gerardo	06/12/76	21	73
Hojman, Alberto	28/04/76	19	74
Jarach, Franca	25/06/76	18	76
Juárez, Gustavo Marcelo	12/08/77	19	76
Kehoe Wilson, Gloria	13/06/77	22	72
Kornblihtt, Adriana	31/03/77	16	78
Krasniavsky, Darío Ignacio	30/08/75	20	72
Lepíscopo, Pablo Armando	05/08/79	24	73
Lovazzano, Mirta Beatriz	29/05/76	18	76
Lozoviz, Juan Carlos	27/09/76	20	74
Malamud, Liliana Alcira	04/06/76	23	70
Marín, Juan Carlos	07/07/76	18	76
Marotta, Gustavo Arturo	27/04/76	22	72
Martul, Federico Julio	26/06/76	17	76
Matsuyama, Norma Inés	08/04/76	19	76
Mellibovsky, Graciela	25/09/76	29	65
Mentaberry, Román	28/11/79	29	68
Merega, Horacio Oscar	23/06/76	23	72
Montero, Jorge	18/07/76	33	63
Nakamura, Jorge	06/05/78	21	74
Ocampo, Carlos Guillermo	23/06/76	22	72
Ocerín, Carlos Abel	23/03/77	30	63
Olmedo, Carlos	03/11/71	27	61
O'Neill, Eduardo Miguel	09/07/77	30	65
Pagés Larraya, Beatriz I. R.	04/09/77	26	70
Pagés Larraya, Guillermo L.	08/12/77	22	72
Palazuelos, Patricia/10/77	20	74
Pargament, Alberto José	10/11/76	31	63
Prieto, Hugo Félix	27/04/77	18	77
Provenzano, Julio César	30/03/73	22	68
Raab, Enrique	17/04/77	45	50
Ramus, Carlos	07/09/70	21	67
Rinaldi, Raúl	06/07/76	20	73
Rizzolo, Miguel Angel	14/07/76	21	72
Rosen, Eduardo	16/09/77	24	68
Rosenblum, José	12/08/77	19	76
Sabelli, María Angélica	22/08/72	23	67
Schwartzman, Guillermo	09/06/76	21	72
Segal, Carolina Sara	19/08/76	20	74
Slemenson, Claudio Alberto	04/10/75	20	73
Speratti, Horacio Rodolfo	06/06/76	40	53
Strejilevich, Hugo Daniel	10/04/77	29	68
Tapia Rodríguez, Enrique R.	30/05/76	23	70
Tisminetzky, Claudio	23/12/75	21	72
Toso, Hugo Osvaldo	07/07/76	17	76
Ullman, Eva	17/04/77	22	72
Vaisman, Gustavo Alberto	20/04/76	21	72
Ventura, José Pablo	04/01/77	28	67
Vodovosof, Hugo	04/11/76	21	73
Zazulie, Sara Beatriz	19/06/76	25	69
Zimman, Alicia Noemí	15/03/77	22	72

Some there be

There be of them, that have left a name behind them,
that their praises might be reported. And some there
be, which have no memorial, who are perished as
though they had never been; and are become as
though they had never been born; and their children
after them.

Apocrypha

Only the rustle of reeds
thin pipe smoke
a flickering paraffin lamp
women in blankets bent over
their faces lost to the light.

And remnants:
gate without hinges
stones in a half circle
afterbirths buried in silt.

Can the forgotten
be born again
into a land of names?

Ingrid de Kok

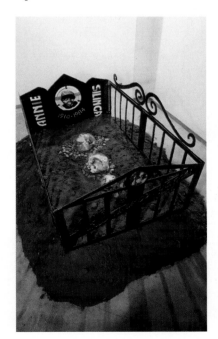

Sue Williamson, *Rest in Peace, Annie Silinga* (1995). When the
exhibition closed, the cradle was returned to Langa graveyard in
South Africa, where Annie was buried.

LEFT: Marcelo Brodsky, list of Colegio Nacional de Buenos Aires killed
and disappeared students and alumni, as it was read in *Memory
Bridge.*

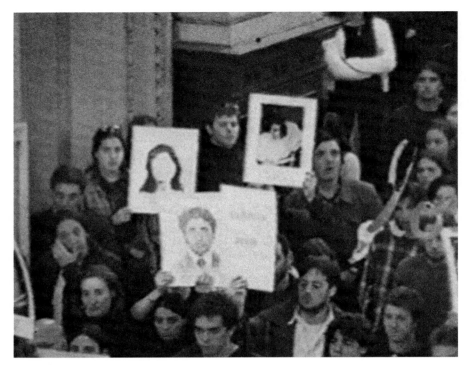

Twenty years after the military coup, the Colegio Nacional de Buenos Aires held an event to remember the students killed or disappeared by the dictatorship. As those students' names were read out, those gathered replied "present," showing that the regime tried, without success, to erase them from memory. Marcelo Brodsky, *Good Memory* and *Memory Bridge* (1996).

Dan Agatep Raralio's bronze Moebius strip, called *Freedom Walk,* has engraved on the outside the names of the disappeared. Inside the strip, passages from Argentine literature appear. *Escultura y Memoria: 655 proyectos presentados al concurso en homenaje a los detenidos desparecidos y asesinados por el terrorismo de estado en la Argentina* (Eudeba: Universidad de Buenos Aires, 2000), 545.

Fabián Eduardo Marcaccio's *Tree of Names* uses iron poles arranged like a forest with names of victims of Argentina's dictatorship engraved on them. *Escultura y Memoria: 655 proyectos presentados al concurso en homenaje a los detenidos desparecidos y asesinados por el terrorismo de estado en la Argentina* (Eudeba: Universidad de Buenos Aires, 2000), 417.

On one side of the wall of the Nangrong Shrine is a list of fallen comrades. Many were radical students who joined the armed struggles in the area after the 1976 massacre in Thailand. *Source: Thongchai Winichakul*

A rural temple in Nongbualamphu, northeast Thailand, commemorates fallen comrades in the 1970s battles with the Thai military. *Source: Thongchai Winichakul*

At the back of the Thammasat University memorial, the names of the dead — as many as are known — are inscribed. At its base is a short passage in Thai and English describing the massacre of 1976. *Source: Thongchai Winichakul*

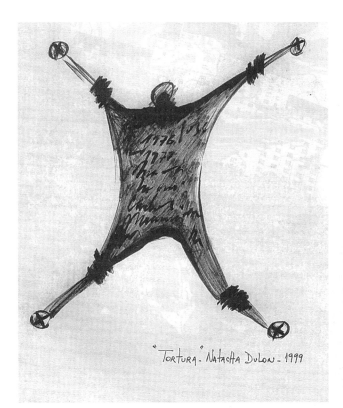

Natacha Dulon's piece, titled *Torture,* inscribes on the body dates and names related to torture during the military dictatorship in Argentina.

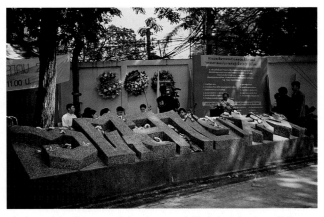

The front of the Thammasat University memorial includes a few bas-relief images depicting the massacre and a brown granite plaque with the Thai date for the massacre: "6 Tula 2519" or October 6, 1976. *Source: Thongchai Winichakul*

Ruins of the Past

NANCY J. GATES MADSEN

[T]he magic of ruins persists, a near mystical fascination with sites seemingly charged with the aura of past events, as if the molecules of the sites still vibrated with the memory of their history —James E. Young

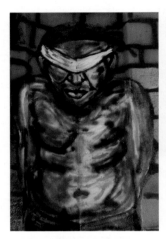

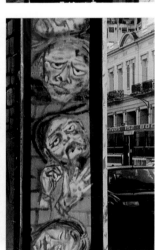

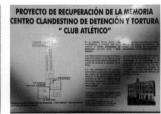

Source: Monica Eileen Patterson and Cynthia E. Milton

The site of the former clandestine detention center El Club Atlético in Buenos Aires remains charged with the memory of past events. Torn down by the junta for the construction of a highway in 1977, Atlético detained hundreds of prisoners during the early period of the dictatorship. Although few victims knew their location while suffering imprisonment and torture in Atlético, at least some sensed the eerie magic of the ruins even after the building was destroyed. While waiting for a bus in 1979, one survivor felt a threatening yet familiar sensation and turned to discover himself standing at the construction site for the highway that passed where the former prison once stood. Soon after the return to democracy, former victims of this torture center responded to the compelling pull of history and petitioned for its excavation, in the hopes of unearthing secrets the military tried

to bury. The government suggested placing a commemorative plaza or plaque at the site, but victims and their families insisted that Atlético needed to be discovered, rather than covered again with an additional layer of memory. Excavation of the site finally commenced in 2002.

Located under a highway overpass, these ruins now form an active archaeological site dedicated to revealing painful memories. To date, excavations have unearthed the basement of the original building, including portions of prison cells, and the space exhibits the unique tension between a state-sanctioned memory site and a more spontaneous call to remember. As Holocaust scholar James E. Young asserts in regard to the preservation of former concentration camps, "On the one hand, we're reminded that it was the state's initial move to preserve these ruins – its will to remember – that turned sites of historical destruction into 'places of memory.' On the other hand, we find that these sites of memory begin to assume lives of their own, often as resistant to official memory as they are emblematic of it."[1] The official sanction of the Atlético excavation lends support and authenticity to the memorializing impulse, yet the site has indeed assumed a life of its own, becoming a space for informal memorials dedicated to the victims. The highway support that rises out of the dig is covered with wrought iron figures apparently climbing out of the ruins, reaching upward as they make their way out of the pit. A modified street sign on one post calls for "Juicio y Castigo" [Justice and Punishment] while an information plaque depicting a figure behind bars reads "Club

Atlético: ex-centro clandestino de detención" [Athletic Club: ex-clandestine detention center]. In addition to these artistic impulses, other highway supports that extend along the street have been covered with graffiti, including poems and drawings that depict faces or bodies in various poses of torment or resistance. Benches in the area display symbols calling attention to the number of disappeared victims and exhort visitors never to forget. A large outline of a human figure lies on the embankment next to the excavation, and each month a group of ex-detainees lights up the form with fireworks in commemoration to victims who did not survive. Inevitably, the space endows the artwork with special meaning, creating a visual dialogue between memory and place. Although some works placed at the site have been targeted by vandals — in 1996, a papier-mâché tree with photographs of disappeared victims was destroyed by Molotov cocktails — the ruins of Atlético are constantly renewing themselves in a continual memorializing impulse.

Despite the numerous artworks that populate the area, the excavation site is not terribly attractive. Its location directly under the highway overpass and alongside a busy city street assures that visitors are bombarded with the constant rumble of traffic moving around the space. Conversation is difficult, and fumes from passing buses and cars have coated the supports and the images they bear with a dull patina. The orange construction signs declaring the site an official project of the city of Buenos Aires and the chain link fence surrounding the dig further detract from the artistic impulses surrounding them. Standing at the site for any length of time, the visitor soon becomes overwhelmed by the noise and fumes, even while attempting to comprehend the solemn significance of the ruins. Nevertheless, when one considers the extent of the horror entombed in Atlético, this ugliness of space seems a more fitting memorial than any beautifully manicured plaza or decorative plaque. Visitors are not drawn to the site by its attractive appearance; rather, those who choose to seek out the ruins do so out of a desire to remember the past in all its horror. For in the end, what better way is there to memorialize a brutal past than through a starkly brutal memorial?

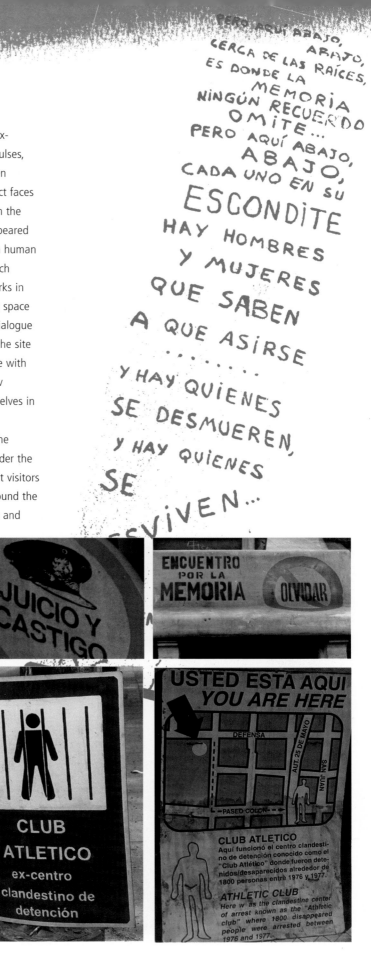

is story...

KSENIJA BILBIJA

There is a story, imagined and written down years ago by Franz Kafka and not burned later on, where a man who refuses to acknowledge his guilt turns into a butterfly. I often think about this image, the guilt metaphorized into a fleeting and beautiful creature, flying away, leaving its origin and living its own, short existence

In October 2000 in Madison, Wisconsin, the Li Chiao Ping dance troupe performed *Other Weapons,* a story by Argentine writer Luisa Valenzuela about a woman's attempt to find the words and meaning to reconstruct her life after being tortured during the dictatorship.
Source: Douglas Rosenberg

elsewhere, allowing for a guiltless society to grow. If this were not a dream, many countries, Argentina, Chile, South Africa, Yugoslavia leading the way for countless others, would be covered with butterflies. But they are not.

Then, there is another story that makes the distinction between truth and illusion even more challenging. It is not even a story but a mere theme of the traitor and the hero, conceived by Jorge Luis Borges. "It needs details, rectifications, tinkering — there are areas of the story that have never been revealed to me," claims the narrative voice under the disguise of the name Borges. "The action takes place in an oppressed yet stubborn country — Poland, Ireland, the republic of Venice, some South American or Balkan state. . . ." It goes on to tell about one possible choice, contemporary Ireland for example, where a great-grandson returns to the village to discover the truth about his heroic ancestor. What he finds out, along with the reader, is that his great-grandfather was a traitor who, relying on Shakespeare's plays *Julius Caesar* and *Macbeth* and, of course, his own imagination, conjured up a spectacle of his own heroic death. He also discovers that the entire village participated in the production of this fiction. Of this truth. Or maybe it is a fiction?

No one wants traitors in their past. We love to have heroes instead, so when life offers us a different story, we imagine, fictionalize and eventually come to believe that what is written must be right. After all, it survived the test of time, and only truth is powerful enough to remain in its purity. We humans love to believe in the power and resilience of truth. The great-grandson from Borges's theme also realizes that his own search for the origins of truth, as well as the origins of his identity, is the outcome of that fictional production. So, he "silences his discovery" and the book that he publishes about his traitorous ancestor is actually an ode to his heroism. In Borges's ploy, history is a manipulated material, and his narrative is helped by the fact that the Spanish language does not distinguish between the words story and history. They are both happily contained in the letters and sounds of "historia." Hi/story that is to be told, written, read, and remembered.

There is an additional, small distinction, also particular to the Spanish language: one of those letters, the first one of the word "historia," the "h," is always to remain silent, yet visually present. So, when memory tells stories and histories, the unspeakable and the unutterable is embedded in it merely resounding in the materiality of the sign. It stands for the stories that never find their

The Chilean dictatorship's security apparatus used the General Cemetery's Patio 29 and its "NN" (No Name) grave markers to hide the bodies of those killed after the 1973 military coup.
Source: Louis Bickford

way into histories, the voiceless stories. But not speechless. And that leads me to another Spanish invention: "a desaparecido." A verb that was not meant to be transitive gave birth during the '70s to a word that denotes an illegally sequestered human body, generally tortured and disposed off, never to be found again. The strategy seemed flawless: eliminate the body as evidence of a crime. And if there is no evidence, then repression will remain even more powerful in its apparent invisibility.

The fear can only grow when bodies are ghostly. "They are neither dead nor alive. They are disappeared," declared General Videla in one of his infamous definitions of the term. These bodies, from which only the personal name and memory remains, haunt the nation, they are the silent yet visible "h" in the country's "historia." Just like the legal term taken from Latin, habeas corpus that literally means "you must present the body" and whose subjunctive form echoes a desperate urgency of the families who were searching for their "desaparecidos." In the Argentina of the late '70s and early '80s this term came to signify the corporeal absence. And only those who were not paralyzed by fear actually filed a writ of habeas corpus for their disappeared relatives.

It is believed that in Argentina 30,000 people remain today under the ghostly category of the "desaparecidos." Due to the reductive nature of language, all history, as well as every story, is fragmentary. And due to the repressive and

Argentine artist Alicia Gil depicts "desaparición" and its English translation "disappearance." The black background alludes to death, while the contrasting white letters suggest nothingness. The empty spaces at the bottom of the piece represent the disappearances.

authoritarian government's actions many of its citizens were to be broken by torture, fragmented and then erased: bodies thrown into the River Plata, buried in mass graves under the shattered sign NN, disposable bodies that had no right to even carry the name or have a place in death. No name, non nominatus. Their story, written in silent letters and contained in dismembered language eludes representation but resonates in the present.

Detained and repressed in the unconscious of many of those who remain alive, the story of the times of the dictatorship awaits to be deciphered and read. By the subjects as well as by the nation as a collective. "The information was in the newspapers, but the facts, although obvious, are devoid of meaning, they are isolated fragments of what is happening. They are inscribed in the unconscious, but the subject that perceives them is absent, it erases them and erases itself with the same gesture. The written facts don't talk by themselves if the subject doesn't question them. By blocking their transaction the fact is inscribed as a trace, mark, unconscious record, but not as a memory," argues Argentine psychoanalyst Gilou García Reinoso. I think of a novel, *Black Novel (With Argentines)* published in 1990. Written by an Argentine author, Luisa Valenzuela, this novel revolves around a male writer who lives in New York after the military dictatorship in his country has collapsed. He's trying to explain to himself why he has just killed a woman he barely knew and who did nothing to provoke him. Is he branded by violence as a national subject? Is the guilt he feels as an Argentine who survived the so-called Dirty War unconsciously determining his present gestures? Is the energy that he employed in order to blind and deafen himself, in order not to acknowledge the violence on the streets, now bursting out? The reader does not find answers in Valenzuela's work, but numerous questions that need to be voiced.

Borges's stratagem of a traitor and a hero raises yet another related issue: "The idea that history might have copied history is mind-boggling enough; that history should copy literature is inconceivable," says the narrative voice who would like to appear as omniscient, but who is also sadly aware that such desire is only a product of our endless vanity.

He brings to the reader's mind plays written by Shakespeare, *Macbeth* and *Julius Caesar*, and the fact that they not only inspired the great-grandfather's plotting of his own death, but also, generations later, his great-grandson's decision not to write a "true" biography of his ancestor. Is it possible that fiction can prefigure history? This is certainly a question that many readers

In January 1998, a poster appeared throughout Buenos Aires inviting people to spit on the photograph of Captain Alfredo Astíz, an infamous murderer during Argentina's dictatorship.

of Elvira Orphee's 1977 novel *The Last Conquest of Angel* asked themselves during the 1985 trials of the military commanders in Argentina. How could the blond Angel from her story be so much like the Naval Captain Alfredo Astiz — a man whom the Mothers of the Plaza de Mayo endearingly called the "Blond Angel" — if she wrote the novel in 1975, long before the dictatorship began and Astiz found it necessary to infiltrate the Mothers' ranks and cause the deaths of two French nuns and a Swedish Argentine woman Dagmar Hagelin, among many others?

"I was so unconscious of it all," said Elvira Orphee in an interview, only a few days before 100,000 people marched from the Congress to the Plaza de Mayo remembering the March 24 of a quarter of a century ago when the military took over the government. "I came back in 1983 and I even sent my book to a marine officer who never read it," she explains. Yet, the scripts of history seem to repeat themselves, and writers, the true ones, are able to sense its pulse and translate it into words.

Then, it is up to the readers to decipher and give meaning to the stories, which become histories.

"Silence is health," read the banner that José López Rega, Isabel Perón's Minister of Social Welfare, posted around the Obelisk in the center of Buenos Aires some time before the 1976 military coup. Although its original meaning intended to remind the drivers not to use their horns unnecessarily and reduce the noise, it actually prompted citizens not to verbalize the seen/scene. "Don't get involved," "Don't interfere," "Nothing is happening here," are some of the expressions that permeated the national psyche during the dictatorship. The fear of the unspoken was so much greater than anything that could be put into words, that even within families, behind the walls of homes

that no longer offered its proverbial sweetness, the rule of silence remained. "No one ever asked anything. We never talked about it. It was like an order," remembers Alejandra Naftal, a high school student disappeared for about nine months, after she miraculously came home. "Don't tell us anything," her parents warned her when they were all alone in the house.

It was months later – when she finally decided to leave Argentina – that she could find not only equivalents in language for what had happened to her but also willing listeners for her story. Silence is health, and Alejandra Naftal was summoned to remain silent for a long time. "You were not there, you erased yourself, they erased you, but it stayed within you and it marked you: your body, your nights and your dreams, your children to whom you pass what you know and what you can not and don't want to know," said Gilou García Reinoso while trying to explain how the individual is branded by the traumatic and unverbalized experience. The experience that goes beyond any language, and yet, the experience that needs to find its way into language. And what about those who were not within the realm of language yet? Could they sense what was in the air? It is said that babies born during the first few years of the Dirty War, the worst and most repressive years, cried endlessly. In their mothers' arms, in their cribs, they cried and cried and cried. It did not matter if they had other siblings or not, or if the family was directly affected by the atrocities: babies weeped, shrieked, and screamed until they were big enough to understand that silence was health.

"From the bottle, fear is drunk sip by sip," Milagros King wrote 20 years after the beginning of the dictatorship, maybe in an attempt to shed light on the cries of those babies born during the war that was dirty. Her Aunt Beatriz, a well-known Argentine psychoanalyst, was disappeared at the age of 30. Fear permeated the pores of society as well as family. Today Milagros is 29 years old. She was a toddler when her aunt was taken away, and she has a story to tell. "Although nobody told me anything, even as a small girl I was afraid that some bad people in a car would come and take my mommy away. Then, I would never see her again. My nightmare did not abandon me throughout my childhood." When Milagros was about 10 she discovered her aunt was disappeared. The year was 1985 and the trials of the members of the military junta were on the front page of every newspaper. But, in the mind of a 10-year-old, the word "disappear" still did not have ghostly connotations. "So, did your aunt appear yet?" her friends in school would ask. "No, she did not," Milagros had to reply every time. "Don't worry, one day she will appear for sure." Other 10-year-olds would comfort her. "So, for years I thought that she

María Milagros King

1996
Translated by Ksenija Bilbija

We didn't know.
We were raised in grief.
It's better not to ask.
Sip by sip,
fear is sucked from the bottle.
Hide-and-seek was our game
Count til ten
Against the wall
Then open your eyes
And see nothing except an empty street.
At times we didn't understand the despair of silences.
But, it's better not to ask.
Just in case.

María Milagros King was born in December of 1975, some four months before the military dictatorship in Argentina. She was only two and a half when her Aunt Beatriz was abducted and later forever "disappeared" by the repressive government. She remembers nothing about the moment of her aunt's disappearance. However, her childhood was marked by the perpetual fear that one day some bad men would come and take her mom away. While growing up, Milagros learned not to ask too many questions. Although her mom was not killed, the fear of asking questions remained.

"The game of hide-and-seek seemed to me as a good metaphor for the disappearances. The poem is about silence, dense and heavy with questions and fear. I tried to express what my generation felt in those times of anguish, times we could not comprehend, but only sense. Writing and talking about it is a way of healing those childhood wounds."

One of Argentina's former dictators stated that "a 'disappeared' is an unknown [person] without substance, neither dead nor alive." But what his statement neglects is the persistence of memory that combats efforts to "disappear" people from Argentine consciousness.

must be doing well, wherever she was, and that one day, she would appear." "We were afraid to ask," repeats Milagros over and over and over. "At times we didn't understand the despair of silences. But, it is better not to ask, just in case," concludes a 20-year-old Milagros in her unnamed poem.

"It happened slowly, from behind, between the lines" writes Graciela Perosio, Milagros's mother and Beatriz's only sister, in her poetry collection *Breaches in the Wall*. What cannot be told in words but echoes in them, what escapes all language known to humans is what stays between the lines. After all, mother and daughter draft the same story of fear rendered invisible. They are tracing the disappeared past, or, one should say, the history.

Which, again, leads me to another related story also foretold by Borges. In his "Theme of the Traitor and the Hero" a great-grandson embarks upon the decipherment of his great-grand-father's past. On some level his search becomes a story of filiation. This aspect is even more pronounced in Bernardo Bertolucci's cinematographic rendition of Borges's theme. *Spider's Strategem* is a 1970 film set in Italy after the Second World War

and the fall of fascism. Unlike Borges, Bertolucci shortens the time period between the story formation and historical ossification: he introduces a son who traces his father's collaborationist past, his subsequent betrayal, and the inversion of the truth. However, in both avatars, the urge to search the progenitor's path comes from an heir, a son, or a great-grandson. In the story, as well as the history of Argentina, that link is missing. "Identity, we are searching for our identity," many Argentines in their late 20s would say. And they are not talking about ethnic or racial identity, they are not thinking, even remotely, about multiculturalism, they are referring to their right to know where they came from, literally the womb and seed that gave them life.

"Do you know who you are?" This question awaited the visitors who in the weeks of March 2001 entered the space of the exhibit called "Identity" in the Cultural Center Recoleta in the heart of Buenos Aires. The space is large. Its whiteness is only broken by the stream of photographs that meet the eyes of visitors. They could be described as repetitive, monotonous even. All the same size, same shape, all telling the same story. A picture of a young man, followed by a picture of a young woman known to be pregnant at the time of her disappearance, followed by a mirror, followed by a brief story of disappearance. "Do you know who you are?" is the question that all those born in the years of the Dirty War, 1976–1983, should ask themselves as they look at the man, then look at the woman, read the story and direct their gaze to the mirror. Maybe some of those babies who cried endlessly, who had to take a bottle instead of their mother's breast, who, in the words of Milagros King's poem were "raised in grief" can recover their stolen identities, the story of their origins, and replace the mirror with their own photograph. Regardless of the outcome of their story, all of them, those who find out that they have been stolen from their parents, those who knowingly remain with their imposed families, those who decide to accept their grandmothers, they are all a war booty. And, we should never forget that the war was called dirty. "The idea is that one of those kids, could now say: they disappeared me, the murderers did it, but my own parents set me forth to that terrible destiny of being disappeared, while living," argues one of the characters in Elsa Osorio's 1999 novel *After Twenty Years, Luz*. Her name is Luz or Light. After two decades she is telling her life story, (or, is it history?) to her biological father who thought that she died right after birth. The one who gave her birth can not tell her story because she was disappeared soon after, her father never looked for her because he was told that his daughter did not survive the birth. She herself believed for many years that she

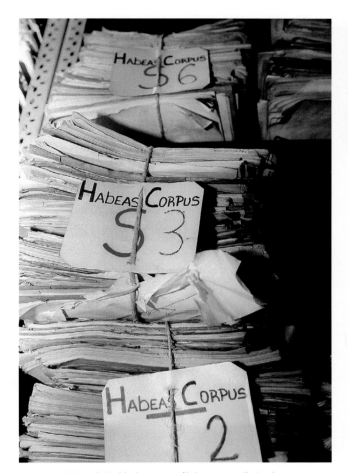

Argentine artist Marcelo Brodsky depicts writs of habeas corpus collecting dust in government archives in *Habeas Corpus S-T* (2001).

Argentine artist Marcelo Castillo places the names of 500 children believed to have been born in clandestine torture centers, but whose fates remain unknown, between the two words "disappearance" and "appearance."

was carried in the womb of the woman she called her mother. Now she is telling him her history, the one she pasted together based on the fragmented stories of many. No longer a speechless baby, she is also asking questions: "Don't you think that if you were such experts in revolution, you should have asked yourselves if you had the right to set forth that child that you wanted in those circumstances, to be disappeared, just like you were, to have his identity stolen. Those babies did not have the opportunity to weigh, in terms of any ideology, the risks that their parents took. Was that called revolutionary moral or is it pure selfishness?"

These questions come from a novel. Luz is a character. Elsa Osorio, a young woman during the dictatorship, now lives in Spain. She once told me that even after the dictatorship ended she could not set foot on the university grounds and teach again. The fear remains. Disgust and the feeling of humiliation too.

Once, the logic of the military rule led their followers to believe that by disappearing the bodies of the victims, the crime inscribed on them would be also erased. Democratic society cannot allow itself to continue with the policy of erasure, any erasure. Not wanting to remember, not wanting to talk, not wanting to listen, not wanting to ask and know, leads to erasure. Demolishing the building in which hundreds of people were brutally tortured and whose name, ESMA, embodies fear will not bring peace to the nation in spite of the wishful thinking of its president. The crime inscribed onto bodies of those whose murder was named disappearance, needs to be told and written. The process is painful because it entails repetition, but then, isn't that exactly what Thursday walks of the Mothers of the Plaza de Mayo are all about? ◼

About the Countries

JELENA SUBOTIĆ

Argentina

In a coup in 1976, the democratic government was overthrown and replaced by a military regime that remained in power until 1983. During that time, a junta with a leader from each of the three branches of the armed forces ruled the country. Its repressive apparatus killed or "disappeared" an estimated 9,000 to 30,000 individuals, considered left-wing "subversives" by the military regime, in the numerous clandestine detention centers around the country. Survivors recounted the physical and psychological torture they experienced in these centers. Eventually, the military regime stepped down in national and international disgrace resulting from the collapse of the economy, embarrassing defeat in a war with Britain over the Falkland/Malvinas Islands, and its extensive human rights violations. A new democratically elected government under Raul Alfonsín (1983–89) appointed a commission to investigate and document the military's abuses. CONADEP titled the final report *Nunca Más*, or Never Again. President Alfonsín responded to the report with both reparations to victims and prosecutions of the perpetrators of state violence under military rule. In the famous "Trials of the Generals," the top leaders of the juntas received prison sentences, while other leaders in the repressive apparatus also went to prison. But a series of coup attempts led by lower-ranking officers called the *carapintada* (painted faces), ended the prosecutions. President Alfonsín issued first a Full Stop Law and a Due Obedience Law, which provided members of the military with immunity from prosecution. His successor, President Carlos Menem (1989–99), continued the immunity process by granting a pardon to the generals. The courts have succeeded somewhat in circumventing the prevailing immunity and prosecuting officers. In most cases, these constitute crimes not covered by the amnesty laws, specifically the robbery of goods and the kidnapping and illegal adoption of children born in the clandestine detention centers. Former chief of state Jorge Videla, junta member Admiral Emilio Massera, and former commander of the First Army Corps Carlos Guillermo Suárez Mason were among a dozen retired officers held under house arrest on charges of ordering the theft of babies born to mothers in secret detention and their handover for adoption to military families. Recently, Argentine courts have ruled that victims and families have a right to demand state investigations of human rights crimes. In 2001, federal courts invalidated Argentina's laws barring prosecution for serious human rights crimes as unconstitutional and in violation of international law, and Argentina has since seen some notable advances in investigations of human rights violations committed under military rule. In July 2002, the Federal Court ordered the house arrest of former military ruler Leopoldo Galtieri for the "disappearance" in 1979 and 1980 of eighteen members of the Montoneros, a left-wing Peronist guerrilla organization. Facing charges as well were former army chief General Cristino Nicolaides and Suárez Mason, both of whom were already under house arrest. The court also ordered the arrest of some 40 lower level police and army agents. While the government nominally supports the trials, it opposes any change in the legal status quo defined by the amnesty laws. At the end of 2002, the Supreme Court had still to rule on appeals of the two federal court rulings striking down the amnesty laws. The future of the continuing trials is dependent on the Supreme Court upholding the nullification of these laws.

Sources

Center for Legal and Social Studies (www.cels.org.ar).

Derechos Human Rights – Argentina (www.derechos.org/nizkor/arg/eng.html).

Hayner, Priscilla B. 1994. "Fifteen Truth Commissions – 1974 to 1994: A Comparative Study." *Human Rights Quarterly*, vol. 16, no. 4 (1994), 600–655.

Human Rights Watch. 2003. *World Report 2003: Argentina.* Washington, DC: Human Rights Watch.

International Center for Transitional Justice (www.ictj.org).

Kritz, Neil J., (ed). 1995. *Transitional Justice: How Emerging Democracies Reckon With Former Regimes.* Washington, D.C. : United States Institute of Peace Press.

Mothers of the Plaza de Mayo Association (www.madres.org).

Nunca Más (www.nuncamas.org).

Bosnia

The disintegration of the former Yugoslavia in the early 1990s was followed by a brutal civil war that engulfed most of the country. The conflict in Bosnia ended in December 1995 with the signing of the U.S.-brokered Dayton Peace Accords by the governments of Bosnia, Croatia, and the Federal Republic of Yugoslavia (Serbia and Montenegro). The Dayton Accords put an end to nearly four years of war, which had caused the deaths of more than 200,000 people and displaced millions. To varying degrees, all parties to the conflict were guilty of the practice of "ethnic cleansing"— the forcible deportation and displacement, execution, confinement in detention camps or ghettos, and the use of siege warfare to force the flight of an "enemy" ethnic

population. Serbian forces, who are believed to have committed the majority of crimes, were made up of military, police, and paramilitary units. They detained hundreds, possibly thousands, of persons in detention camps, and engaged in organized campaigns of ethnically inspired murder, expulsion, and rape. Croatian forces brutally executed Bosnian Muslims on a number of documented occasions, and evicted Bosnian Muslims from cities under Croatian control. In the biggest single atrocity committed during the 1992–1995 Bosnian war, and the first documented instance of genocide in Europe since World War II, more than 7,500 Bosnian Muslim men were killed by Serbian forces in the city of Srebrenica in July 1995. The war in Bosnia ended after the NATO military intervention in 1995. Although a NATO-led peacekeeping force was deployed to implement the Dayton Peace Accords, seven years later many of the agreement's provisions remain unfulfilled, most notably the return of refugees to their homes and the arrest of officials and officers indicted by the International Criminal Tribunal for the former Yugoslavia (ICTY) for war crimes and crimes against humanity. In addition, Bosnia remains ethnically segregated into two entities, the Serb-dominated Republika Srpska and a tenuous Muslim-Croat feder-ation. The Hague-based ICTY was established under the auspices of the UN Security Council in 1993. The tribunal has delivered precedent-setting decisions, such as finding that rape and sexual slavery constitute crimes against humanity. Many high-ranking officials of the Serbian and Croatian armies, as well as low-ranking soldiers, were prosecuted and convicted by the ICTY, with sentences up to life imprisonment. The June 2001 transfer of former Yugoslav president Slobodan Milošević – widely perceived as the single most important organizer of the ethnic cleansing campaigns – to stand trial in The Hague before the ICTY is an important victory against impunity. Most significantly, Milošević was charged with genocide – crimes committed with the intent to destroy a national, ethnic, or religious group – the most serious offense under international law. However, a number of Serbian military or government officials – including Bosnian Serb leader Radovan Karadžić and army chief Ratko Mladić – still remain at large. As a complement to the work of the ICTY, Bosnian civil society groups and members of the international community have called for the creation of a national truth and reconciliation commission. Draft legislation for the establishment of such a commission has been agreed to with the ICTY, and will soon be presented to the appropriate legislative bodies for possible adoption.

Sources
Human Rights Watch. 1993. *World Report 1993: Bosnia-Herzegovina.* Washington, DC: Human Rights Watch.
Human Rights Watch. 1994. *World Report 1994: Bosnia-Herzegovina.* Washington, DC: Human Rights Watch.
Human Rights Watch. 2002. *World Report 2002: Bosnia-Herzegovina.* Washington, DC: Human Rights Watch.
Human Rights Watch. 2001. *Bosnia: Arrest of Srebrenica Indictee Hailed.* Washington, DC: Human Rights Watch.
International Center for Transitional Justice (www.ictj.org).
International Criminal Tribunal for the Former Yugoslavia (www.icty.org).
Office of the High Representative in Bosnia and Herzegovina (www.ohr.int).

Cambodia

In 1975, the Khmer Rouge, under the leadership of Pol Pot, seized control of Phnom Penh and deposed the US-sponsored government of Lon Nol. The Khmer Rouge renamed the country the Democratic Kampuchea, and Pol Pot became prime minister. Phnom Penh was immediately evacuated, and the entire Cambodian urban population was forced to move to rural areas and work as farmers. Most of the country's technology, such as vehicles and machines, were destroyed because the Khmer Rouge opposed Western machinery and know-how. It is estimated that two million Cambodians died from execution, starvation, and disease during the Khmer Rouge rule from 1975–1979. Members of the upper, middle, or educated classes, as well as anybody the regime suspected was an "enemy," were killed in a systemic genocide. In 1978, the Vietnamese army invaded, and took over Phnom Penh in 1979. The Khmer Rouge was driven into the countryside, but the government of the Kampuchean People's Republic, led by Pol Pot, was still recognized by the United Nations as the legitimate government of Cambodia. Various guerrilla factions formed throughout the 1980s and had frequent skirmishes with the Vietnamese army and the Khmer Rouge. Cambodia's first democratic elections were held in May 1993, under the supervision of a large UN peacekeeping mission. A coalition government with co-premiers Prince Norodom Ranariddh and Hun Sen was formed. The Khmer Rouge boycotted the elections, and it continued armed opposition and maintained control of large portions of Cambodian North and West. A new constitution reinstated the monarchy, and Sihanouk became king

in September 1993. Fighting continued after attempts at mediation with the Khmer Rouge failed. The Khmer Rouge split into two factions in 1996, one of which made an agreement with the government. Pol Pot was ousted and detained by the remaining Khmer Rouge in 1997. He died in 1998 in exile. Almost immediately, the Khmer Rouge lost most of its remaining power and support. While Cambodians have made their desire for justice clear, many former leaders of the Khmer Rouge, including Nuon Chea, Pol Pot's notorious deputy, live freely among their victims. Since 1997, the United Nations and Cambodian government have been negotiating the establishment of a tribunal for the Khmer Rouge, modeled after those in the former Yugoslavia and Rwanda. In 1999, UN experts wrote a report asking for the establishment of an international tribunal, concerned with the lack of independence and confidence in the Cambodian judiciary's ability to prosecute the perpetrators. Prime Minister Hun Sen rejected the appeal. In 2000, the United Nations agreed to participate in the first "mixed tribunal," made up of a majority of Cambodian judges and co-prosecutors. Negotiations have stalled since, amidst widespread fear that the Cambodian tribunal would fail to meet international standards of independence and integrity.

Sources

Human Rights Watch. 2002. *Cambodia: Khmer Rouge Tribunal Must Meet International Standards.* Washington, DC: Human Rights Watch.

International Herald Tribune. 2002, December 27. *Cambodians, Too, Deserve Justice.*

The Columbia Encyclopedia. Sixth edition. New York: Columbia University Press, 2002.

Chile

In September 1973, the Chilean armed forces under General Augusto Pinochet staged a coup against President Salvador Allende. The brutal coup resulted in Allende's death and in the execution, detention, or expulsion of thousands of people. In 1974, Pinochet became the undisputed leader of Chile, and in 1977 he abolished all political parties and restricted human and civil rights. Pinochet's military junta imposed a state of siege across the country, detaining members and sympathizers of the Allende government, members of the Socialist Party, the Communist Party, and the extreme-left Movement of the Revolutionary Left (MIR). The newly formed Directorate of National Intelligence (DINA) was responsible for most acts of brutal oppression. It is estimated that more than 3,000 people were victims of executions, "disappearances," and killings between 1973 and 1990. Government agents secretly disposed of more than 1,000 of these victims, presumably after torturing and killing them. The exact fates or places of burial of most "disappeared" remain unknown to this day. In addition to extra-judicial summary executions, "disappearances," and torture, Pinochet's regime was also responsible for widespread arbitrary arrests, exile and internal deportation of government opponents, and other gross violations of human rights. Pinochet lost the October 1988 plebiscite, held to determine if he would hold power for another eight years. He was forced to hold presidential elections in 1989, at which time former senator Patricio Aylwin became president. Aylwin soon established a "National Commission for Truth and Reconciliation" headed by Raul Rettig, with the aim of investigating abuses of the Pinochet dictatorship. In presenting the commission's final report to the public, President Aylwin formally apologized to the victims and their families on behalf of the Chilean state. The "National Corporation for Repression and Reconciliation" was established to continue the work of the commission and oversee reparations to victims. In 1999, representatives of the armed forces participated in a roundtable dialogue with human rights lawyers and representatives of the church and civil society. In October 1998 Pinochet was detained in London on charges of genocide, terrorism, and torture. The indictment was filed by Spanish judge Baltasar Garzón. This was the first time a former foreign head of state had been detained abroad for extradition on charges of grave human rights abuse in his own country. Pinochet returned to Chile in March 2000, where the courts ruled that he was mentally incapacitated to stand trial. Although the Supreme Court decision satisfied members of the government, the armed forces, and the Catholic Church, many Chileans remained unconvinced that Pinochet was too ill to be prosecuted. The courts achieved justice in other cases dating from the military dictatorship. Carlos Herrera Jiménez, a former army intelligence agent, was sentenced to life imprisonment for the 1982 murder of trade union leader Tucapel Jiménez. The director of army intelligence at the time, Ramsés Álvarez Scoglia, received a ten-year prison sentence for ordering the murder. Three other former army generals who helped cover it up received reduced sentences. Human rights organizations welcomed the increasingly aggressive actions by Chilean courts in bringing perpetrators of Pinochet-era crimes to justice.

Sources

Hayner, Priscilla B. 1994. "Fifteen Truth Commissions – 1974 to 1994: A Comparative Study." *Human Rights Quarterly*, vol. 16, no. 4 (1994), 600–655.

Human Rights Watch. 1999. *When Tyrants Tremble: The Pinochet Case.* Washington, DC: Human Rights Watch.

Human Rights Watch. 2003. *World Report 2003: Chile.* Washington, DC: Human Rights Watch.

Kritz, Neil J., (ed). 1995. *Transitional Justice: How Emerging Democracies Reckon With Former Regimes.* Washington, D.C. : United States Institute of Peace Press.

Croatia

The civil war in Croatia erupted after Croatia's declaration of independence in 1991. Croatian Serbs refused to recognize the legitimacy of the new state and declared the predominantly Serbian areas of Slavonija and Krajina as independent Serbian territories. The intense armed hostilities, population expulsions, and summary executions were at their peak from 1991 until 1992, when the tensions in Croatia somewhat decreased, and the war focus turned on Bosnia. In the course of the Croatian war, both Serbs and Croats engaged in mass atrocities, the Serbian siege of the Croatian city of Vukovar in 1991 being among the most notorious. In August 1995, however, the Croatian Army launched "Operation Storm," an offensive to retake the Serb-dominated Krajina region. The offensive, which lasted a mere 36 hours, resulted in the deaths of an estimated 526 Serbs, 116 of whom were civilians, and in the displacement of an estimated 350,000 who fled Croatia in the immediate aftermath. Seven years after the Dayton Peace Agreement brought peace to the region, most of the displaced Croatian Serbs had still not returned home. While the Croatian military broke humanitarian laws during the course of the offensive by shelling the retreating Serbian civilians and soldiers, the vast majority of the abuses committed by Croatian forces occurred after the area had been captured. These abuses, which continued on a large scale even months after the area had been secured by Croatian authorities, included summary executions of elderly and infirm Serbs who remained behind and the wholesale burning and destruction of Serbian villages and property. In the months following the August offensive, at least 150 Serb civilians were summarily executed and another 110 persons forcibly disappeared. Although some steps have been taken by the Croatian government to purge its ranks of abusive police officers, prosecution of such officers and, more particularly, of abusive members of the Croatian army remained largely inadequate. Croatian

cooperation with the International Criminal Tribunal for the former Yugoslavia (ICTY) has been mostly insubstantial. Under strong international pressure, the highest ranking indicted Croat, General Tihomir Blaškić, voluntarily gave himself up to the tribunal in 1996. Croatia's own war crimes tribunal made a show in 1996 of trying eight Croatians for killing eighteen elderly Serbs after Croatian forces retook Krajina. The court, however, found no evidence to incriminate six of the eight and sentenced the other two for burglary. In 1999, under the threat of United Nations sanctions and rising diplomatic pressure, Croatia agreed to extradite indicted Bosnian war crimes suspect Mladen Naletilić Tuta to the ICTY. There was considerable progress in Croatian cooperation with the ICTY with the 2000 inauguration of new president Stipe Mesić. General Ademi, indicted for killing at least 38 people and other abuses committed by troops under his command in 1993, surrendered voluntarily to the ICTY in 2000. Another Croatian general, indicted for killings, house destruction, and other abuses against Croatian Serbs in 1995 remained at large. In 2002, the ICTY prosecutor indicted retired General Janko Bobetko for war crimes committed against Croatian Serbs in 1993. Croatian government officials have refused to surrender Bobetko, arguing that he was only doing his constitutional duty to protect Croatia's territorial integrity. Also in 2002, six former military police were arrested on charges of torturing and killing non-Croat detainees in the Lora military prison in 1991. This trial ended in a scandal when all suspects were acquitted, and the judge, a member of an extremist right-wing party, openly questioned the validity of the indictment and led a highly biased and politicized trial throughout the proceedings. While the Mesić administration continues to cooperate with the ICTY, domestic pressures from the Croatian Catholic Church, war veterans' associations, and right-wing political parties are persistently obstructing attempts to bring perpetrators to justice and start a process of national reconciliation and healing.

Sources

Human Rights Watch. 1996. *Impunity for Abuses Committed During "Operation Storm" and the Denial of the Right of Refugees to Return to the Krajina.* Washington, DC: Human Rights Watch.

Human Rights Watch. 2002. *Croatia Failing Test on War Crimes Accountability.* Washington, DC: Human Rights Watch.

Human Rights Watch. 1993–2002. World Reports 1993–2002: Bosnia-Herzegovina. Washington, DC: Human Rights Watch.

International Criminal Tribunal for the Former Yugoslavia (www.icty.org).

Guatemala

For the past 50 years, Guatemala has been plagued with violence that resulted in 150,000–200,000 deaths, countless massacres, destruction of nearly 700 villages, assassinations, death squads, and dislocation of over a million people. The beginning of the cycle of violence can be traced to 1954, when the United States government, looking for friendly allies for its anti-communist efforts in the hemisphere, helped overthrow the democratically elected and socially reformist government of Jacobo Arbenz. In 1963, a military coup completed the shift from civilian to military rule and the army began to extend its influence into all facets of state and society, repressing those in the left, progressive church, and labor movements and assassinating and "disappearing" prominent opposition leaders. The first civilian massacres and significant violence by insurgent groups occurred in 1965, when 28 prominent members of the two main insurgent groups MR-13 and PGT went "missing," the victims of a military kidnapping. In retribution, the FAR insurgent group kidnapped government officials, hoping to pressure the military for the release of prisoners. This type of guerrilla action and military counter-insurgency continued until the late 1970s. The peak of violence occurred from 1978 to the mid-1980s, referred to as *La Violencia*, and targeted rural areas, particularly where Mayan people lived. Perceived as guerrillas or guerrilla sympathizers, Mayan and other rural villagers faced systematic executions and random assassinations to eliminate and intimidate rural opposition. In 1980 the military massacred mostly Mayan farmers at the Spanish Embassy. Guerrilla activity peaked in 1981 when insurgent groups united in the Guatemalan National Revolutionary Union (URNG). The toll of *La Violencia* included 626 Mayan villages razed, approximately 150,000 dead, and 50,000 disappeared. Under pressure from the United Nations, the Catholic Church, and numerous foreign governments, the military and URNG engaged in negotiations in 1986. For the first time in more than 30 years, Guatemalans elected a civilian reformist president, Marco Vinicio Cerezo Arévalo. Tensions eased somewhat, and the UN-brokered Commission for Historical Clarification (CEH) was established in 1994, with the aim of investigating the human rights abuses of the past decades. In 1999 the commission published the report "Memory of Silence," which documented over 42,000 victims of human rights violations. State forces and paramilitary groups were responsible for 93 percent of the documented cases, the URNG insurgents for 3 percent, and unknown parties for the remaining 4 percent. The most damning charge, however, was the discovery that the army had carried out acts of genocide against Mayan communities between 1981 and 1983. In addition, the CEH report recommended several measures to promote reconciliation and end impunity: reforms of the judiciary and security apparatus, a program of victims' reparations, exhumations of victims from clandestine cemeteries, an administrative purge of the armed forces, and the creation of a commission to follow up on other CEH recommendations. Human rights issues received an unprecedented boost with the 2000 inauguration of President Alfonso Portillo. Within two months, Portillo declared a national day in honor of the victims of the civil conflict, ratified the Inter-American Convention on Forced Disappearances and admitted state responsibility for past violations. One of the first successful prosecutions was the 2002 trial of three senior officers charged with planning the 1990 murder of anthropologist Myrna Mack. Juan Valencia Osorio, sentenced to 30 years, was the first senior military officer to be jailed for human rights violations committed during the civil war. His co-defendants, Augusto Godoy Gaitán and Juan Guillermo Oliva Carrera, were acquitted. Limited progress was made in a case involving charges pressed by 21 indigenous communities against former presidents Romeo Lucas García and Efraín Ríos Montt, as well as top military officers for alleged war crimes and crimes against humanity, including genocide, committed in the early 1980s. Yet, serious human rights problems remain. Guatemala's weak judicial system continued to allow perpetrators virtual impunity. Justice officials, witnesses and lawyers continue to be intimidated, and the Guatemalan military refuses to cooperate with the civilian justice system. Former General Efraín Ríos Montt, the 1982 coup leader and head of the country during *La Violencia,* became president of the Guatemalan congress although he lost power in the 2003 election. The exhumations have led to few trials and local and national human rights leaders continue to receive death threats for their outspoken challenges to impunity.

Sources

Guatemalan Commission for Historical Clarification. 1999. Guatemala Memory of Silence (http://shr.aaas.org/guatemala/ceh/report/english/toc.html).

Human Rights Watch. 2002. *Guatemala: Political Violence Unchecked.* Washington, DC: Human Rights Watch.

Human Rights Watch. 2002. *Guatemala's Verdict a Victory for Military Accountability.* Washington, DC: Human Rights Watch.

The Peace Accord and the Commission for Historical Clarification (http://www.caske2000.org/countries/guatemala/truth.htm).

Indonesia

Indonesia was ruled for 32 years by General Suharto, during which time the armed forces were responsible for widespread human rights abuses. During massive unrest in 1965, thousands of alleged communists were executed. The military instigated violence throughout the country, often carried out by anti-communist Muslims and other rural groups. A massacre ensued, with an estimated 750,000 people killed, primarily communists and ethnic Chinese. In east and central Java and in Bali entire villages were wiped out. East Timor, a former Portuguese colony, was forcibly annexed by Indonesia in 1975, and until 1999, the population of the island suffered brutal occupation and violence. In August 1999, Indonesia allowed a referendum on the territory's future. Fighting in East Timor between government security forces and anti-independence militias on one side and separatist guerrillas on the other increased as the vote approached. In August, 79 percent of the voters chose independence, but the territory descended into chaos as pro-Indonesian militias and the army engaged in a campaign of terror and brutality, killing an estimated 1,000–2,000 Timorese, destroying much of the territory's infrastructure. The crimes included mass murder, torture, assault, forced disappearance, mass forcible deportations, the destruction of property, and rape and other sexual violence against women and children. Between 200,000 and 500,000 refugees fled or were forced to go to West Timor. The UN Transitional Administration in East Timor (UNTAET) has established a special prosecutions unit to prosecute high-level perpetrators of human rights. A commission for reception, truth, and reconciliation was inaugurated in early 2002 in order to help reintegrate perpetrators of less serious offenses and account for past crimes. In Indonesia proper, the Ad Hoc Human Rights Court was established in 1999 to prosecute those responsible for human rights abuses, although it is only now beginning to hear cases. In the cases decided thus far, all nine Indonesian military and police personnel have been acquitted, while the only two persons convicted were East Timorese. In addition, some military officers implicated in atrocities in East Timor have actually been promoted. In February 2003, the East Timor Special Panel for Serious Crimes filed an indictment against "The East Timor 8" — four Indonesian generals, three colonels, and the former governor of East Timor — for crimes against humanity. The charges include murder, arson, destruction of property, and forced relocation for the period before and after the 1999 referendum. The accused include former Indonesian Minister of Defense and Armed Forces Commander General Wiranto. All of the suspects are believed to be in Indonesia, but the Indonesian government has thus far refused to extradite them to East Timor.

Sources

East Timor Transitional Administration (www.gov.east-timor.org).

EastTimor.com (www.easttimor.com).

Human Rights Watch. 2002. *Justice Denied for East Timor*. Washington, DC: Human Rights Watch.

Human Rights Watch. 2003. *Indonesia Should Hand Over the "East Timor 8."* Washington, DC: Human Rights Watch.

Kontras — Commission for Disappearances and Victims of Violence (www.desaparecidos.org/kontras).

TimorAid (www.timoraid.org).

UN Transitional Administration in East Timor (UNTAET) (www.un.org/peace/etimor/etimor.htm).

Nigeria

Nigeria was ruled by a succession of military dictators for nearly three decades. Thousands of civilians were victims of gross human rights violations, including summary executions, kidnapping, illegal detention, torture, and rape. Nigeria gained independence from Great Britain in 1960 and was ruled by a coalition of regional factions until 1965, when it disintegrated into civil war. More than a million people were killed in ethnic and political violence from 1967 to 1970. Since the 1970s, the country has been ruled mostly by military dictatorships. In 1985 a coup led by Ibrahim Babangida brought a new regime to power, along with the promise of a return to civilian rule. However, he annulled a series of elections and was forced to resign in 1993. General Sani Abacha, a long-time ally of Babangida, became president and banned all political institutions and labor unions. Some of the most serious human rights abuses took place in the oil-rich Niger Delta. The Ogoni people, who are among the smallest ethnic minorities in the region, were particularly targeted after this community and their leader, the playwright Ken Sara-Wiwa, staged protests against the dictatorship and the Anglo-Dutch oil giant, Shell. A few thousand people were summarily executed, women were raped, and thousands were tortured, arrested, and arbitrarily detained. Abacha died suddenly in June 1998. He was succeeded by General Abdusalam Abubakar, who immediately freed Olusegun Obasanjo and other political prisoners. In May 1999, Obasanjo, a former military ruler who spent three years in prison during the regime of Abacha, was elected as president through a democratic ballot. Within a month of assuming power, he established the Human

Rights Violations Investigation Commission (widely known as the "Oputa Panel" for its chairman, the former Supreme Court Justice Chukwudifu Oputa), which is investigating human rights abuses committed between January 19, 1966, and May 28, 1999. The Oputa Panel also probed high-profile cases such as the death of Moshood Abiola (the president-elect in 1993) and the abduction of the ex-transport minister Omaru Diko. The panel's mandate was to investigate and prepare a historical record of human rights violations. It could also make recommendations to the government, but unlike in South Africa, there were no provisions for amnesty for perpetrators. With varying degrees of success, the commission called on current and retired military leaders and officials to appear before the panel in many public hearings, but there is widespread disappointment with the failure of the panel to subpoena former Nigerian military rulers Muhammadu Buhari, Babangida, and Abubakar. The commission issued an interim report to the president in June 2002. The crucial question is whether the recommendations of the Oputa Panel will be followed up by the government and by the courts. Worryingly, Nigeria continues to be plagued by human rights abuses. In October 2001 more than 200 civilians in several towns and villages in Benue State were killed by the military. No action has since been taken to prosecute those responsible for ordering and carrying out the crime.

Sources
Centre for Democracy and Development (www.cdd.org.uk).
Constitutional Rights Project (www.crp.org.ng).
Human Rights Monitor Home Page (www.kabissa.org/hrm).
Human Rights Watch. 2003. *2003 World Report: Nigeria*. Washington, DC: Human Rights Watch.
International Center for Transitional Justice (www.ictj.org).
"Overcoming Fear." Radio Netherlands. 3 December 2001 (http://www.rnw.nl/humanrights/html/nigeria011203.html).
The Columbia Encyclopedia. Sixth edition. New York: Columbia University Press, 2002.

Philippines

When President Ferdinand Marcos declared martial law in 1972, he told his country that harsh measures were need to save the Philippines from communist threat. In fact, it was martial law itself that provided new opportunities for the dramatic growth not only of the Communist Party of the Philippines but also of a Muslim secessionist movement in Mindanao and the Sulu archipelago. After the Congress had been shut down, civil liberties restricted, the press muzzled, and the courts cowed into submission, many Filipinos saw armed conflict as the only means by which they could express their grievances against the government. By the end of the martial law era in 1986, 3,257 persons were killed, 35,000 were tortured, and 70,000 imprisoned. Marcos, meanwhile, used his dictatorial powers to accumulate billions of dollars in riches for himself, his family, and his myriad "crony" supporters. Outrage over political repression, economic crisis, crony capitalism, and electoral fraud led to the fall of Marcos in the massive "People Power" uprising of 1986. Marcos fled the country, and to this day there has been next to no punishment of those responsible for either human rights abuses or the plunder of the country's riches. Corazon Aquino took power and restored democratic institutions, but human rights abuses continued in the midst of conflict throughout the archipelago. Both government forces and the communist New People's Army (NPA) were responsible for grave human rights violations in the 20-year war. Neither the government-appointed Commission on Human Rights nor independent monitoring groups had reliable statistics, but even in the new democratic order, numerous cases of politically motivated killings, torture, disappearances, and unfair trials were documented. There were many allegations of abuses by members of the government-trained paramilitary force, Citizens' Armed Forces – Geographical Unit (CAFGU), and anti-communist "vigilante" groups, suggesting that its recruitment and screening measures were little changed from the Marcos years. Some of the more notorious abuses included several beheadings in Negros and Mindanao of suspected NPA supporters, and politically motivated killings elsewhere. Army regulars were reportedly responsible for several summary executions of suspected rebels in Negros during military operations there. Prosecutions of soldiers were rare, and a military court in July 1989 acquitted 24 in the so-called "Lupao Massacre" case. Seventeen civilians in Lupao, Nueva Ecija, including an elderly couple and several children, died when the army opened fire on a village from which an NPA attack was staged in February 1987. The government's Commission on Human Rights had a rocky start. President Aquino established the Presidential Committee on Human Rights with the mandate to investigate both past and present human rights abuses. The seven-person commission was understaffed and underfinanced, and it was quickly overwhelmed with a huge number of complaints. Continuing military intransigence and other political pressures slowed down its work, and in January 1987 the entire committee resigned. Later in 1987, a new

constitution was promulgated which explicitly established the Commission on Human Rights. The commission has been active ever since. Despite this, courts have continued to grant military impunity, even in the most visible human rights abuse cases. In a widely publicized case in 1991, 15 soldiers were acquitted of charges of having massacred 19 civilians in November 1990 in Sultan Kudarat, Mindanao despite eyewitnesses and physical evidence that strongly linked the unit to the massacre. Because of these judicial lapses and continued human rights violations, public confidence in existing complaints bodies, including the Commission on Human Rights and the Office of the Ombudsman, remains very low.

Sources

Amnesty International. 1999. *Amnesty International Report: Philippines.* London: Amnesty International.

Amnesty International. 2002. *Amnesty International Report: Philippines.* London: Amnesty International.

Human Rights Watch. 1989. *World Report 1989: Philippines.* Washington, DC: Human Rights Watch.

Human Rights Watch. 1990. *World Report 1990: Philippines.* Washington, DC: Human Rights Watch.

Human Rights Watch. 1991. *World Report 1991: Philippines.* Washington, DC: Human Rights Watch.

South Africa

With the election of Nelson Mandela as president in 1994, South Africa came out from more than 40 years of the apartheid regime. An outgrowth of Afrikaner nationalism and a mode of colonialism, apartheid (separateness) was declared a crime against humanity by the international community in 1973. Over the course of 40 years, it produced massive political violence and human rights violations, including massacres, killings, torture, lengthy imprisonment of activists, and severe racial, political, and economic discrimination against black and other non-white South Africans. Black South Africans had long mobilized against their inferior treatment through organizations such as the African National Congress (ANC) and the Congress of South African Trade Unions (COSATU). The 1950s and early '60s saw many protests against apartheid policies, involving passive resistance and the burning of "passbooks." In 1960, a peaceful protest against the pass laws organized by the Pan-Africanist Congress at Sharpeville was brutally crushed when police opened fire, killing 70 protesters and wounding about 190 others. During the 1960s, most opposition leaders, including Mandela, were either imprisoned or were living in exile, and the government implemented further plans to perma-

nently segregate the black population. The armed wing of the ANC, Umkhonto we Sizwe (MK) was formed in 1961. Open revolt erupted in 1976 in the black township of Soweto near Johannesburg against the use of Afrikaans as the language of teaching in black schools. Over the next few months rioting spread to other large cities, resulting in the deaths of more than 600 blacks. In 1977, the suspicious death of black leader Steve Biko in police custody provoked more protests. In 1984, a new constitution was enacted which left the blacks completely outside of the political system. During F. W. de Klerk's presidency, Nelson Mandela was freed after 27 years of imprisonment and became head of the recently legalized ANC in 1990. A series of negotiations started between the white minority government, the ANC, and others such as the Inkatha Freedom Party (IFP), resulting in the relatively peaceful elections and transfer of power in 1994. After many months of intense discussions and preparation, the South African Parliament passed the Promotion of National Unity and Reconciliation Act in 1995, which established the Truth and Reconciliation Commission (TRC), with Archbishop Desmond Tutu as chair. The TRC was a part of a much larger transitional process, which included such new institutions as the Constituent Assembly and the Commissions for Land, Gender, and Human Rights. The TRC's mandate was to investigate human rights abuses that took place between 1960 and 1994. The TRC also established the identity of the victims, their fate or present whereabouts, and the nature and extent of the harm they suffered, and the commission determined whether the violations were the result of deliberate planning by the state or any other organization, group, or individual. Once victims were identified, they were offered support to help restore their dignity, and to formulate recommendations on rehabilitation and healing of survivors, their families, and communities. The hearings started in April 1996, and the commission's five-volume report was published in October 1998. The TRC took testimony from more than 23,000 victims and witnesses, and 2,000 of them appeared in public hearings. The most controversial aspect of the TRC's work stemming from its legislative mandate was the "amnesty for truth" offer made to perpetrators who were willing to confess their crimes. The TRC was formally dissolved in March 2002. While human rights organizations widely agree that the TRC has prepared a ground-breaking history of human rights violations in South Africa and made important recommendations, there have been concerns that the

TRC's recommendations have not been fully implemented, in particular in the areas of victims' reparations and continuing prosecution of identified perpetrators.

Sources

Centre for Study of Violence and Reconciliation (www.wits.ac.za/csvr).

Hayner, Priscilla B. 1994. "Fifteen Truth Commissions – 1974 to 1994: A Comparative Study." *Human Rights Quarterly*, vol. 16, no. 4 (1994), 600–655.

Human Rights Watch. 2003. *World Report 2003: South Africa.* Washington, DC: Human Rights Watch.

Institute for Justice and Reconciliation (www.ijr.org.za).

International Center for Transitional Justice (www.ictj.org).

Kritz, Neil J., (ed). 1995. *Transitional Justice: How Emerging Democracies Reckon With Former Regimes.* Washington, D.C. : United States Institute of Peace Press.

Truth and Reconciliation Commission (www.doj.gov.za/trc/index.html).

Villa-Vicencio, Charles and Wilhelm Verwoerd (eds.). 2000. *Looking Back, Reaching Forward: Reflections on the Truth and Reconciliation Commission of South Africa.* Cape Town: University of Cape Town Press.

Thailand

In 1957 Field Marshal Sarit Thanarat staged a military coup in Thailand. A year later, under the pretext of fighting communism, Sarit deposed his own premier, suspended the constitution, and declared martial law. King Bhumibol Adulyadej proclaimed an interim constitution in 1959 and named Sarit premier. When Sarit died in 1963, General Thanom Kittikachorn returned to power. Under Sarit and Thanom Thailand's economy in the 1960s continued to flourish, stimulated by a favorable export market and considerable U.S. aid. Thailand strongly supported the American policy in Vietnam, providing bases for U.S. troops and airfields for strikes against the North Vietnamese, while thousands of Thai troops were sent in support of South Vietnam. The 1970s, however, saw an economic downturn, as the international demand for rice dropped substantially. In addition, Thailand's security was threatened by the spread of the Vietnam War into Cambodia and Laos and by growing, mostly communist, insurgencies in three separate areas within the Thai mainland. The increasing economic and security problems prompted a coup against his own government in November 1971 by Premier Thanom Kittikachorn, who abolished the constitution and the parliament and imposed military rule. On October 14, 1973, Thanom's military regime was toppled after a week of student demonstrations and violence in Bangkok. Thousands of people, mostly students, took to the streets of Bangkok to demand the end of a corrupt military dictatorship and a return to constitutional rule. As the protesters attacked government buildings, the police

and army opened fire, killing by some estimates 400 people (official number of dead is 77) and injuring several thousand (official figure is 800 wounded). This day was later designated as Wan Maha Wippasok or "most tragic day." As a consequence of the protests, Thailand received its first civilian premier in 20 years. Only three years later students again took to the streets. On October 6, 1976, thousands of right-wing activists stormed Thammasat University and attacked left-wing students. After this initial attack, the right-wing mob was joined by the police and military forces, who then started to fire indiscriminately at students. Students who tried to flee were held and attacked by the right-wing forces that had surrounded the campus. The violence lasted for almost two days, and the official body count was 41 dead students. Unofficially, the figures were considerably higher. Almost 3,000 students were arrested and brought to various detention centers. A military tribunal tried 19 of them. In the evening following the riots, the so-called National Administrative Reform Council, led by Admiral Sangad Chalawyoo, toppled the government of Prime Minister Seni Pramoj and installed General Thanin Kraivixien as the new prime minister. Left-wing activists fled en masse into the mountains to join the Thai Communist Party. After the 1976 revolt, the Thai military held power almost continuously until the early 1990s. The student riots of 1973 and 1976 are not a part of official Thai history. Recently, there have been moves to acknowledge this dramatic period of history, with a monument commemorating the students who died in the revolt. The proposed monument, however, would only commemorate the 1973 victims. To address this historical gap, a special committee, led by a political scientist from Chulalongkorn University, was set up in 2000 to revise the October 6, 1976, history. In a renewed attempt to revive the memory of the student protests of the 1970s, the Thai government commissioned one of the country's leading poets, Naowarat Pongpaiboon, to write an account of the events and their immediate aftermath. However, human rights activists have been skeptical of the Thai government's intentions. For example, pro-democracy advocates were outraged when in 1999 Prime Minister Chuan Leekpai awarded former dictator Thanom, under whom the 1973 events occurred, honorary membership in the Thai Royal Guard. Prime Minister Leekpai has also suggested the formation of a national committee that would look into the events of 1973, but human rights activists have been equally wary.

Sources

Asean Focus Group. "Thailand" (http://www.aseanfocus.com/gateway/thailand/strongmanP4.asp).

Janchitfah, Supara. 1996. "Hidden Violence in a Culture of Peace: Remembering a Lesson." *Bangkok Post*, October 13.

Singh, Ajay and Julian Gearing, 1999. "The Murky Events of October 1973: A Book Proposal Reopens Thailand's Wounds." *Asiaweek*, January 28.

"Stirring Up the Dark Past." 1999. *The Nation* (Bankok), July 26.

"Ball in PM's Court on Proposed Oct 14 Probe." 1999. *The Nation* (Bankok), October 4.

"Setting the Story Straight." 1999. *The Nation* (Bankok), October 9.

Yugoslavia (Serbia and Montenegro)

The 13 years of Slobodan Milošević's authoritarian rule of Serbia (1987–2000) is a period marked by a series of brutal ethnic conflicts in Croatia, Bosnia, and Kosovo; intense international isolation; and severe domestic repression. Milošević is widely perceived as the mastermind of the Balkan wars. Although the war operations, until the Kosovo crisis, were not carried out on Serbian territory, Milošević is believed to have been directly in charge of Serbian forces in both Croatia and Bosnia, where he used proxy local governments to pursue his warmongering agenda. The total tally of the Yugoslav wars is yet to be made, but it is estimated that a few hundred thousand people were killed in the armed conflict, summary executions, detention camps, and campaigns of ethnic cleansing. More than a million have been internally displaced or made refugees. Milošević's last war, the conflict in Kosovo, brought the fighting into Serbia proper. Thousands of Kosovo Albanians have allegedly been murdered in the Serbian police and paramilitary incursions into the province. The Kosovo conflict ended when the NATO air force bombed the Serbian military and infrastructure and Milošević signed a peace deal. In 2000, Milošević was finally ousted from power by a surge of popular unrest following his refusal to accept the results of presidential elections. He was replaced by a loose coalition of reformers and moderate nationalists. While Milošević was still in power, but increasingly after his ousting, Serbia has been under tremendous international pressure to cooperate with the International Criminal Tribunal for the Former Yugoslavia (ICTY). While some Bosnian Serb officials and lower-rank soldiers have been apprehended and successfully prosecuted in The Hague during the 1990s, it was really the 2001 extradition of Milošević to The Hague that started a new page in Serbian cooperation with the Tribunal. Amidst great domestic opposition, the Serbian government authorized the transfer of Milošević to The Hague to face charges of genocide, crimes against humanity, and war crimes committed during the conflicts in Croatia, Bosnia-Herzegovina, and Kosovo. This historic extradition marked the first time a former chief of state faced such grave charges in an international criminal court. Despite this great success in Serbia's struggle to deal with impunity, of all the Yugoslav successor states the issue of national reconciliation and war crimes is perhaps the thorniest in Serbia. While national reckoning and investigations of war crimes were, not surprisingly, impossible during Milošević's rule, his successors in office were also reluctant to open the wounds of the past and come to terms with Serbia's great responsibility for ten years of bloodshed. The Hague tribunal is widely perceived as an illegitimate, political court where new history is being rewritten according to "victor's justice." Many military and police officials directly involved in war crimes are still in positions of power, and the paramilitary forces engaged in some of the worst massacres in the wars regrouped as a network of organized crime, widely believed to be behind the assassination of Serbia's reformist Prime Minister Zoran Djindjić in March 2003. Despite ICTY's unpopularity, domestic courts have been reluctant to open proceedings against war criminals in national courts. Other prominent Serbian war criminals are still at large, including former Bosnian Serb leader Radovan Karadžić and his military chief Ratko Mladić, who is held directly responsible for the largest single atrocity in the Yugoslav wars — the 1995 massacre of 7,500 Muslims in Srebrenica. The new Serbian president has announced in 2001 the formation of a Commission for Truth and Reconciliation that would investigate war crimes that occurred during the Yugoslav wars. The commission, however, has immediately received strong criticism from human rights organizations for its selection of cases and its emphasis on crimes committed against, and not by the Serbs. For many victims of grave human rights violations in Croatia, Bosnia, and Kosovo, Serbia's slow path towards ascertaining responsibility for abuses is a sign that national reconciliation is a long way away.

Sources

International Criminal Tribunal for the former Yugoslavia (ICTY). 2002. (www.icty.org).

International Crisis Group (ICG). 2001. *Milosevic in The Hague: What it Means for Yugoslavia and the Region*. Brussels: ICG.

International Crisis Group (ICG). 2001. *Serbia's Transition: Reform under Siege*. Brussels: ICG.

International Crisis Group (ICG). 2002. *Belgrade's Lagging Reform: Cause for International Concern*. Brussels: ICG.

Marina Antić studies Slavic languages and literature, Balkanism, and post-colonial studies. She is originally from Sarajevo, Bosnia. She immigrated to the United States in 1995 and is a graduate student in comparative literature at University of Wisconsin–Madison.

Louis Bickford works at the International Center for Transitional Justice (www.ictj.org). He consults with human rights activists, opposition movements, and governmental and non-governmental organizations on human rights prosecutions, truth commissions and reparations in more than a dozen countries, including Burma, Mexico, and Nigeria. He trained as a political scientist at McGill University.

Ksenija Bilbija works on 20th-century Latin American literature and film. Her work includes a recently published study on Luisa Valenzuela's writing, *Yo soy trampa: Ensayos sobre la obra de Luisa Valenzuela*. She edits *Letras Femeninas*, a journal featuring Latin American women's writing. She teaches literature and culture in the Department of Spanish and Portuguese at the University of Wisconsin–Madison and translates Latin American writing into her native Serbian.

Nicole Breazeale's research focuses on inequality and social change in Appalachia. In 2002, she married an Argentine and became interested in the parallels between the development histories of Appalachia and parts of Latin America, including the strategies used to fight back. Nicole is a doctorate student in the Department of Sociology at the University of Wisconsin–Madison.

Janet Cherry has worked extensively as an activist and research consultant on development and human rights issues in South Africa. She served as a full-time researcher for South Africa's Truth and Reconciliation Commission from 1996–1998. Currently, she is working as a senior research specialist for the Human Sciences Research Council of South Africa.

Laurie Beth Clark is working on a project called *Yahrzeit*, a video about performance truth. Her artistic work involves large scale, site-specific performances and installations, as well as single channel videotapes that she has exhibited in international galleries and art spaces. She teaches in the Art Department at the University of Wisconsin–Madison.

Michael Cullinane's research explores 19th- and 20th-century Philippine social, political and demographic history. He has published widely on these topics, including a recent book, *Ilustrado Politics: Filipino Elite Responses to American Rule, 1898–1908*. He is the associate director of the Center for Southeast Asian Studies and teaches in the Department of History at the University of Wisconsin–Madison.

Jo Ellen Fair's current work examines reporting on national reconciliation in Ghana, where she has also conducted training workshops with journalists. She is editor of *African Issues* and teaches courses on international communication, media in developing countries, and global cultures at the University of Wisconsin–Madison.

Enrique García Medina is an Argentine photographer who started his career by recording the images of Patagonian landscapes in 1990. In 1997, he began working for major national newspapers *Página/12, Clarin, Noticias*, and also freelances with Reuters. He is presently writing about the current Argentine economic and political crisis.

Teresita Gimenez Maceda is currently producing a social drama forum aimed at helping build a culture of responsible citizenship for mainstream Filipino radio. She has written several books and articles on revolutionary and protest songs sung by workers, students, and other disenfranchised groups. She is a professor of Philippine literature and Philippine Studies at the College of Arts and Letters, University of the Philippines, Diliman.

Nyameka Goniwe became immersed in political life when her husband, Matthew Goniwe, a leader in the anti-apartheid movement, was assassinated by South African security forces near Cradock in the Eastern Cape. She now works for the Institute for Justice and Reconciliation in Cape Town, where she focuses on community reconciliation projects.

Cecilia Herrera is a native of Chile who experienced the dictatorship first-hand. As a result, she became interested in studying how artists create their works to address repression in authoritarian regimes. She is a lecturer in the Department of Spanish and Portuguese at the University of Wisconsin–Oshkosh.

Sanja Iveković is a visual artist whose projects examine women's identity in post-communist cultures. Her solo exhibitions include *Frozen Image* (Long Beach Museum, California); *Personal Cuts* (Taxispalais Gallery, Innsbruck, Austria and NGBK in Berlin); and *Lady Rosa of Luxembourg* (Luxembourg). Her art has also been presented at Paris Biennial, Documenta IV and Documenta V (Kassel), Manifesta 2 (Luxembourg), and Liverpool Biennial 2004.

Catherine Jagoe is a freelance translator, interpreter, and writer based in Madison, Wisconsin. She holds the American Translators Association accreditation for Spanish-English translation and works on fiction and non-fiction by Spanish and Latin American writers. Her latest translation is the novel *My Name Is Light* by Argentine writer Elsa Osorio, which deals with the fate of children of the disappeared under the military junta in Argentina in the 1970s.

Agung Kurniawan was born in 1968 and lives and works in Yogyakarta, Indonesia. He studied archeology and graphic art. Since 1990, he has had both solo and group exhibitions in Indonesia and abroad. His award-winning work has been exhibited in many locations: National Art Council (Singapore), Queensland Arts Gallery (Australia), Graphic Atelier Utrecht (Netherlands), KLM (Netherlands), The Jakarta Post (Jakarta, Indonesia), and Deutsche Bank (Jakarta, Indonesia).

Tomislav Longinović is a novelist, psychologist, and cultural scholar interested in the connection between media, war, and nationalism in the former Yugoslavia. His novel *Moment of Silence* focuses on post-Titoist Yugoslavia. He teaches in the Department of Slavic Languages at the University of Wisconsin–Madison.

Nancy Gates Madsen is working on a book that explores the expressive silences left in the wake of authoritarian rule in Argentina. She is a scholar of Latin American literature and culture, with special emphasis on the Southern Cone.

Senzeni Mthwakazi Marasela is based at the Bag Factory (Fordsburg Artists Studios) in South Africa. Her work often addresses themes of absence and gaps in personal history. Some of her exhibits include *Translation/Seduction/Displacement* in New York state, and *Truth Veils* and *Democracy's Images* in Johannesburg.

Cynthia E. Milton works on history in the Andes. She is the author of *The Many Meanings of Poverty* (forthcoming). She teaches Latin American history at the Université de Montréal, Canada.

Courtney Kay Monahan's current research focuses on literature written during and after Argentina's Dirty War. She has studied testimonies of Argentines who survived detention. She is a doctoral student in the Department of Spanish and Portuguese at the University of Wisconsin–Madison.

Lidy B. Nacpil is a political activist, feminist, and currently working on debt, globalization and related issues as Secretary General of the Freedom from Debt Coalition–Philippines and as International Coordinator of Jubilee South. She started as a student activist in 1980, when the Philippines was still ruled by the Marcos dictatorship. She was widowed in 1987, when her husband, Lean L. Alejandro, was assassinated by the Philippine military, leaving her with a six-month-old daughter.

Erica Nathan became interested in the use of humor to cope with the effects of radical evil while studying in Buenos Aires, Argentina. She is currently a Spanish teacher at Hume Fogg Academic Magnet High School in Nashville, Tennessee.

Monica Eileen Patterson's research explores how young South Africans remember violence in their childhood and how violence has shaped the way they now think of themselves and their country. She is a doctoral student in anthropology and history at the University of Michigan, Ann Arbor. She has also conducted research in Zimbabwe.

Leigh A. Payne is currently writing a book, titled *Unsettling Accounts,* on the political impact of confessions made by perpetrators of state violence in Argentina, Brazil, Chile, South Africa, and in the War Crimes Tribunals for Rwanda and Yugoslavia. She teaches

courses on Latin American politics and democratic theory at the University of Wisconsin–Madison.

Mileta Prodanović is a painter, writer, and art critic. Since 1980, he has had more than 30 solo exhibitions at various galleries in Europe and the former Yugoslavia, as well as group shows in Italy, Germany, Switzerland, and Austria. He has also served a curator of exhibitions on Yugoslav contemporary art. He lives in Belgrade, Serbia.

Roger Richards's photojournalism career began in 1979, focusing on political and social conflict in the Caribbean, El Salvador, and Nicaragua. Based in Miami and then Europe, his work has included the U.S. invasion of Panama, political upheaval in Haiti, civil war in Croatia, and the siege of Sarajevo. Richards was a member of the Gamma Liaison photo agency, an Associated Press photo bureau chief in Bogota, Colombia in 1994–1995 and a staff photographer at the *Washington Times* in Washington, D.C., from 1997 to 2001. His work is now syndicated by the 21mm photo agency http://www.21mm.us.

Victoria Sanford has worked with Maya refugees since 1986. She is the author of *Buried Secrets: Truth and Human Rights in Guatemala* and was co-author of the Guatemalan Forensic Anthropology Foundation's report to the Commission for Historical Clarifications. She teaches anthropology at Lehman College–CUNY and is Senior Research Fellow at the Institute on Violence and Survival at the Virginia Foundation for the Humanities.

Harold Scheub is currently working on the final volume of a trilogy on the nature of story, *Shadows – Deeper into Story.* The first two volumes are *Story* and *The Poem in the Story.* Scheub, who has spent 10 years in Africa teaching and conducting research, teaches courses on the oral and literary traditions of Africa at the University of Wisconsin–Madison.

Jonathan Shapiro, also known as Zapiro, is a South African cartoonist. During his required military service, Shapiro became politically active, focusing his cartoons on the political, economic and cultural life of the country. Now famous for his satirical portrayals of public

figures in the news, he creates cartoons for the *Mail & Guardian,* the *Sowetan,* and the *Sunday Times* newspapers. Shapiro is known for his uncompromising political commentary, even in the face of censorship.

Tyrone Siren is currently conducting research on the role that the international gambling industry plays in Cambodia's post-conflict cultural and economic "development." He is a doctoral candidate in the Department of Anthropology and works closely with the Center for Southeast Asian Studies at the University of Wisconsin–Madison.

Jelena Subotić has worked for human rights organizations and independent media in her native Belgrade, Serbia. She continues her work on issues of nationalism, human rights, and state collapse in Yugoslavia as part of her doctoral program in political science at the University of Wisconsin–Madison.

Sarah A. Thomas has long been interested in grassroots work and community mobilization, especially in North and South America. She is a University of Wisconsin–Madison graduate with degrees in international relations and Spanish.

Fadjar Thufail explores different narratives of riots that took place in May 1998 in Indonesia. He is working as a researcher at the Indonesian Institute of Sciences and completing his doctoral studies in the Department of Anthropology at University of Wisconsin–Madison.

Luisa Valenzuela's many novels, essays, and story collections commenting on Argentine society before, during, and after authoritarian rule have appeared worldwide in several languages. Her titles in English translation include: *Strange Things Happen Here, Other Weapons, The Lizard's Tail,* and *Black Novel with Argentines.* She lives in Buenos Aires and is working on a new novel.

Thongchai Winichakul is working on a book about the 1976 massacre of Thai students in Bangkok, the incident he witnessed as one of the student leaders. After 20 years of the Thai government's refusal to accept responsibility for the deaths, he initiated a commemoration of the massacre in 1996. He teaches Southeast Asian history at University of Wisconsin–Madison.

Acknowledgments

Victor Abramovitch
Gbemisola 'Remi Adeoti
Gabriela Alegre
Jane Alexander
Shireen Ally
Jacinto Alves
Gaddis Arivia
Branca Arisć
Rebecca Atencio
J. Wayne Barker
Claudio Barrientos
Guillermo Bastías
Marco Bechis
Carol Becker
Nkosinathi Biko
Miško Bilbija
Mila Bilbija
Byron Bland
Pablo Bonaldi
Marlene Bossett
Katherine Bowie
Claudia Braude
André Brink
Marcelo Brodsky
Gerardo Caetano
Silvio Caiozzi
Estela Barnes del Carlotto
Melissa Castan
David Chandler
Kamala Chandrakirana
Youk Chang
Susana Chávez-Silverman
Ana Cilimbini
Ruphin Coudyzer
Robert Cribb
Michael Cullinane
Michael Curtin
Juan Luis Dammert Egoaguirre
John Daniel
Ludmila da Silva Catela
Harriet Deacon
Carlos Ivan Degregori
James Delehanty
Teresita Quintos Deles
Carlos Demasi
Maria Serena Diokno
Arif Dirlik
Marc Edwards
Alejandro Elias
Diego Escolar
Claudia Feld
Damian Fernández
Vanessa C. Fitzgibbon
Luis Fondebrider
David Foster
Lindsay French
Alicia Frohmann
Madeleine Fullard
Kenneth George
Álvaro di Giorgi
Benny Gool
Patrick Harries
Adrian Heathfield

Stephen Heder
Butch Hernandez
Eric Hershberg
Ariel Heryanto
Hillary Hiner
Lee Hirsch
Katherine Hite
Martha Huggins
Leonora Reyes Jedlicki
Elizabeth Jelin
Ronald Jenkins
Silvina Jensen
Gonzalo Justiniano
Susana G. Kaufman
Melinda Kiesow
Heinz Klug
Vanessa de Kock
Ingrid de Kok
Carrie Konold
Rudy Koshar
Alicia Kozameh
Matthew Kukah
Anu Kulkarni
Duma Kumalo
Premesh Lalu
Victoria Langland
Peter Lekgoathi
Brian Lennon
Cecilia Lesgart
Elizabeth Lira
Alistair Little
Consuelo Katrina A. Lopa
Federico Lorenz
Brian Loveman
Brian Lutenegger
Jaime Malamud-Goti
Florencia Mallon
Billy Mandindi
Xolela Mangcu
Aldo Marchesi
Pedro Matta
Mayibuye Center
Alfred McCoy
Jeff Meinke
Catherine Meschievitz
Paulo de Mesquita Neto
Gray T. Miller
Zoran Mojsilov
Laura Mombello
Cristina Jayme Montiel
Michael Mosser
Khwezi Mpumlwana
Carina Muñoz
Todong Mulya Lubis
Eva Muzzopappa
Sipho Ndlovu
Rob Nixon
Rossana Nofal
Regina Novaes
Liliana Obregón
Andre Odendaal
Antonette Palma-Angeles
Graciela Perosio

Brian Porter
Denzil Potgieter
Agung Putri
Oki Rakaryan
Fazel Randera
Dan Agatep Raralio
Maki Raymo
Kerri Rentmeester
Miguel Repiso
Marcela Rios Tobar
Rayen Robira
Juan Carlso Romero
Douglas Rosenberg
Daniel Rothenberg
Pete Rottier
Monica Roveri
Lynette Russel
Doris Salcedo
Isidora Salinas
Nora Sánchez
Chaiwat Satha-Anand
Mark Schrad
Dora Schwartzstein
Gay Seidman
Diego Sempol
Mark Shaw
Clifford Shearing
Kathryn Sikkink
Steve Smith
Martin Snoddon
Aderito Soares
Noel Solani
Yasmin Sooka
Sirei Sopheak
Daniel Sparringa
Steve J. Stern
Eliseo Subiela
Vanchai Tan
Karen Tanada
Jennifer Taylor
Anders Thorsell
Karen Till
Nicanor Tiongson
Benjamin Tolosa
Thamrin Tomagola
David M. Trubek
Carolina Turba
Silvana Turner
Pieter-Dirk Uys
Teresa Valdés
Patricia Valdez
Minnette Vári
Wilhelm Verwoerd
Charles Villa-Vicencio
Catherine Weaver
Alexander Wilde
Sue Williamson
Wattanachai Winichakul
Crawford Young
Jenny Young
Mary Zurbuchen

Notes

FOREWORD

1 Avery F. Gordon, *Ghostly Matters: Haunting and the Sociological Imagination* (Minneapolis: University of Minnesota Press, 1997), 24, 8.
2 Jorge Semprún, *Literature or Life*, trans. by Linda Coverdale (New York: Viking Penguin, 1997), 13.
3 Fred D'Aguiar, *Feeding the Ghosts* (Hopewell, N.J.: Ecco Press, 1997), 230.

INTRODUCTION

1 James Scott, *Weapons of the Weak: Everyday Forms of Peasant Resistance* (New Haven: Yale University Press, 1987).
2 Deborah Posel, "The TRC Report: What Kind of History? What Kind of Truth?" in *Commissioning the Past: Understanding South Africa's Truth and Reconciliation Commission,* edited by Deborah Posel and Graeme Simpson (Johannesburg: Witwatersrand University Press, 2002), 147–172.
3 John Collins, "Fixing the Past: Stockpiling, Storytelling, and Palestinian Political Strategy in the Wake of the 'Peace Process,'" paper presented at the conference Legacies of Authoritarianism: Cultural Production, Collective Trauma, and Global Justice, University of Wisconsin–Madison, April 2–5, 1998.

NOW FOR A STORY

This essay is adapted from Harold Scheub, "The Storyteller Fishes in the Sky," paper presented at the Fact and Fiction in Post-Authoritarian Societies workshop, University of Wisconsin–Madison, April 26–27, 2001.
1 David Albahari, *Bait: Writings from an Unbound Europe,* trans. Peter Agnone (Evanston: Northwestern University Press, 2001), 4–5.
2 Alicia Partnoy, *The Little School: Tales of Disappearance and Survival in Argentina,* trans. Alicia Portnoy with Lois Athey and Sandra Braunstein. (San Francisco: Midnight Editors, 1986), 27–28.
3 South African Broadcasting Company radio broadcasts from the Truth and Reconciliation Commission. "In the eye," http://www.sabctruth.co.za/worldsright.htm.
4 Jacobo Timerman, *Prisoner Without a Name, Cell Without a Number,* trans. Toby Talbot (New York: Vintage Books, 1982), 4.
5 Pramoedya Ananta Toer, *Footsteps, Buru Quartet,* vol. 3, trans. Max Lane (New York: Penguin Books 1996), 18.

YOUTH STRUGGLE

1 Ellen Kuzwayo interview in "You Kill One, You Kill All!" *South Africa's Human Spirit: An Oral Memoir of the Truth and Reconciliation Commission,* in *Slices of Life* production script (Johannesburg: South African Broadcasting Corp., 2000), http://www.sabctruth.co.za.
2 Peter Mugubane interview in "You Kill One, You Kill All!"
3 Aboobaker Ismail, interview in "Fires of Revolution," *South Africa's Human Spirit: An Oral Memoir of the Truth and Reconciliation Commission,* in *Worlds of License* production script (Johannesburg: South African Broadcasting Corp., 2000), http://www.sabctruth.co.za/worldsright.htm.
4 *Report of the Truth and Reconciliation Commission of South Africa,* vol. 4, ch. 9 (Cape Town: Truth and Reconciliation Commission, 1999).
5 Neo Ramoupi, "September 12, 1997! Let's Recall Some Great Men (and Women) Who Fought for Our Freedom" (September 13, 1996), http://www.hartford-hwp.com/archives/37a/023.html.
6 Sophie Thema interview in "You Kill One, You Kill All!"

BANGING OUT THE TRUTH

1 Personal communication (April 28, 2004).
2 "Propuesta para un Nuevo modelo de pais," *Mi Belgrano* (February 10, 2002), www.cacerolazos.8k.com/propuesta1.htm.
3 José Piterman, "Uno Busca Lleno de esperanzas," *Mi Belgrano* (n.d.), www.cacerolazos.8k.com/esperanzas.htm.
4 Personal communication (January 4, 2002).
5 Adapted from Anonymous, "Last Night in Buenos Aires Argentina: My Personal Experience," Independent Media Center (December 20, 2001), http://www.indymedia.org:8081.
6 Eduardo Galeano, "Los Invisibles," *Mi Belgrano* (n.d.), www.cacerolazos.8k.com/invisibles.htm.

7 Eduardo Galeano, "Los Invisibles," *Mi Belgrano.* (n.d.), www.cacerolazos.8k.com/invisibles.htm.
8 elx, "Nuestro Asunto" (January 28, 2002), www.cacerolazos.com.ar.
9 "Anonimo," *Mi Belgrano* (n.d.), www.cacerolazos.8k.com/anonimo.htm.
10 Personal communication (April 15, 2004).

ARTWORLDS

This essay is adapted from Jo Ellen Fair and Ken George, "Art and the Legacy of Authoritarianism," paper presented at the Fact and Fiction in Post-Authoritarian Societies workshop, University of Wisconsin–Madison, April 26–27, 2001.
1 Paul Stopforth, quoted in Sue Williamson, *Resistance Art in South Africa* (Cape Town: David Philip, 1989), 114.
2 Catherine Gallagher, "Marxism and the New Historicism," in *The New Historicism,* H. Aram Vesser, ed. (New York: Routledge, 1989), 37–48.
3 T. J. Clark, *Farewell to an Idea: Episodes in a History of Modernism* (New Haven, Conn.: Yale University Press, 1999), 292.
4 Karen McCarthy Brown, "Arts and Resistance: Haiti's Political Murals, October 1994" *African Arts* 29 (1996): 46–57.
5 Sue Williamson and Ashraf Jamal, *Art in South Africa: The Future Present* (Cape Town: David Philip, 1996), 31.
6 Marcelo Brodsky, *Buena memoria: Puente de la memoria* (1996), http://www.zonezero.com/exposciones/fotografos/brodsky/menusp.html (accessed: 12 December 2001).
7 Okwui Enwezor "Reframing the Black Subject: Ideology and Fantasy in Contemporary South African Representation," *Third Text* 40 (1997): 21–40.
8 Lyman Chaffee, *Political Protest and Street Art: Popular Tools for Democratization in Hispanic Countries* (Westport, Conn.: Greenwood Press, 1993), 111.
9 Marjorie Agosín, *Scraps of Life: Chilean Arpilleras,* trans. Cola Franzen (London: Zed Books, 1987).
10 Sandra Klopper, "Hip Hop Graffiti Art," in *Senses of Culture: South African Culture Studies,* Sarah Nuttall and Cheryl-Ann Michael, eds. (Cape Town: Oxford University Press, 2001), 178–196.
11 Aneta Szylak, "The New Art for the New Reality: Some Remarks on Contemporary Art in Poland," *Art Journal* 59 (2000): 54–63.
12 Jane Taylor, "Arts of Resistance, Acts of Construction: Thoughts on the Contexts of South African Art, 1985–1995," *World Literature Today* 70 (1996): 93–97.
13 Camara-Dia Holloway, "Claiming Art/Reclaiming Space: Post-apartheid Art from South Africa," *African Arts* 33 (2000): 78–79.
14 Wayne Barker, "Man Made Man Made Man," in Williamson and Jamal, *Art in South Africa,* 79.

A PARK FOR MEMORIES

1 "Between Memory and History: Les Lieux de Mémoire" *Representations* 26 (1989), 13.
2 New Haven: Yale University Press, 1993, 27.
3 Young, 104.

THROUGH THE GRAPEVINE

1 Claudio Javier Barrientos, "Emblems and Narratives of the Past: The Cultural Construction of Memories and Violence in Three Peasant communities of Southern Chile, Neltume, Liqui'ne and Chihuío, 1950–2000," doctoral dissertation (University of Wisconsin–Madison, in progress).
2 "The Fifth Column" rumor was shared by Marina Antić at the "Rumor Roundtable Discussion" at the University of Wisconsin–Madison, November 2, 2001.
3 Teresita Maceda's "Myriad Voices, Converging Wills: Rumor, Humor in the Varied Texts of People Power II," paper presented at the Fact and Fiction in Post-Authoritarian Societies workshop, University of Wisconsin–Madison, April 26–27, 2001.
4 James C. Scott, *Domination and the Arts of Resistance: Hidden Transcripts* (New Haven: Yale University Press, 1990).

RECOLLECTING THE DEAD

1 The EAAF official website is http://www.eaaf.org.ar.
2 Eric Stener Carlson, unpublished interview with Courtney Monahan (October 2002).

THE POWER OF SONG

This essay is adapted from Michael Cullinane, "Singing the Revolution: 'Bayan Ko' and the Anti-Marcos Movement," and Teresita Gimenez Maceda, "Truth-telling Power of Songs," papers presented at the workshop Fact and Fiction in Post-Authoritarian Societies, University of Wisconsin–Madison, April 26–27, 2001.
1 "Die Stem" ("Call of South Africa") was the other. In 1996, the two anthems were combined and adopted as South Africa's national anthem (see http://www.polity.org.za/misc/nkosi.html#hist, accessed March 5, 2002).
2 Sting, "They Dance Alone," on *Nothing Like the Sun* (A&M Records, 1987). U2 performed both songs, "One" and "El Pueblo Vencerá," in their concert at the National Stadium in Santiago, February 11, 1998. See also Elizabeth Jelin and Susana Kaufman, "Layers of Memories: Twenty Years after in Argentina," paper presented at the conference Legacies of Authoritarianism: Cultural Protection, Collective Trauma and Global Justice, University of Wisconsin–Madison, April 3–5, 1998.
3 Gal Costa, "Vale tudo," on *Brasil* (Brazil: BGM, 1997).
4 Jelin and Kaufman, "Layers of Memories."
5 From the popular song "Por el fusil y la flor" from *Canto Claro* (Paredon Records, 1975).

HUMOR THAT MAKES TROUBLE

Adapted from Leigh A. Payne and Teresita Gimenez Maceda, "Humor as Truth – Truth as Humor," paper presented at the conference Legacies of Authoritarianism: Cultural Protection, Collective Trauma and Global Justice, University of Wisconsin–Madison, April 3–5, 1998.
1 Steve Lipman, *Laughter in Hell: The Use of Humor During the Holocaust* (Northvale, N.J.: Jason Aronson, Inc., 1991), 193.
2 Algis Ruksenas, *Is That You Laughing, Comrade? The World's Best Russian (Underground) Jokes* (Secaucus, N.J.: Citadel Press, 1986), 164.
3 Milan Kundera, *The Joke,* trans. Zert (New York: Harper Perennial, 1993), 94–98.
4 Lipman, *Laughter in Hell,* 54–55.
5 Ruksenas, *Is That You Laughing,* 34.
6 See http://www.netfunny.com/rhf/jokes/89q3/some.560.html (accessed January 14, 2002).
7 Ruksenas, *Is That You Laughing,* 11.
8 James C. Scott, *Weapons of the Weak: Everyday Forms of Peasant Resistance* (New Haven: Yale University Press, 1985). See also James C. Scott, *Domination and the Arts of Resistance: Hidden Transcripts* (New Haven: Yale University, 1990).
9 Joke contributed by Mileta Prodanović, 2001.
10 Joke contributed by Teresita Maceda.

TEASING OUT THE TRUTH

1 Excerpted from Wilhelm Verwoerd and Mahlubi "Chief" Mabizela, "An Interview with Zapiro (Jonathan Shapiro)," in *Truths Drawn in Jest,* edited by Wilhelm Verwoerd and Mahlubi "Chief" Mabizela (Cape Town: David Philip Publishers, 2000), 154–155.

SERIOUSLY FUNNY

1 Joaquín Salvador Lavado, *Déjenme inventar* (Buenos Aires: Ediciones de la Flor, 1983).
2 Roberto Fontanarrosa, *Fontanarrosa y la política* (Buenos Aires: Ediciones de la Flor, 1983).

PERFORMING TRUTH

1 Marvin Carlson, *Performance: A Critical Introduction* (London, Routledge, 1996).
2 Jane Taylor, *Ubu and the Truth Commission* (Cape Town: University of Cape Town Press, 1998), v.
3 The importance of drawing on Jarry's Ubu is that expressionist theater techniques are borrowed. Taylor, *Ubu,* iii–iv.
4 *South African Freedom Songs: Inspiration for Liberation* (CD, Cape Town: Mayibuye Center, 2000).
5 Erving Goffman, *The Presentation of Self in Everyday Life* (New York: Doubleday, 1959), demonstrated from a sociological perspective that our identities are realized and made known through performance. Michel de Certeau, *The Practice of Everyday Life* (trans. Steven Rendall; Berkeley: University of California Press, 1984), did the groundbreaking work on shopping as resistance. Dick Hebdidge, *Subcultures:*

The Meaning of Style (London: Metheun, 1979), elaborated the specific performances of resistance through fashion. Judith Butler, *Excitable Speech: A Politics of the Performative* (London: Routledge, 1997), is arguably one of the best-known writers on perfomativity.

OUTING PERPETRATORS
1 Gonzalo Martínez, "Dos escraches en Belgrano." *El País* (March 24, 2002), 13.
2 Red Nacional e Internacional de H.I.J.O.S. 2002.

AFTER THE FALL
1 For additional information, consult Mileta Prodanović, *Stariji i lepšl Beograd* (Belgrade: Stubovi Kulture, 2002).

MEMORYSCAPES
This essay is adapted from Louis Bickford, "Memorials, Memoryscapes and the Struggle to Reclaim the Paste Sky" paper presented at the workshop Fact and Fiction in Post-Authoritarian Societies, University of Wisconsin–Madison, April 26–27, 2001.

GEN XX
1 Essay adapted from *Personal Cuts* (Vienna: Triton, 2001).

RUINS OF THE PAST
1 *The Texture of Memory: Holocaust Memorials and Meaning* (New Haven: Yale University Press, 1993), 120.